P9-CNI-677

DICTIONARY OF FILM TERMS

Frank E. Beaver

The University of Michigan

McGRAW-HILL BOOK COMPANY

New York St. Louis San Francisco Auckland
Bogotá Hamburg Johannesburg London
Madrid Mexico Montreal New Delhi
Panama Paris São Paulo Singapore
Sydney Tokyo Toronto

DICTIONARY OF FILM TERMS

1 2 3 4 5 6 7 8 9 0 DOCDOC 8 9 8 7 6 5 4 3 2

ISBN 0-07-004212-8 SC

ISBN 0-07-004216-0 HC

This book was set in Press Roman by Allen Wayne
Communications, Inc.
The editors were Christina Mediate and David Dunham;
the designer was Joan E. O'Connor;
the production supervisor was Phil Galea.
The soft cover photograph was taken by Demarco/Tomaccio Studio.
R. R. Donnelley & Sons Company was printer and binder.

Library of Congress Cataloging in Publication Data

Beaver, Frank Eugene.
 Dictionary of film terms.

 Includes indexes.
 1. Cinematography–Dictionaries. I. Title.
TR847.B43 1983 791.43'03 82-14046
ISBN 0-07-004216-0
ISBN 0-07-004212-8 (pbk.)

PHOTO CREDITS

The photographic stills in this book are the courtesy of the Muse-
um of Modern Art Stills Library and the University of Michigan
Photographic Services Laboratory. The author wishes to thank
Columbia Pictures, MGM, Paramount, Warner Brothers, RKO,
Twentieth Century-Fox, United Artists, and Universal Studios
for their cooperation in making stills available for this dictionary.

For
Julia, John, and Johanna
and
John and Josephine Place

CONTENTS

PREFACE

A *Dictionary of Film Terms* consists primarily of alphabetically arranged definitions of the techniques, concepts, genres, and styles that have evolved as a part of cinematic expression and analysis. The topical index lists groups of terms that relate to larger concepts of film art, such as editing, cinematography, composition, and lighting. An outline of the important events in the historical development and progress of motion-picture art is also included.

Together, these three elements are intended to present in brief, accessible form a handbook on the methods of a unique, multifaceted, and constantly changing medium of dramatic and nondramatic storytelling. The handbook offers, through definition, explanation, and, wherever possible, photographic illustration, a basic, but by no means absolute or exhaustive, breakdown of both the commonly used and the not-so-familiar terms which have been employed in describing the cinema in its many aspects.

In an attempt to provide a thorough overview of film aesthetics, A *Dictionary of Film Terms* includes definitions of concepts which are relevant to the historical development of the motion picture (for example, *actualité*, last-minute rescue) as well as those which are applicable to contemporary cinema (for example, "buddy" films, structural film). Many film terms have both historical and contemporary value. When this is the case, I have noted the historical continuity by citing earlier as well as more recent films for which the concept or technique has relevance.

Technical terminology has been incorporated freely

into the dictionary; but in each entry involving a techno-logical concept, an effort has been made to expand the definition so that it encompasses and suggests the term's value as an aesthetic variant of motion-picture expression. The entry film "grain," for example, carries both a chemical and an aesthetic meaning. In an effort to keep the dictionary focused on film aesthetics, terms which might be considered primarily technical have been eliminated.

I have made an attempt to define each term in the dictionary so that it stands on its own. For easy referencing, however, a term which is used in defining a concept and which appears elsewhere in the dictionary as a separate definition is indicated by boldface type. Other relevant terms, to which the reader might want to refer, are listed at the end of definitions.

No dictionary of film terms can ever be complete or perfect. Yet, it has been my goal to provide one which the filmgoer will find illuminating in the range and clarity of its entries.

A number of people have helped me in this effort, including Al Pietras, David Gruber, Jerry Salvaggio, David Zuppke, Robert Holkeboer, David Yellin, Kathryn Notestine, Cindy Willson, and Grace Gervasi. Mary Corliss at the Museum of Modern Art was marvelously perceptive in suggesting photographic illustrations that would reveal in a single image often complex film concepts. And Phillip Butcher and David Dunham at McGraw-Hill offered constantly useful advice and criticism during the preparation and editing of the dictionary. To all these individuals I owe gratitude and thanks.

Frank E. Beaver

Abstract film A type of film which expresses, through its rhythms and visual design, intentions that are essentially nonnarrative (photo 1). Abstraction emphasizes form over content. In an abstract film which employs recognizable objects, the images are used not to suggest their usual meanings but for effects which are created by the film's editing, visual techniques, sound qualities, and rhythmic design, i.e., form. The rhythmical and mechanical motion of common objects in Fernand Léger's *Ballet*

1. Francis Thompson's abstract study of a large-city environment, *N.Y., N.Y.* (1957), was realized through the extensive use of prisms and distorting lenses.

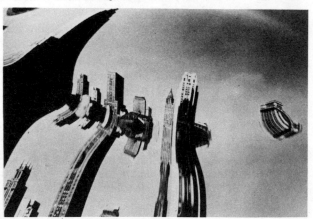

Mécanique (1924) represents a type of abstract film. Many contemporary **animated films** where colors and shapes are the principal interest of the artist can also be described as abstract in quality. The animated **computer films** of John and James Whitney, for example, represent a type of abstract film: *Permutations* (1968), *Lapis* (1963–1966). These films consist of abstract configurations which are computer-generated. The images are enhanced by optical techniques such as **filter** coloring and **dissolves** to give the works a feeling of totally free, nonassociative form. See **Experimental film, Avant-garde**.

Academic editing (see **Invisible cutting**)

Accelerated montage (see **Montage**)

Acting (for film) The film actor has been defined in many ways: as a nonactor, as a mannequin, as a "maker of faces." These descriptive labels result in part from the mosaic, edited nature of film construction. A film performance, like a film scene, is often "built" rather than shot. It has also been said that the screen actor is more dependent on physical characteristics than the stage actor and that physique and facial features often determine the kinds of roles a film actor plays throughout an entire career.

Because of the possibility for candid, natural acting and because the screen performance does not always demand refined theatrical skills, the film actor has often been described by theorists as an individual whose art is

that of effective behaving. "Behaving" in motion-picture acting implies concessions to the piecemeal process of filmmaking. Unlike the stage actor, who enjoys the benefit of a continuous performance, the film actor must usually develop a character in bits and pieces and usually out of story-line sequence. The **director** guides the actors from scene to scene, often giving them on the spot the emotions and actions required in a given situation. Rehearsal time is often kept to a minimum because of both the shooting process and the economics of filmmaking.

A popular theory is that the best film performance is behavioristic—one in which the actor is completely without the airs and self-sufficient qualities of the trained artist. The film actor, some critics argue, must not appear to be acting at all. This claim is based on the assumption that the motion picture is a medium committed to realism. Many directors have, in fact, favored untrained actors, as in the case of Italian **neorealist** films. Film actors of long standing, however, contend that the successful screen performer utilizes skills equal to those of the theatrical performer.

The degree to which an actor is allowed to reflect on characterization and to make the effort to reveal subtleties of character varies from director to director. Michelangelo Antonioni has said: "The film actor ought not to understand; he ought to be." Federico Fellini has told his film actors, "Be yourselves and don't worry. The result is always positive."

Other directors (e.g., D. W. Griffith, George Cukor, Arthur Penn) have sought closer collaboration with the film actor in developing a character for the screen.

At least four facets of a screen actor's performance can be critically evaluated:

1 The physical dynamics of the character
2 The inner spirit of the character
3 The cinematic control of the character
4 The truth of the character

A screen performance is physically dynamic when the actor's movements, physique, facial features, and personality traits attract and hold the attention. The inner spirit of the character is the quality of the performance in revealing subtle emotions and character shadings. The truth of the character refers to the success of the actor in revealing a character who seems dramatically believable. Cinematic control of the character refers to a proper use of the medium, the ability of the actor to create a character without overplaying or underplaying. The screen performance in varying degrees demands vocal, facial, and physical restraint because of the more intimate and realistic nature of the film medium. The large size of the motion-picture screen itself creates a demand for actor restraint. See **Method actor.**

Actualité A term which refers to a **documentary**-like film (photo 2). Historically, *actualités* are associated with the early work of the Lumière brothers in France. Films of workers leaving a factory, a train arriving at a station, and a mother feeding her child presented "actual" views of the world. Unlike the work of later documentarists such as Robert Flaherty (*Nanook of the North,* 1922), the Lumière films were objective record-

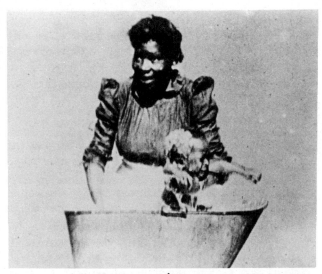

2. An Edison Company *actualité, Washing the Baby,* ca. 1894.

ings of events in motion. Flaherty frequently staged or restaged scenes in creating his environmental studies. The motion-picture camera, placed at a single recording position, was the exclusive agent in the Lumière views of everyday life, omitting the expressive role of editing. These short *actualités* are viewed as the beginning of the documentary impulse in filmmaking and the recognition of the motion-picture camera's penchant for realism.

Contemporary independent filmmakers often return to the concept of the *actualité* in examining subject matter. Andy Warhol's *Sleep* (1963) and *Empire* (1964) can be described as extended *actualités.* In these films Warhol simply photographs a sleeping man in one case and

the Empire State Building in another, allowing his camera to run for lengthy periods of time from a single, unvaried **angle of view**. These uninterrupted views of actuality in which the independent filmmaker's involvement is minimal have led to the label "**minimal cinema**" or "minimal film."

Adaptation A screenplay which has been adapted from another source, such as a play, novel, short story, or biography, and rewritten for the screen. Best-selling novels have been a major source for film adaptations, mainly because of the commercial appeal of an already popular book title.

Screen adaptations from novels and plays have generated a considerable amount of theoretical discussion about similarities and differences in the story-telling media. Many of the discussions of adaptations center on the differences between the visual nature of film versus the novel's opportunities for expression through descriptive prose and the literary trope (metaphors and similes). To film theorists such as Siegfried Kracauer and George Bluestone, an adaptation of a book for the screen implies the need to translate literary images into visual images. The adaptation is, they say, necessarily different from the original if it is to be an effective screen story. Although film writers will often include forceful dialogue in the script, many of the essential elements of characterization and plot in a film emerge through non-verbal communication: costumes, makeup, physique, and action.

The screenwriter is also usually committed to an economy of expression in adapting stories from another me-

dium. The film story is bound by a time constriction which traditionally has resulted in films of approximately two hours or less in length. What may be richness of detail in a novel can become distracting in a motion picture. The screenwriter usually aims for a swift, economical development of character and plot. Often secondary characters and subplots from a novel are used minimally in a film because they clutter and interrupt the steady development of dramatic crises which are essential to the success of a motion picture. For this same reason screenwriters in adapting a novel will most often select the active parts of the plot and ignore elements that do not directly relate to it. A memorable minor character in a book may be only a background **extra** in a film, and an idea that an author may develop poetically and metaphorically in a novel may be reduced to a passing line of dialogue or an image on the screen.

Theorists do not suggest that either the novel or the motion picture is a more desirable medium than the other. Outstanding screen adaptations can be significantly different from the parent novel and yet be equal to the novel in quality. What *The African Queen* (1951), a popular descriptive novel, lost in adaptation it gained in the unforgettable performances of Humphrey Bogart and Katharine Hepburn. In adapting *The Godfather* (1972), screenwriters Mario Puzo and Francis Ford Coppola were able to present a romantic pageant that rivaled the best that the epic screen had ever achieved despite deletions and concessions to action rather than character. Ideas taken from the novel and brought to imagistic life on the screen revealed the heart of Puzo's book, if not its full substance.

Ad lib A nonscripted line of dialogue or comic quip, delivered spontaneously by a performer.

Aerial shot A shot taken from an airplane or a helicopter, intended to provide views of sky action or expansive, bird's-eye views of a scene below. Aerial shots are often used liberally in treating fast-paced, action stories, e.g., the James Bond films.

Aleatory film (technique) A motion picture in which content is developed entirely or in part through chance conditions rather than through preconceptualization of idea and form. The use of aleatory techniques in the filming of an event means that the filmmaker has trusted that the event and the techniques used will reveal meaning despite the uncertainties involved.

The term "aleatory" is from the Latin word *aleator,* meaning "gambler," thus suggesting the risks involved in use of the approach in a filmmaking situation. Aleatory techniques are used commonly by *cinema verité* and **direct cinema** documentarists and by fiction filmmakers who have employed improvisation in the direction of a film narrative, e.g., Robert Altman in *A Wedding* (1978).

Allegory A type of story, film, or play in which the objects, characters, and plot represent a larger idea than that contained in the narrative itself. An allegory is an extended narrative **metaphor** achieved by the dual representation of characters, events, or objects. The characters (objects) and events are intended to represent both themselves and abstract ideas which lead to a greater

thematic significance. The western film *High Noon* (1952) was written so that the marshal (Gary Cooper) might be seen as a personification of individual courage in times of public threats. *High Noon* was intended to evoke an inspirational response to issues surrounding the freedom-threatening activities of McCarthyism during the late 1940s and early 50s.

Ambiguity (dramatic) An approach in theater and film where the meaning of dramatic and character action is intentionally unclear. Inspiration for this approach can be attributed in part to the work of the playwright Luigi Pirandello (*Six Characters in Search of an Author,* 1921). Film directors such as Jean-Luc Godard and François Truffaut have presented screen characters who, in a Pirandellian manner, are searching for personal identity; by making the characters conscious of the medium (theater or film) in which their search is being conducted, an ambiguous theatrical response is effected. Self-conscious awareness of both the "search" and the dramatic medium of expression produces in the audience an uncertainty as to what is real and what is dramatic. Fiction and reality are subtly combined. The philosophy behind such films is that the **director** must have the right of personal expression and be free to raise questions about life and illusion (art) without necessarily providing answers. In many ways this philosophy grows from both an awareness of cinema's possibilities as well as a rejection of the well-made film of explicit meaning. Haskell Wexler's *Medium Cool* (1969) tackles the thematic question of illusion and reality in the motion picture (dramatic and journalistic) through a story that is highly ambiguous in

3. Peter O'Toole portrays Eli Cross, a motion-picture director, who is making a film about World War I in *The Stunt Man* (1980). When a young fugitive is hired as a stunt man, he becomes caught up in a game of confusion—deviously carried out

its narrative form and in its resolution. *The Stunt Man*
(1980) was another screen exercise about the ambiguous nature of illusion and reality in the filmmaking
process (photo 3). A more recent example of dramatic
ambiguity in the motion picture is found in *The French
Lieutenant's Woman* (1981), a film directed by Karel
Reisz with a screenplay by Harold Pinter.

There is also often a political motive behind dramatic
approaches which are intentionally ambiguous, particularly with filmmakers like Godard and Wexler. In works
by these directors (*Le Gai Savoir,* 1968; *Medium Cool*)
viewers are made aware of the illusory nature of the medium, rather than seduced by it, and thus are more intellectually alert to the message.

American montage (see **Montage**)

American studio years The period in American filmmaking, roughly between 1925 and 1960, when the studio system dominated production and exhibition. Film
production was highly departmentalized, with each stage
of the filmmaking process treated in an assembly-line
manner. **Producers** within the studio's units oversaw all
aspects of film production—writing, directing, editing,
release of finished product—and sometimes assumed
authoritarian positions within the studio system.

by the director, who does not reveal to the stunt man the exact
nature of individual scenes in his film. The stunt man cannot tell
what is real and what is being staged for the cameras. Dramatic
ambiguity results for both the stunt man and for the viewer.

The studio system was geared to the production of motion pictures designed to appeal to mass audiences. It was an era characterized by well-made pictures whose technical quality enhanced their sentiment and romantic appeal. Narrative **conventions** and formulae were repeated from one picture to the next as the studios turned out popular film types: musicals, gangster films, westerns, series films, romances, comedies. Imitation of successful pictures in each genre was standard studio procedure. Production heads argued on the industry's behalf and in support of the studio system by stressing the role of motion pictures in providing diversion and escape for the American people. In addition to this escapist approach, a code of values was employed in the treatment of subject matter which tended to support the American work ethic and right over wrong.

After 1946, a peak year in motion-picture attendance, there began a steady decline in box office grosses and major alterations occurred in the old studio system. The reasons for the changes were varied:

1 World War II was over, tensions abated, and many people who had sought emotional release through films during the war ceased to attend them.
2 The period after the war was a time when many Americans moved to the suburbs, away from the metropolitan and neighborhood movie houses.
3 Other diversions began to compete for the budgeted entertainment dollar: racetracks, night baseball, bowling alleys, more extensive travel.
4 Installment buying became a widely available mer-

chandising practice, thus stimulating more spending
on home products.

5 By 1948 television was having a significant impact as
 an entertainment medium.

6 In 1948, in an antimonopoly move, the United States
 Supreme Court ruled that the production studios
 must divest themselves of their theater chains, thus
 depriving the studios of guaranteed outlets for their
 releases. The result was a curtailment of **B-picture**
 production and the dismissal of numerous studio em-
 ployees, including contract players.

Following these events, the studio system changed
dramatically. Independent production increased through-
out the 1950s and 1960s, eventually leading the studios
out of self-initiated feature-film production and into
new roles as administrative overseers for independently
produced projects. All production arrangements would
be handled by the outside producer, who would then
seek investment money from the studios, rent studio
space, and negotiate for the studio to handle promotion
and distribution of the finished product. This set of
operating procedures was common in 1980. See **Studio
picture**.

Anamorphic lens An optical **lens** which allows a scene
of considerable width to be photographed onto a stan-
dard-size **frame** area. By using a similar lens on the pro-
jector, the narrowed image is increased to an aspect ratio
of 2.35:1, or a scene that is more than twice as wide as

4. The squeezed-together images in an anamorphic frame from *The Robe* (1953).

it is high. The standard **aspect ratio** for 8-mm, 16-mm, and 35-mm film is 1.33:1. The anamorphic, wide-screen process was introduced commercially by Twentieth Century-Fox with *The Robe* in 1953 (photo 4). The device

itself had been invented by Henri Chrétien in 1927. See **CinemaScope**.

Angle The positioning of a motion-picture camera so as to view a given scene. A camera may be placed straight on to a scene; or it may be placed at a side angle, **high angle,** or **low angle.** Many of the early cinematographers failed to recognize the aesthetic values of camera angles. The tendency was to place the camera in a single straight-on, wide-angle view of a scene. This was particularly true for filming of action on sets. Early sets tended to be theatrical and flat and, therefore, were limited in the dimensionality that would have allowed angle shooting. To "angle" the camera in the early years of filmmaking meant to risk overshooting the flat theatrical settings.
 The angle of a shot is regarded to have both compositional and psychological values. It also aids in diminishing the "flatness" or two-dimensionality of a scene by placing scenic elements into an oblique relationship to one another. By so doing, the angle provides a varied perspective of the scene. See **Angle of view, Dutch angle.**

Angle of view A photographic term which refers to the scope of a shot (see photo 5) as determined by choice of **lens** and camera distance from subject. The angle of view ranges from a wide angle of view **(long shot)** to a narrow angle of view **(close-up).**

Animated film Most commonly a film type in which individual drawings have been photographed frame by frame. Usually each frame differs slightly from the one

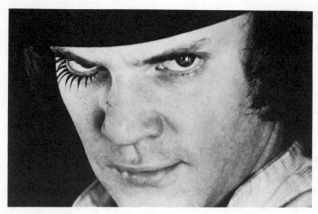

5. Angle of view is illustrated here in three progressive shots from *A Clockwork Orange* (1971). Increasingly the camera moves from a narrow angle of view (close-up above) toward a wide angle of view (long shot, bottom right).

which has preceded it, thus giving the illusion of movement when the frames are projected in rapid succession (24 **frames per second**). "**Pixilation**" is the term used to describe the frame-by-frame animation of objects and human beings as distinguished from the animation of hand-drawn images.

The short animated film has been widely used for curtain raisers and filler material for feature-length **live-action** pictures. Full-length animated films, particularly those of Walt Disney and, more recently, Ralph Bakshi *(Fritz the Cat,* 1972; *Wizards,* 1977), have enjoyed enormous popularity with the film-going public.

Increasingly, many serious artists have begun to use

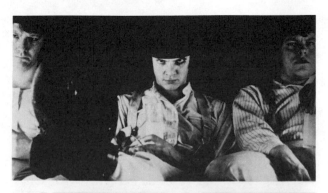

the genre for its distinct artistic, social, and information-
al potential. These artists see the animated film as a me-
dium being closer to the graphic and plastic arts than to
live-action films. Their films exhibit the expressive possi-

bilities of line and composition available to the graphic artist. Some film theorists, noting these efforts, have maintained that animated films are most aesthetically pleasing when the animator is "graphic" rather than "photographic." The Zagreb School of Animation in Zagreb, Yugoslavia, has been a major producer since 1950 of animated films which are principally abstract and graphic in design.

Animated films are being produced in many different artistic media, among them: clay animation (*Closed Mondays*, 1976); puppet animation (*The Hand*, 1965); sand animation (*The Owl Who Married a Goose*, 1974); computer animation (*Permutations*, 1968); cutout collage (*Frank Film*, 1975); and pixilation (*Neighbors*, 1952). See **Animation school of violence**.

Animation school of violence A term applied to animated cartoons which use slapstick, and sometimes extreme violence, as a major comedic element. These cartoons are typified by the work of Tex Avery, a Hollywood animator for Walter Lantz, Warner Brothers, and M-G-M in the 1930s, 40s, and 50s. Avery, who created Bugs Bunny, Chilly Willy, and Lucky Ducky, among other characters, employed a bizarre approach in his cartoon gags. A character would often receive a blow on the head, crack into a pile of jigsawlike pieces, than reshape itself on the screen. Avery was also intrigued by the cartoon's ability to present grotesque changes in character size and shape. These violent, bizarre approaches led critics to describe Avery as an anarchic filmmaker—"a Walt Disney who has read Kafka."

Antagonist That individual or force which opposes the hero (**protagonist**) of a motion picture or a play and imbues the work with dramatic conflict. The antagonist may be another character (like Darth Vader in *Star Wars*, 1977) or a more abstract force such as the raw elements of nature in *Nanook of the North* (1922).

Anticlimax A concluding moment in a motion picture's dramatic development which fails to satisfy audience expectations. The final plotting mechanism which is used to resolve the film's conflict, for example, may be too trivial, implausible, or uninteresting to be dramatically pleasing. Something more important or more serious was expected at this point in the motion picture. This undesired effect is referred to as an "anticlimax." In mystery and detective films an anticlimax may be an intentional plotting device to place the viewer off guard.

Antihero A character in a film, play, or novel who is a sympathetic figure but who is presented as a nonheroic individual—often apathetic, angry, and indifferent to social, political, and moral concerns. In film the antihero, as typified by James Dean in the 1955 film *Rebel without a Cause* (photo 6), and Jack Nicholson in *Five Easy Pieces* (1970), is presented as a tough and resentful character externally, but one who is highly sensitive inwardly. He is motivated by a need for personal truth and justice and struggles to rise from an underdog position to one of control over his own situation.

In screen comedy the antihero usually takes the form of the little man bucking the system, its pettiness and

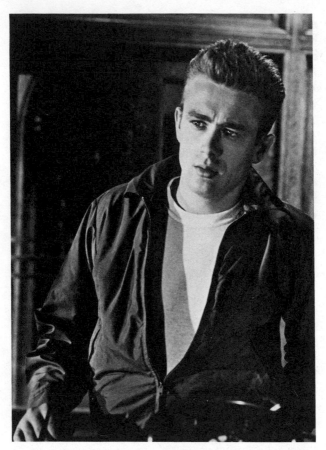

6. James Dean became the prototype for the teenage screen antihero of the 1950s—largely because of his role in Nicholas Ray's *Rebel without a Cause* (1955), a film about unmotivated, violent-prone youth.

adherence to false, shallow values. Charlie Chaplin, an early antihero type, has been followed in more recent times by the likes of Dustin Hoffman in *The Graduate* (1967) and Woody Allen in *Bananas* (1971) and *Play It Again, Sam* (1972). Charlie Chaplin's antihero persona is the well-intentioned and innocent, yet insecure, bumbler who is aspiring to social stature but who fails constantly. He remains on the edges of society but is content and reasonably happy, and, in being so, is victorious.

In **gangster films** lawless figures for whom sympathy is evoked are also frequently referred to as antiheroes, e.g., the main characters in *Bonnie and Clyde* (1967) and *Butch Cassidy and the Sundance Kid* (1969).

Aperture (lens) The diaphragmatic opening of a given **lens.** A motion-picture lens can be "opened-up" or "stopped down" to regulate the amount of light which passes to the sensitized film surface. A large aperture (open), necessary in adverse lighting situations, permits more light to reach the film; a small aperture (stopped down), necessary when available light is more than adequate for a proper **exposure,** allows less light to pass to the film **emulsion.**

The size of the aperture opening has certain aesthetic implications in photographing a scene. A large aperture opening decreases the **depth of field** in a shot and can cause the blurring of images in parts of the picture. By regulating the aperture opening so that some images in a shot are in sharp **focus** and others are blurred (**soft focus**), compositional emphasis can be placed on desired

elements in a scene. Conversely, a small aperture can increase depth of field and can be employed to keep all elements in a framed shot in sharp focus.

A-picture A term originating in the 1930s, used to denote the higher-quality film on a **double-feature** bill. The A-picture was usually made with popular stars and with careful attention to **production values**. Its counterpart, a lower-budgeted effort, was referred to as the **B-picture**.

Archetype A literary term, inspired by psychologist Carl Jung, which refers to that element in film, drama, myth, literature, or religion which evokes in the viewer or reader a strong sense of primitive experience. Any image or arrangement of images which activates such primordial responses to literary and dramatic subject matter is referred to as the archetype. Archetypal criticism is the study of those patterns and images in mythic, literary, and dramatic expression which, through repetition, can be recognized as elements which produce an awareness of common, universal conditions of human existence. John Ford's *Stagecoach* (1939), for example, can be studied for its archetypal structure as a mythic journey through "the heart of darkness" to light, with the experience bringing to the vehicle's occupants spiritual cleansing and new knowledge of the conditions for survival through human interaction. The mythic, revealing journey as a dramatic framework is as old as storytelling itself, and its use by Ford in *Stagecoach* or Francis Ford Coppola in *Apocalypse Now* (1979) becomes archetypal.

Arc shot A moving camera shot in which the camera moves in a circular or semicircular pattern in relation to the object or character being photographed rather than moving in a parallel line. The arc shot provides a varied perspective of the photographed scene by partially or totally circling characters or objects. Circular arc shots were used by Claude Lelouch at the end of *A Man and a Woman* (1966) as two lovers are reunited in a long embrace in a train station. Brian de Palma heightened the romantic dance sequence in *Carrie* (1976) with arc shots. See **Trucking shot**.

Art director The individual responsible for the set design of a motion picture. The art director works to create settings that are compatible with other production elements, e.g., costumes and furnishings, so that a consistent visual style is projected for the film. The achievements of the art director are often more readily apparent in the **studio picture** than in a **location picture**, although the art director's work may be equally important in the latter type of film where certain interior work must be matched to exterior scenes. The art director is sometimes credited as the production designer.

Art theater A term frequently used in the 1950s and early 60s to describe a motion-picture theater which exhibited films that were for the most part outside the commercial mainstream. Art theaters exhibited works that were considered important to the state of film expression regardless of their popular appeal: films by foreign directors, by **independent filmmakers**, and works

not released nationally. Art theaters also frequently presented programs which included film classics.

During the 1970s the term "art theater" was also often used by exhibitors who showed, exclusively, pornographic motion pictures. The adoption of this term by such exhibitors was a promotion gesture that was intended to call attention to specialized subject matter and to suggest serious purpose behind the showing of admittedly candid and controversial films. The "art theater" label implied that films being exhibited there had artistic merit, a criterion which the Supreme Court used in determining whether a motion picture possessed "redeeming social value."

ASA rating (see **Film speed**)

Aspect ratio A term for the comparative relationship of width to height in a projected motion-picture image. The standard aspect ratio for 8-mm, 16-mm, and 35-mm films is 1.33:1, or an image that has a width-height relationship of 4 to 3. The **anamorphic** process can produce an aspect ratio of 2.35:1, a projected image which is almost 2½ times wider than it is high. See **CinemaScope, Cinerama**.

Asynchronous sound A term for film sound which has not been synchronized with the screen image.

Asynchronous sound also includes aesthetic use of sound for expressive purposes. Because of the composite nature of film art, the element of sound (**music, dialogue, sound effects**) is highly manipulative. The sounds of a clucking chicken can be juxtaposed with a shot of a ranting politician for satirical effect.

A popular variation of asynchronous sound in contemporary filmmaking has been in the use of **sound advances** in the editing of scenes. An asynchronous sound advance occurs when the film editor shows the face of a character screaming in horror. Instead of using the natural sounds of the character's horrified voice, the piercing, shrill siren of a police car, to be seen in the following scene, is momentarily advanced as a substitute for the scream.

The device of the sound advance combines asynchronous and **synchronous sound** in a uniquely cinematic way.

Francis Ford Coppola made extensive use of combined synchronous-asynchronous sound in the baptism scene of *The Godfather* (1972). Near the end of the film, shots of a solemn religious ceremony are juxtaposed with scenes of a vendetta occurring simultaneously in various parts of the city. The sounds of the grand church music and priestly intonations of the baptismal rite continue uninterrupted as the gunmen carry out their tasks. Through this use of synchronous-asynchronous sound, with visual **crosscutting**, an ironic, psychological linking of past, present, and future occurs.

Asynchronous sound serves to create **irony** between sound and image, to satirize and parody situations, and to link separate moments of time in expressive ways, with the end result being greater viewer involvement.

Atmospheric quality A term applied to a motion picture with a special visual appeal that is derived from the dramatic use of natural elements: light, weather conditions, heat, landscape, environment. Dry weather condi-

7. The constant suggestion of heat and fire imbues Lawrence Kasdan's *Body Heat* (1981) with strong atmospheric qualities which underscore the film's torrid love story.

tions and heat added atmospheric quality to Roman Polanski's *Chinatown* (1974). Fire and heat supplied both atmospheric and symbolic quality to Lawrence Kasdan's 1981 film *Body Heat* (photo 7). Expression-

istic light and shadow provided such atmospheric quality to a type of detective-mystery film of the 1940s that it was given its own visual label: *film noir,* or literally "black film."

Auteur (criticism) A critical-theoretical term which comes from the French, meaning "author." As a theoretical concept the term "auteur" has been used to describe motion-picture **directors** whose works were said to have been produced with personal vision. Hence, an auteur is a director who "authors" a film by a driving personality and individual artistic control of the filmmaking processes.

The auteur theory denies to some extent the idea that film **criticism** must examine the cinema as a collective art form and view each picture as the end result of a team of artists and technicians. While this is true in many cases, the auteur critics in expounding their theory claimed that many major directors have carried with them from film to film individualized self-expression. As with an author, the filmmaker of vision incorporates into his pictures a view of life through individual style. Therefore, the auteur critics judge motion-picture art by examining both the filmmaker (director) and the works that director has produced. A single film by a major director does not stand alone, but is viewed in relation to all the films by that director. The auteur critics claim that this critical procedure allows for the serious examination of lesser works by a given director which might have been previously overlooked.

The auteur theory was first discussed by François Truffaut in an article, "Une certaine tendance du cinéma français," written in 1954 for the French film magazine *Cahiers du Cinéma.* Andrew Sarris, an American critic for *The Village Voice,* is given credit for bringing Truffaut's ideas on auteur criticism to the United States. The French critics, as well as Sarris and other subscribers to the auteur concept, have developed lists of directors who are considered to have achieved auteur status. Among those directors are Alfred Hitchcock, Raoul Walsh, John Ford, Max Ophuls, Joseph Losey, Howard Hawks, and many others.

The major opposition to the auteur theory came from critics who pointed out that this procedure of criticism made certain motion pictures acceptable when they were clearly poor films; others have argued that the approach tended toward hero worship and led to a priori judgments.

At the same time, the auteur theory has served a number of useful functions in film criticism: (1) it provided a method for looking at film technique and style rather than content alone; (2) it stimulated, as a result of its controversial nature, provocative discussion of the motion picture as a serious art form; (3) it brought recognition to directors such as Alfred Hitchcock and John Ford who had previously been overlooked by the critics as serious artists; (4) it reestablished the importance of the director in film art and criticism.

Available light Light which comes from existing sources such as daylight or room lighting, and which is used as total or partial illumination in the filming of a motion

picture. The term "available lighting" differentiates it
from lighting which is supplied by studio lights or trans-
portable lighting instruments that are specifically de-
signed for professional use in location shooting. When
available lighting is the only type of illumination for a
film scene, and when it is in no way manipulated for spe-
cial effect, the images can carry a realistic quality.

Avant-garde A term used to describe the first **experi-
mental film** movement which began in Europe about
1920. "Avant-garde" is often applied in contemporary
criticism to any film which employs new, original tech-
niques and experimental approaches in expressing ideas
on film. The first avant-garde filmmakers produced two
general types of films: those which employed techniques
commonly associated with the **Dada** and **surrealist** move-
ments in literature and art, and those which were non-
narrative and **abstract** in quality.

The impetus behind the first film avant-garde move-
ment grew out of a revolt against cinema realism. The
filmmakers embraced surrealism because of its "belief in
the higher reality of certain hitherto neglected forms of
association, in the omnipotence of the dream, in the dis-
interested play of thought," as stated by surrealism's
principal spokesman, André Breton. The surrealist move-
ment also provided filmmakers with opportunities for
parody of painting, sex, psychology, contemporary poli-
tics, and the motion picture itself. The surrealists seized
upon and photographed a variety of material phenomena
and arranged these "word pictures" in disparate, illogical
ways to effect subjective, dreamlike meanings. They did

not want their images to have a mimetic life, but a spiritual life—to become images sprung free of a material existence. Man Ray's films *Emak Bakia* (1927) and *L'Etoile de Mer* (1928) and Luis Buñuel-Salvador Dali's *Un Chien Andalou* (1928) are representative of these surrealist impulses.

Surrealism by no means dominated the film avantgarde, either in practice or in theory. Within the movement there was a group of filmmakers who were advocates of *cinéma pur,* "pure cinema": artists who wanted to return the medium to its elemental origins. At the center of this group was René Clair, who wrote in 1927: "Let us return to the birth of the cinema: 'The cinematograph,' says the dictionary, 'is a machine designed to project animated pictures on a screen.' The Art that comes from such an instrument must be an art of *vision* and *movement.*"

The cinema purists—Clair, Viking Eggeling, Fernand Léger, Hans Richter, among others—were interested in the rhythm, movement, and cadence of objects and images within a film—the building of an internal energy through which vision and movement would become both the form and the meaning of the film.

The film titles of the cinema purists suggest the musical-like emphasis on animated pictures: *Rhythmus 21, Ballet Mécanique, Symphony Diagonale, The March of the Machines, Berlin: The Symphony of a Great City.*

The pure-cinema interests were not limited to rhythmical abstractions alone, but also manifested themselves in the fiction film: in Jean Renoir's adaptation in 1926 of Emile Zola's *Nana,* a film where the original plot is incidental and Renoir abstractly treats Zola's story; in Carl

Dreyer's *The Passion of Joan of Arc* (1928), where the ordered use of extreme **close-ups** produces a spiritual response to the face; and in Jean Cocteau's *Blood of a Poet* (1930), a film made up almost entirely of visual transformations which take place in the mind of the poet. See **Futurism, Noncamera film.**

Background music Music which appears on the **sound track** as accompaniment to a film scene. Background music may be specially supplied accompaniment or it may appear to originate from a source within the scene, e.g., an orchestra, a phonograph, or a radio. The latter type of background music is referred to by musical composers as **source music**. In theatrical films, background music is usually employed to reinforce mood or emphasize action. The amount of background music varies according to the filmmaker's intentions, often appearing liberally in screen **melodramas**, for example, and less noticeably in the works of realist directors.

Backstage musical (see **Musical film**)

Balance (compositional) "Compositional balance" refers to the harmonious arrangement of elements in an artistic frame (photo 8). Balance in a motion-picture frame depends on a variety of visual elements: placement of objects and figures, light, color, line, and movement. The aesthetic purpose of frame balance or imbalance is to direct attention and to evoke psychological responses from images appropriate to the dramatic tone of the film story. See **Composition**.

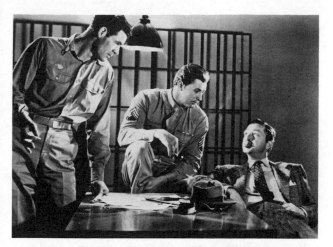

8. A compositionally balanced frame in *Crossfire* (1947). The stronger, dominant right side of the frame (because our eyes scan right) is balanced by having Robert Young seated while Robert Ryan (on the left) stands. Ryan's height on the left brings balance to a shot which otherwise would be dominated by Young's position. Robert Mitchum's placement between the other two characters at midlevel further balances the frame.

Belasco tendency A historical term once used to describe pictorial realism in theatrical art. In the late nineteenth century when the theater was leaning progressively toward melodrama, romance, and spectacle, the stage setting and environment gained in importance. David Belasco, an American theater producer-director of the period, became obsessed with the idea of total verisimilitude on the stage. On one occasion, Belasco went so far

as to transfer an entire hotel room, wallpaper and all, to a stage for realistic impact in a melodrama he was producing. These trends toward pictorial realism and the increasing appeal of more popular theater forms made the advent of the motion picture at the turn of the century especially timely. It has been noted by historians (such as Nicholas Vardac) and theorists that the Belasco tendency could be more easily realized in the medium of film than on the stage.

Biographical film A motion picture based on the life of a public figure, most commonly an individual struggling to achieve goals against considerable odds or to recover from a major setback which threatens an already successful career. The biography film was a popular studio staple at Warner Brothers during the 1930s when the lives of famous people working on behalf of the public good were brought to the screen for their inspirational value, e.g., *The Story of Louis Pasteur* (1936), *The Life of Emile Zola* (1937, photo 9), and *Juarez* (1939). Sports figures have also been popular subjects for screen biographies (*The Babe Ruth Story*, 1948), as have been entertainment personalities (*Coal Miner's Daughter*, 1980). Common characteristics of the biography film are the heroic elements of determination and personal courage. "Bio pic" has been the colloquial term frequently used to designate this type of film genre.

Bit part A small acting role in a motion picture. The character being portrayed usually has some lines of dialogue or at least a moment of dramatic significance in

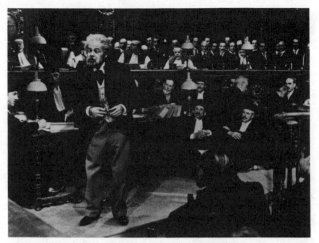

9. *The Life of Emile Zola* (1937), one of the many biographical films produced at Warner Brothers during the 1930s. These studies were noted for their inspirational qualities. Paul Muni portrays Zola.

the film story. A bit part differs from the role of an **extra,** the latter being a nonspeaking figure who is included in the film as a bystander or a background element.

Black-and-white film A film that is produced and released on an **emulsion** that renders images in shades of gray.

Almost all films prior to 1935 were produced on black-and-white stock, although it was a common practice to tint film prints for symbolic effect.

Directors, until the perfection of color emulsions,

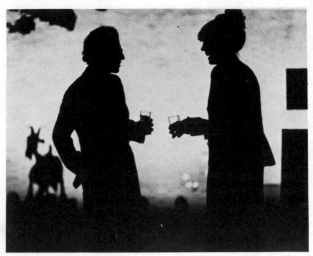

10. The expressive powers of a black-and-white film emulsion are evident in this two-toned silhouette, realized by cinematographer Gordon Willis in Woody Allen's *Manhattan* (1979).

worked successfully with the aesthetic possibilities of black-and-white film. The use of light and dark images on the screen became a visual art. Black-and-white film stocks permitted considerable opportunities for expressionistic use of light and shadow. Psychological inferences could be made through artistic shadings of the gray scale, and creation of mood was possible through tonal renderings. The luminous images achieved by outstanding directors of the 1930s and 40s led to the use of the phrase "the silver screen." This term clearly and favorably suggested an awareness of the unique aesthetics of black-and-white films.

Although **color** has been the norm in filmmaking since the mid-1960s, black-and-white emulsions have remained popular with independent filmmakers and have occasionally been used by major feature directors such as Peter Bogdanovich in *The Last Picture Show* (1971) and *Paper Moon* (1973), Mel Brooks in *Young Frankenstein* (1974), and Woody Allen in *Manhattan* (1979, photo 10).

Black comedy A motion picture or a stage play which treats serious subject matter in humorous ways. The tone of the comedy is dark and pessimistic. *Dr. Strangelove* (1963), a satire about the possibilities of nuclear war, *Catch 22* (1970), an absurd, satirical view of World War II, and *The End* (1978), a humorous character study of a terminally ill man (Burt Reynolds), are examples of black comedy films.

Blaxploitation film A commercial-minded film of the 1970s made to appeal specifically to the interests of black audiences. The design of such films drew heavily on the popularity of black actors in screen stories that were often highly sensational. Tough crime plots with a superhero figure (e.g., *Shaft*, 1971) were common ingredients. The enormous commercial success of *Shaft*, directed by black director Gordon Parks, generated many imitations which were made to capitalize on the drawing power of action films with black heroes. Other titles within the genre include *Melinda* (1972), *Superfly TNT* (1973), *Black Belt Jones* (1974), *Three the Hard Way* (1974), and *Coffey* (1974).

Blimp A camera silencing device which prevents the sound of the camera motor and its gears from being picked up by the recording microphone. *Cinema verité* documentarists and feature-film directors who wish to deny illusory experiences will often leave the camera un-blimped, employing the motor noise as an alienating element on the film's sound track.

Blind bidding The act of bargaining for the exhibition rights to a motion picture without having an opportunity to view the film. **Block-booking**, which was introduced by American studios in the 1920s and which required an exhibitor to take a full package of films or receive none of the studio's offerings, constituted an earlier form of blind bidding. During the 1970s blind bidding on individual films became common, especially for screen spectacles and sequels which were considered by distributors to have enormous box office appeal, e.g., *Rocky II*, 1979; *The Empire Strikes Back*, 1980. Numerous states began to enact legislation which prohibited blind bidding.

Block-booking A motion-picture distribution-rental practice introduced when Hollywood production companies began to purchase and develop their own theater chains. Eventually the procedure extended to almost all exhibitors and became the standard booking method of the 1920s, 30s, and 40s. An exhibitor, in order to buy a studio's products, was required to purchase, sight unseen, a full year's program of film features.

Block-booking had adverse effects on both the studios and the exhibitors. Producers were forced to provide

films to the exhibitor at all costs, often resulting in rapidly made and inferior pictures. In 1948, in an anti-monopolistic move, the Supreme Court ruled that the Hollywood companies had to divest themselves of their motion-picture theaters.

Without the assured outlet of a chain of exhibitors, block-booking could no longer survive. A system evolved in which exhibitors bid on each film individually, and contracts are awarded on the basis of a guaranteed percentage of box office gross.

Blocking The arrangement of characters and objects within a film frame. Blocking is a significant element in photographic **composition** and dramatic expression. Blocking may be used to project a sense of depth into the flat, two-dimensional screen. The blocking of an object or character at the edge of the frame in the immediate foreground and the placement of additional characters or objects in midground and background create a sense of compositional depth within the film frame. In most instances of character blocking, where objective **points of view** are desired, the characters do not openly acknowledge the presence of the camera and are blocked in ways to make the viewer less aware that the camera has recorded the action. When shots are angled slightly, even in **close-ups,** the camera's presence is less noticeable because characters do not appear to be looking directly into the lens. For both aesthetic and objective recording purposes, actions are blocked so that close-up shots of actors are usually taken in three-quarter profile.

When a character does actually look directly into the camera lens, as if to "present" himself or herself or

to "address" the camera, a form of **presentational blocking** occurs. While neither objective nor subjective photography as such, presentational blocking brings the character and the viewer into a dynamic relationship. The character seems to be reaching out to make the viewer a more active participant in the drama.

A form of presentational blocking which breaks the illusion of objectivity altogether takes place when a character actually acknowledges the presence of the audience through speech or gestures. In *Tom Jones* (1963), Albert Finney winks at the audience in "knowing" moments and shrugs his shoulders in times of defeat.

B-picture A term describing a film which appeared on **double-feature** bills in the 1930s, 40s, and 50s. The B-picture was usually the second movie on a two-picture bill. It was characteristically inferior to the main picture (**A-picture**): low budget, lesser-known stars, reworked themes from familiar genres such as the **western** and **science-fiction** story. Production of B-pictures for theatrical release ceased in the late 1940s, although the characteristics of this type of film have continued in the form of made-for-television movies.

The term is sometimes used in contemporary film criticism in a derogatory manner to describe a low-budget film or a film of inferior quality. However, in recent years many film critics and historians have expressed an intense interest in the study of the B-picture category and its directors. They argue that this class of picture and its artists must be judged alongside the A-picture because of (1) the important role each type played in motion-picture and cultural history, (2) the economic sys-

tem which produced the B-picture, and (3) the perspective the B-picture provides in terms of both cinematic style and content within an art form that is ever-changing.

Among the many memorable B-pictures were John Blystone's *Great Guy* (1937), Edgar Ulmer's *Detour* (1946), and Roger Corman's *Apache Woman* (1955).

Buddy films A type of film also popularly called "the buddy salvation" picture, so named because its stories involve male companionship. The term came into use during the 1960s and early 70s through the popularity of such films as *Midnight Cowboy* (1969), *Butch Cassidy and the Sundance Kid* (1969), *The Sting* (1973), *The Last Detail* (1973), *California Split* (1974), and *Freebie and the Bean* (1976). These were among the many films of the period dealing with males who bolstered one another in dramatic conflict and crisis. In these pictures women were relatively unimportant as pivotal characters.

Caesura Principally a literary term denoting a rhythmical pause and break in a line of verse. The caesura is used in poetry to diversify rhythmical progress, and thereby enrich accentual verse. The term first gained significance in motion-picture art because of the editing experiments of Sergei Eisenstein. In applying his concept of **montage** as the "collision of shots," Eisenstein often included caesuras—rhythmical breaks—in his films. The acts of *The Battleship Potemkin* (1925) are separated by caesuras which provide a rhythmical contrast to the preceding action. The intense frenetic action of the mutiny, for example, is followed by the lyrical journey of the vessel to the shore (photo 11).

The three Burt Bacharach musical sequences in *Butch Cassidy and the Sundance Kid* (1969) provide contrasting caesuras that separate the major actions of the film.

Cameo role A brief but important role in a motion picture, usually acted by a major star who often appears only in one scene. Ava Gardner's appearance in the concluding scene of *The Life and Times of Judge Roy Bean* (1972) can be called a "cameo role."

Camera movement The movement of the motion-picture camera for the purpose of following action or changing the view of a photographed scene, person, or

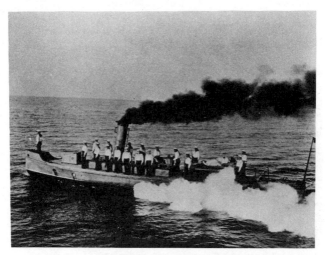

11. Following the frenetic mutiny aboard *The Battleship Potemkin* (1925), Sergei Eisenstein varies the film's pace with a lyric shot of a smaller boat carrying Vakulinchuk's body to the Odessa port. This rhythmic break serves as one of the film's many caesuras.

object. The camera and the base to which it is affixed may both move together in order to: move toward or away from a stationary subject (**dolly shot**); move behind or ahead of a moving person or object (**tracking shot**); move alongside a moving subject (**trucking shot**, photo 12); move up or down on an automatic crane for a lower or higher **angle of view** of a scene (**crane shot**). The camera may also be moved while the base to which it is attached remains stationary: a movement of the camera left or right on a fixed base is **a pan,** while one up and down is a **tilt.** A **zoom shot** can give the effect

12. The camera tracks ahead of a group of characters as they walk and talk in a scene for Mike Nichols' *Catch 22* (1970).

of camera movement, although it is the variable **focal length** of the lens rather than a moving camera which creates the effect.

Camera movement, in addition to following action and changing image composition, can be used to suggest a **subjective** point of view by having the moving camera assume character eye or body movements, as in Delmer Daves' *Dark Passage* (1947). A constant use of camera movement in a motion picture is often referred to as **fluid-camera technique.**

Camera obscura A device developed by Leonardo da Vinci in the sixteenth century which established the ba-

sic principle of photographic reproduction. The camera obscura (darkroom) allowed a small ray of light to pass through a hole into a totally dark room. An inverted and laterally reversed image of the outside scene appeared on the darkened room's rear wall, thus producing the earliest form of a "camera." Da Vinci's image could be traced by the artist to achieve greater realism in artistic renderings. With the development of a photographic plate by Nicéphore Nièpce and Louis J. M. Daguerre in the 1830s which would preserve the inverted image, still photography became possible.

Camera speed The speed at which film runs through a motion-picture camera. Usually camera speed is noted in **frames per second** (fps). Motion pictures consist of a series of still photographs (**frames**) which in rapid projection give the impression of movement. Standard projection speed for sound motion pictures is twenty-four frames per second, and for silent film sixteen frames per second.

Canned drama A term used by early film critics to describe a motion picture. Many turn-of-the-century critics unable to recognize the unique qualities of the cinema employed terms and standards taken from the theater (photo 13). Because early short film narratives also often resembled stage plays, yet were permanently recorded on celluloid, they were frequently referred to as "canned drama." Similar terms, such as "picture plays" and "photo dramas," indicate the difficulty early writers had in finding a separate vocabulary for describing motion pictures.

The term "canned" is still used frequently in film cri-

13. A classic example of canned drama: the adaptation of Sarah Bernhardt's stage production *Queen Elizabeth* (1912) produced by the Film d'Art company in France.

ticism to imply that all motion-picture performances are immutable and thus to suggest differences between film and theater. The expression comes from the fact that once a film is completed it is stored in a motion-picture can.

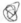 **Cartoon** A hand-drawn **animated film,** usually ten to fifteen minutes in length. The term comes from the Italian word *cartone,* meaning "pasteboard," a material on which sketches were made. "Cartoon" was first used to describe satirical newspaper and magazine drawings which commented on public figures or political matters. Early film animators in the 1920s began to apply the term to their short character sketches which were re-

leased as motion-picture shorts (e.g., Walt Disney's *Alice in Cartoonland,* 1924). There evolved in the extensive production of these short animated films during the 1920s, 30s, and 40s a host of familiar cartoon characters: Mickey Mouse, Donald Duck, Bugs Bunny, Mr. McGoo, etc.

Censorship (U.S.) Motion-picture censorship includes three kinds of regulation: (1) the suppression of film material intended for production, (2) the inspection of film material after the motion picture has been produced with the possible intention of denying public access to the material, and (3) the deletion of material from motion pictures by a censor, or the banning of a motion picture in its entirety because of "objectionable" content.

Statutory censorship began in the United States in the first decade of the new medium. By 1922 more than thirty states had pending censorship legislation.

In 1930, the Hollywood industry, under the guidance of Will Hays, drew up a self-regulatory code of moral standards to be used as a film production guide. This code and its administering organization, popularly called the "Hays Office," were designed as an internal means of combatting outside statutory censorship. The code contained a list of specific and general production taboos. Illicit sex, undue suggestiveness, illegal drug use, pointed profanity, and methods of crime were among the kinds of materials forbidden by the code.

First Amendment guarantees of freedom of speech were given to the motion picture for the first time in *"The Miracle* Case" (1952) decision.

The rating system, devised by the Motion Picture Association of America in 1968, replaced Hollywood's self-regulatory code. The rating system classified films according to their suitability for various age groups and offered four categories: (G), General audiences; (M), later changed to (PG), Mature audiences, "parental guidance" advised; (R), Restricted, adult accompaniment required for anyone 17 or under; (X), No one admitted under 18 years of age.

Censorship activity centered on the issue of obscenity increased in the United States after the Supreme Court ruled in *Miller vs. California* (1973) that community standards, rather than state or national standards, would be applied in interpreting individual cases.

Chase A popular film element characterized by the pursuit of individuals or objects on the screen. The chase has been a significant part of motion-picture story-telling since the advent of the medium. Many early film narratives contained a chase as a means of providing excitement in what were often otherwise static films. A French producer for Pathé, Ferdinand Zecca, was an early master of chase films—producing numerous short pictures made up almost entirely of pursuit sequences (*Slippery Jim*, 1905).

The chase comedy was also a highly popular film genre in the first decades of the motion picture. The Keystone Kop comedies of Mack Sennett invariably ended with a zany chase. The chase was also a significant element in Charlie Chaplin's one-reel comedies. Audiences in the silent film era came to expect the chase as the standard means of bringing a screen comedy to its conclusion.

D. W. Griffith made extensive use of the chase as an element of dramatic tension in his films. Most of Griffith's major films ended with extended chases, carefully edited to build tension and usually concluding with a **last-minute rescue**.

The chase as a thematic element has had a major place in many of the standard film genres: the **western**, the **gangster**-intrigue picture, and the **costume film**.

Film theorists have attributed the popularity of the chase to both the appeal of action on the screen and the motion picture's unique ability to follow complex, intense movement.

Chiaroscuro lighting A painting term used frequently to describe a type of motion-picture imagery in **black-and-white** and **color films** where the pictorial representations are rendered in terms of light and shade. The artistic arrangement of lights and darks, without regard for strong color values, becomes the primary method of visual presentation of scenic elements. The early interior scenes of *The Godfather* (1972, photo 14) have a chiaroscuro effect, particularly those involving Don Corleone in conference at his desk while the wedding party dances outside. In these interior scenes Don Corleone, lit in muted **sepia** tones, is set against a dark, **limbo** background.

Cineaste A term from the French, meaning filmmaker or producer. Cineaste is usually used, however, in France, and recently elsewhere, to describe the serious student of film art or the serious film enthusiast.

Cinema novo A South American film movement that

14. The opening interior scenes of *The Godfather* (1972) possess a chiaroscuro look because of a lighting scheme which has deemphasized strong color values for a tonal effect that is rendered primarily in light and shade.

originated in Brazil in the 1960s and which was characterized by a spirited interest in social and political ideology. Nelson Pereira dos Santos (*Barren Lives*, 1963) and Glauber Rocha (*Black Gold, White Devil*, 1964) were

two of the important filmmakers who led the movement, mixing in their films social realities of national concern with purely aesthetic interests. The combination of local subject matter and dynamic expression inspired film directors throughout Latin America.

Cinéma pur (pure cinema) An **experimental-film** term usually applied to works made during the first **avant-garde** movement which occurred in Germany and France during the 1920s. Pure cinema enthusiasts were opposed to narrative expression in the motion picture, advocating instead an exploitation of the unique cinematic devices of the medium in order to provide a purely visual and rhythmic experience. **Dynamic cutting, fast and slow motion, trick shots,** and moving camera shots were among the techniques employed to give visual-rhythmic life to subject matter that included inanimate objects as well as people. In Germany, Hans Richter used **stop-action cinematography** for *Rhythmus '21* (1921), a pure-cinema exercise which animated geometric paper designs of various shapes and tones. For *Ballet Mécanique* (1924) Fernand Léger, a French cubist painter, placed people and household objects in nonassociative rhythms on the screen. The *cinéma pur* efforts of the first avant-garde movement fall into a type of film now more commonly referred to as the **"abstract film."**

Experimental filmmakers continue to produce purely abstract films, e.g., Francis Thompson's *N.Y., N.Y.* (1957), Stan Brakhage's *Mothlight* (1963), Norman McLaren's *Synchromy* (1972), and Larry Cuba's *3/78* (1978).

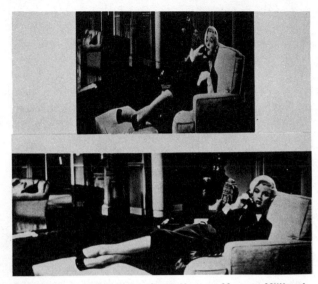

15. A CinemaScope image from *How to Marry a Millionaire* (1953), shown above as it looked in the film print and below as it appeared when projected on the screen.

CinemaScope A wide-screen process developed and introduced by film technicians at Twentieth Century-Fox in the early 1950s. In CinemaScope filming the aspect ratio of images varied from 2.66:1 to 1.66:1. The traditional screen ratio had been 1.33:1. Camera technicians employed **anamorphic lenses**, invented by Henri Chrétien in 1927, to photograph scenes so that they were wider than they were high (approximately 2½ times wider, photo 15). By using a comparable lens on the 35-mm projector, the images could be projected at their original width.

Cinematic A critical term expressing an awareness of that which is peculiar and unique to the film medium. "Cinematic" generally encompasses the full range of techniques available in motion-picture art. When applied to a specific film, the term is used to indicate that the filmmaker has employed the editing and visual devices, themes, or structural approaches which are especially appropriate to the medium.

"Cinematic" can also be defined historically by examining the innovations of early film artists who sought to break the new medium away from the artistic traditions of the legitimate theater. These innovations—peculiar to the film medium—included the use of camera **angles**, realistic decor in dramatic setting, mobile camera, naturalistic **acting**, optical techniques (**dissolves, fades, superimpositions, irises**), and especially the advantages of motion-picture editing which allowed (1) variety in the scope of shots, (2) rhythmical control of dramatic action, and (3) the ability to move freely in time and space through editing.

The exploitation of the unique time-space possibilities of the motion picture has often been a principal factor in a film's being deemed "cinematic."

"Cinematic" has also been used to describe certain kinds of story material which seem especially suited to the film medium. The **chase**, for example, is regarded as a narrative element which is peculiarly cinematic; the motion picture, again because of its free use of time and space, is able to follow intense, complex action with ease.

The term has also been frequently used in literary criticism to describe fictional methods which suggest cer-

tain affinities with the motion picture. Likenesses have been drawn between film techniques and the fictional methods of such writers as James Joyce, Marcel Proust, Virginia Woolf, John Dos Passos, William Faulkner, Gustave Flaubert, and many others. Primarily the cinematic analogy has been used because of these authors' temporal (time) arrangement of their material. The goal of the writer may be simultaneous action **(parallel development)** as in Dickens' *A Tale of Two Cities* and Faulkner's *Light in August;* an impressionistic, stream-of-consciousness point of view found in James Joyce's *Ulysses* and Virginia Woolf's *To the Lighthouse;* or the collective narrative with several interweaving stories which was the approach used in John Dos Passos' *USA.* These techniques are viewed as resembling the cutting techniques which are also available to the filmmaker and thus have been labeled cinematic. See **Cinematic time and space, Filmic, Simultaneity.**

Cinematic time and space A term which indicates the relationship of time and space in the motion picture. In a theatrical experience space remains static and constant. On the other hand, space in the cinema can be altered because the camera serves as a selective intermediary in the screen experience. Individual shots within a motion picture are capable of breaking up the rigid space-time continuum of the real-world experience.

In the real-world experience a man rises from his armchair where he has been reading the evening newspaper, crosses to the bar, and mixes a drink. His movements from the chair to the bar must be made through actual space and time. In the cinema experience the man can

rise and start his movement to the bar. This initial movement can be followed by a brief two-second shot of a startling headline in the newspaper lying on the armchair, followed immediately by a close-up of the man sipping his drink at the bar and contemplating the impact of the headline.

Cinematic space is thus intimately woven with the unique temporal (time) possibilities of the motion picture. A character's movement, for example, can be made to appear unusually prolonged through the addition or repetition of visual space. In *Bonnie and Clyde* (1967), the moment of recognition by the two killers that they are about to be ambushed is extended with unusual effect by intercutting numerous close-ups of the gangsters as they glance at one another.

Through the elimination or addition of visual space in photographing and editing a film, time can be either expanded or contracted.

Cinématographe A combination motion-picture camera-projector apparatus developed in France in 1895 by August and Louis Lumière, photographers and manufacturers of photographic materials whose business was located in Lyons. The portability and projection capabilities of the Lumière machine made it vastly superior to Edison's bulky **Kinetograph** camera and single person peep-show device, the Kinetoscope. The Cinématographe utilized an **intermittent motion** system which advanced the film at a rate of sixteen frames per second, momentarily registering each image behind a lens and in front of a strong light source for sharp projection. A public presentation of Lumière *actualités* was held in Paris on

December 28, 1895; the first American-shown Lumière programs were at Keith's Union Square Theatre in New York City, June 1896.

The success of the Cinématographe led to the Edison Vitascope, an intermittent-motion projector invented by Thomas Armat of Washington, D.C. Armat's machine employed a loop procedure to ease tension as the film was advanced by sprocket. Edison purchased the rights to manufacture and promote the Armat projector, introducing it as the Edison Vitascope in a program of films shown at Koster & Bial's Music Hall in New York City on April 23, 1896.

Cinematographer (director of photography) A title used to distinguish motion-picture photographers from still photographers. If the cinematographer in the filmmaking process is fully responsible for the artistic and technical quality of the screen images, that individual is known as the "director of photography." The director of photography, working with camera operators and other technicians, has the larger responsibility for (1) **exposure,** (2) **lighting,** (3) color, (4) **camera movement** and placement, and (5) **lens** choice and **framing** of the screen **image.** The film director works closely with the director of photography to achieve the desired visual compositions and moods that enhance and carry the story.

A director of photography usually works to develop a visual **style** for a film. That style may be romantic or harshly realistic, or it may be standard studio photography.

Cinema verité A stylistic movement in **documentary**

filmmaking, and a term often applied to a fictional film which presents drama in a candid, documentarylike manner. In this type of film the filmmaker either seeks to use the motion-picture camera in an improvisational way or does so out of necessity. *Cinema verité,* meaning "cinema truth," attempts to avoid the slick, controlled look of **studio pictures. Available lighting, hand-held cameras, long takes, in-camera editing,** and natural sound recordings are techniques used to achieve a newsreel-like quality on film. The *cinema verité* method deemphasizes the importance of artistic lighting, exact focus, perfect sound, and smooth camera movements in favor of an ostensibly more realistic, truthful recording of an event. **Lighting** is often intentionally "**flat,**" and **exposures** may be less than perfect.

The documentaries of Frederick Wiseman have been described as *cinema verité* films because of their starkly naturalistic photographic styles. In his studies of American institutions, *Titticut Follies* (1967), *Hospital* (1969), and *High School* (1968), Wiseman uses black-and-white film stock, natural sound, and available lighting to add a realistic impact to already shocking exposés.

One of the intended effects of *cinema verité* is that of having the "story" appear to develop as it is being watched, thus adding to its candor.

Cinema verité filming techniques were widely used by the French **New Wave** film directors of the late 1950s and early 60s. In the United States, John Cassavetes has employed the approach in pictures such as *Faces* (1968), *Husbands* (1970), and *A Woman Under the Influence* (1975).

An early instance of this technique was that seen in

the "News on the March" sequence of *Citizen Kane* (1941). A jerky, hand-held camera with **telephoto lens** is used to show Kane being pushed in a wheelchair about the grounds of his Gothic estate, effecting a sense of candor that resembles the *cinema verité* school of filmmaking. See **Direct cinema, Realistic cinema.**

Cinerama A motion-picture process first used commercially in 1952. Cinerama employed three cameras and three projectors, a wide curved screen, and a complex, **stereophonic sound** system. Three separate images were projected simultaneously onto the curved screen, thus allowing the effect of peripheral vision for audience members. The Cinerama process, invented in 1935 by Fred Waller, permitted novel opportunities for audience participation in the film experience. Viewers, because of the peripheral nature of the screen images and the use of carefully controlled sound effects, felt as though they were riding in an automobile or hurtling down a roller-coaster track.

The first Cinerama release, *This Is Cinerama* (1952), was essentially a travelogue demonstration of this process, but because of curiosity the film proved to be a commercially successful venture.

Cinerama did not prove to be as successful when used to tell a dramatic story on the screen. An apparent conflict resulted between the use of a gimmick and the necessity of developing plot and characterization. Narrative films using Cinerama, such as *The Wonderful World of the Brothers Grimm* (1962), seemed hampered by the technique. This fact, coupled with the considerable expense of installing equipment to handle the process,

limited the use and appeal of Cinerama. The technique
has been occasionally used in certain theaters for screen
spectacles and in special presentations at exhibitions and
amusement centers.

Climax (see **Dramatic structure**)

Close-up A shot which provides a limited, magnified
view of a character or an object in a scene. It is a shot
which usually emphasizes the face if characters are in-
volved and provides a principal method by which the
filmmaker can achieve empathy for characters. If fo-
cused on an object, the close-up bestows dramatic or
symbolic value on the isolated element.

The close-up has been recognized as a device for (1)
directing audience attention, (2) establishing identifica-
tion with and immediacy for screen characters, (3) iso-
lating detail in a scene, (4) creating visual variety in film
scenes, and (5) providing dramatic emphasis.

A close-up, like the **long shot**, conveys a considerable
amount of information, but of a different type. Emo-
tions, feelings, and nuances can be suggested by the
close-up by merely magnifying and isolating an individ-
ual in an intensely dramatic moment. Similarly, the
close-up view of an object—e.g., a gun or a hand—be-
stows and conveys dramatic significance which might be
lost in longer scenic shots.

The duration or length of time that a close-up remains
on the screen also has importance as dramatic material.
By sustaining close-up shots of a character's face, it is
possible for the filmmaker to suggest thought and feel-
ing. The French critic André Bazin observed that if an

object or person is left on the screen long enough it will begin to lay bare its own reality. This unique perceptual possibility that exists through the close-up is a source of expressive power for the filmmaker. In Carl Dreyer's *The Passion of Joan of Arc* (1928), close-ups are used as the predominant method of conveying the spirituality of the woman on trial as well as the intensity of the legal proceedings.

Collage film A film whose images are created through the overlay of assorted materials (as in an artistic collage) and photographed with the intention of achieving both visual and rhythmic effect. Experimental filmmaker Stan VanDerBeek frequently produced collage films, e.g., *Breathdeath* (1964), a film which employed pictures of famous people, cutouts of objects, newspaper headlines, and other material phenomena for an animated protest against war.

Collective story film A motion picture containing one or more narrative units, and arranged so that the separate stories and characters create an expanded treatment of related ideas. D. W. Griffith's *Intolerance* (1916) and Vittorio de Sica's *Yesterday, Today, and Tomorrow* (1964, photo 16) are examples.

Color film A film in which the **emulsion** layer has been chemically developed to respond to reflected light in such a way that color images are produced rather than **black-and-white** images. Color in a motion picture may carry both realistic and expressive values in (1) suggest-

ing time and place, (2) conveying atmosphere, (3) under-scoring theme, and (4) revealing abstract ideas. Through the use of color and lighting in *The Godfather* (1972), Francis Ford Coppola was able to evoke temporal feeling for the parts of the picture which were set in the 1940s. Colors in the early parts of the film were "warm," consisting of brown, yellow, and orange colors, which provided the scenes with a period look. The colored images resembled the warm colors of old paintings and also had a golden glow like that seen in early color motion pictures made in the late 1930s and early 40s. As *The Godfather* moved into the 1950s, the images became cooler—containing more blues and whites and suggesting more recent times. Its sequel, *The Godfather Part Two* (1975) also combined colors to evoke a sense of past and present. Coppola used earthy, warm colors for the nostalgic **flashback** scenes of Don Corleone set at the turn of the century. The contemporary sequences with Michael were somberly blue or starkly bright to convey both a sense of modernity and a psychological mood.

The Taming of the Shrew (1967) was photographed with an almost golden gilt around its images. The effect was designed to resemble the look of "Old Master" paintings of the Renaissance period.

A color technique known as "sepia" is sometimes used in motion pictures to depict the past. Sepia is a light brown image, which can be achieved by printing black-and-white images on color emulsions or through the use of **filters**. Its color association with brown tintypes and sepia photographs has made the technique appropriate for evocative period cinematography. The New York se-

16. *Yesterday, Today and Tomorrow* (1964), Vittorio de Sica's collective story film, presented Sophia Loren as three different types of Italian women: left, top, a Neopolitan woman who keeps out of jail by staying pregnant; left, bottom, a rich but vain woman from Milan; and, above, a modern-day prostitute who challenges religious values.

quence in *Butch Cassidy and the Sundance Kid* (1969), concluding with the trip by boat to Bolivia, is photographed in sepia. The use of sepia images, combined with animated photographs, gave the sequence the quality of an old photograph album.

The overexposed, washed-out color images in the **flashback** scenes of *Marathon Man* (1976) were an effective means of indicating time through color. The images of Levy's suicide had the muted "true-color" look of color films made in the early 1950s, the time of the blacklisting which prompted Levy's suicide.

Atmospheric color. Color to convey an atmospheric or thematic climate within a motion-picture story. In the films *Raintree County* (1957), *Elvira Madigan* (1967), and *Women in Love* (1970), the lush colors of nature are emphasized with such visual beauty that they immediately set the romantic tone of these films.

In Michelangelo Antonioni's *Blow-up* (1967), scenes set in the photographer's studio are given a bluish-white clinical quality that enhances the searching, investigative theme of the film. By contrast, the park scenes—where the emotionally bankrupt photographer stumbles onto a moment of romantic intrigue—are vividly green and "alive." Colors throughout *Blow-up* are both atmospheric and psychologically suggestive. The brightly painted buildings, visible as David Hemmings drives through the streets of London, add a mod, contemporary look to the environment in which the photographer works and lives.

Because colors have been given symbolic connotations, their use in motion pictures may be more abstract than colors designed to suggest time or to convey atmospheric background for a story. Federico Fellini's *Juliet of the*

Spirits (1965) used colors that were fantastic and psychologically suggestive. The inexplicable ambiguous nature of the story was compounded by fantastic, brightly colored costumes and vivid surreal settings. Color provided a visual motif for the "spiritual" nature of Fellini's highly imagistic, nonnarrative film.

The color red in Ingmar Bergman's *Cries and Whispers* (1972) is so dominant and so ever-present that its use is highly theatrical and symbolic. The color stands before the viewer at all times, providing a visual cue for the deep passions and emotions at work in the film. Such uses of color are rare in motion pictures where more commonly a wide range of colors are in a constant state of flux.

Color can also be a significant element in suspense stories. In Nicholas Roeg's *Don't Look Now* (1973), a film about a man with powers of extrasensory perception, the color red becomes the story's principal plotting device. Red is the omen that signals the man's visionary experiences and which leads in the end to his fateful demise.

Before the development of color **emulsions**, it was common practice to hand-tint film prints for symbolic value. A night scene would often be tinted a deep blue, romance scenes rendered in shades of pink. See **Chiaroscuro lighting**.

Commedia dell'arte An **improvisational** approach to comic performance taken from the Italian *commedia dell'arte* companies that gained popularity during the sixteenth century. The *commedia dell'arte* actor was permitted to incorporate spontaneously any comic details, sight gags, and antics which might possibly occur as the

plot synopsis was acted out. Rough-and-tumble pratfalls, stock characters, and vulgarity were also an accepted part of *commedia dell'arte*. The approach was widely used by silent-screen performers, particularly Charles Chaplin and many of the comedians at Mack Sennett's Keystone Company.

Compilation film Any film created principally from already existing footage that has been reedited around a topical, historical, or visual theme. Charles Braverman's *The Sixties* (1970), a compilation film, employs television and news footage of the 1960s to evoke a sense of the social, political, and cultural temperament of that decade. Henri Erlich's *My Way* (1975) is a satirical compilation film which combines the voice of David Frye singing "My Way" with "outtake" and newsreel footage of Richard Nixon's public career.

The compilation approach has also been a vital method of **information films** and propaganda documentaries, e.g., Frank Capra's *Why We Fight* series (1943–1945), Paul Rotha's *Land of Promise* (1945), and television's many historical series such as *Victory at Sea* (1952–1953) and *The Twentieth Century* (1957–1964).

Composition The use of light (including color), camera **angle**, movement, and object and character **blocking** within the film **frame** for photographic and dramatic expression.

The impact of these elements in a film shot depends upon certain psychological and learned facets of visual perception. Lighter objects attract the eye more readily than darker objects; therefore, light can be used as a

means of achieving compositional emphasis. Mass, volume, and movement also have importance for emphasis in frame composition. A single figure separated from a crowd will usually stand out as significant. Similarly, a moving actor will draw attention away from static figures. Because of the kinetic nature of the motion picture, composition is rarely static, and, hence, emphasis and psychological impact through composition are constantly in a state of flux.

A straight-on view of a scene in which actors and objects have been harmoniously arranged so as to fill with equal "weight" all areas of the screen frame is said to be **formally balanced.** In a deathbed scene, formal composition can be achieved by photographing the scene from a straight-on view taken at the foot of the bed. The placement of a nurse on one side of the bed and a doctor on the other side adds further formality to the scene which would have been lost if both nurse and doctor had been placed ("weighted") on the same side of the bed, or if a sharp side angle had been chosen for the camera's positioning. The "balanced" arrangement of characters and objects and the straight-on photography causes the deathbed scene to appear "at rest."

Whereas formal composition connotes harmony and an at-rest feeling in a scene, a slanted, or **Dutch angle,** shot produces a sense of unrest. See **Balance, Obscured frame.**

Composition in depth The blocking or arrangement of characters and objects within the film frame to give a sense of depth to the screen imagery (photo 17). Composition in depth is effected by positioning characters

17. This mirror shot in Haskell Wexler's *Medium Cool* (1969) illustrates composition in depth. The action is blocked deep into the frame as well as in foreground and midground areas.

and objects in the foreground, midground, and background areas of the frame so that the eye looks "in depth." See **Deep-focus photography.**

Computer film An **animated film,** usually of abstract imagery, generated by computer processes (photo 18). The work of John Whitney, the foremost pioneer in computer films, has been primarily in the area of motion graphics—animated designs which Whitney created with the aid of an analogue computer of his own invention. This mechanical device, which was combined with an **optical printer,** permitted Whitney to preprogram and

18. A series of computer-generated configurations as they appear in selected shots from a Whitney film.

vary the nature of the graphic designs, thus making the results of his filmed efforts more than mere happenstance. Some of the many graphic possibilities of the analogue computer were displayed in *Catalogue,* a film released by Whitney in 1961. The multivaried abstract effects of Whitney's work are vividly displayed in this demonstration film. Whitney has also employed a digital computer to create radiant dot patterns which constantly change color and shape.

Stan VanDerBeek is among the other independent filmmakers who have experimented with computer animation, e.g., *Collide-oscope* (1966).

Computer animation is now widely used for industrial purposes, for programming the basic movements of television cartoons, and for generating title and **credit** designs.

Conceptual montage (see **Montage**)

Conflict A term for the struggles and tensions which result from the interaction of two opposing elements in a motion-picture plot. Expressed another way, conflict is the central problem within a film story which ultimately must be resolved. It is the conflict between the **protagonist** (the film's sympathetic figure) and the opposing force (the **antagonist**) which engages the audience's interest.

Continuity The development and structuring of film segments and ideas so that the intended meaning is clear. Continuity is another term for film construction, which includes the development of plot or idea, the editing devices, and the transitions employed to connect the film parts.

In a more specific meaning "continuity" refers to the matching of individual scenic elements from shot to shot so that details and actions, filmed at different times, will edit together without error. This process is referred to as "continuity editing." To maintain continuity within sequences the editor will usually cut on character action so that the scene flows together without noticeable **jump-cuts**. Lapses in the flow of action can be avoided by **cutaways** and **transition** devices.

Music and sound are often utilized to provide a sense

of continuity to a scene or sequence which may contain a variety of unmatched shots taken in different locations. In *Rocky* (1976) the song "Getting High" served as a continuity device during the highly fragmentary sequence showing Rocky in the various training preparations for his title fight. The song connected the numerous brief shots so that they appeared as a single and complete unit within the film.

Contrivance A plotting device or story element which does not seem plausible and which detracts from a motion picture's credibility. The ending of *The Last Laugh* (1924), in which the old doorman (Emil Jannings) is relieved of his misery as a washroom attendant through an unexpected inheritance, is a contrivance. F. W. Murnau, the film's director, intended the contrivance as an ironic commentary on the differences between real life and life in motion pictures, where happy endings predominate. Most contrivances are seen as plotting flaws rather than ironic statements, e.g., the arrival of a cavalry unit at the last minute to save the inhabitants of a fort from an outside attack.

Convention An accepted dramatic element or stylistic approach or type of subject matter that is commonly associated with a kind of motion picture or with motion pictures in general. Films of a particular **genre** are characterized by the use of accepted conventions and mythic elements which are repeated from film to film. The conventions of the **western film** include conflicts involving guns and horses and climaxes that often center on shootouts and **chases**. A visual convention of the western

film is the display of the open spaces of the American frontier.

Voice-over narration was a convention common in *film-noir*-style detective films of the 1940s. Although the use of the voice-over narrator was eventually abandoned, the convention was revived in the remake of *Farewell My Lovely* (1975) in order to evoke a film style reminiscent of earlier versions of the Raymond Chandler story.

In a more general sense, the liberal use of **music** to underscore the actions of screen **melodramas** is a longstanding convention. On the other hand, such conventional use of music is considered inappropriate for **realist-cinema** expression, which traditionally has avoided the use of both narration and supplied music.

Each film type, ranging from **minimal cinema** to the **epic** feature film, has its own set of established conventions.

Editing and camera techniques employed in the construction of a motion picture and accepted by audiences as indigenous to the medium's methods of expression are also regarded as film conventions, e.g., **shot sequence editing**, optical **transitions, camera movement, parallel development, flashbacks**, etc.

Conventions, when overused, can become trite and ineffective, e.g., the use of **slow motion** to depict a violent death—a common convention in **gangster** and **law-and-order films** during the 1960s and early 1970s.

Cookie (cukaloris) A flat, opaque sheet with cutout patterns which will cast shadows onto the film set when placed before a strong light source (photo 19). The

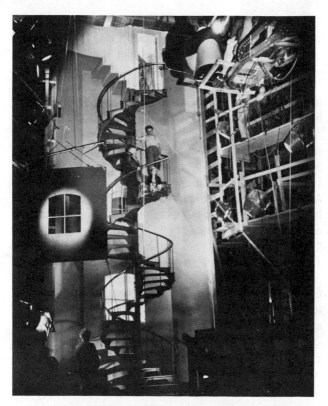

19. In *Captain January* (1936), a film with Shirley Temple, a "cookie" produces the effect of window light being reflected onto the back wall of the set.

cookie (taken from the Greek *cukaloris*) may be used to produce nondistinct patterns for the purpose of breaking up the blandness of a set, or it may be used to cast shadows of doors, blinds, windows, etc.

Costume film A motion-picture **genre** characterized by historical pageantry and **spectacle**. Since the beginning of the film narrative, the costume spectacle has been a commercial mainstay of the screen. One of the earliest films made by Thomas Edison was a brief costume drama titled *The Execution of Mary Queen of Scots* (1896). The feature-length costume drama originated in Italy with pictures like *Quo Vadis?* (1913) and *Cabiria* (1914). Bible-inspired spectacles on a much larger scale were popularized in the 1920s through the work of Cecil B. DeMille (*The Ten Commandments,* 1923, and *King of Kings,* 1927). Costume-action spectacles of a swashbuckling variety were given impetus by the great popularity of films starring Rudolph Valentino (*Blood and Sand,* 1922) and Douglas Fairbanks (*The Mark of Zorro,* 1920). The development and use of **wide-screen process-es** in the early 1950s brought about a new rash of costume dramas displaying spectacle, color, and **stereophon-ic sound**. The genre went into a demise in the 1960s after the failure of *Cleopatra* (1963); occasionally more modern variations of the costume film appear, e.g., *The Three Musketeers* (1974), *Excalibur* (1981)—films which have brought added touches of realism along with the costume film's expected spectacle and pageantry.

Cover shot A long view of a film action, taken for the purpose of establishing the location and all characters within the scene (photo 20).

Craftsman director (see **Director**)

Crane shot A moving shot that may be horizontal, ver-

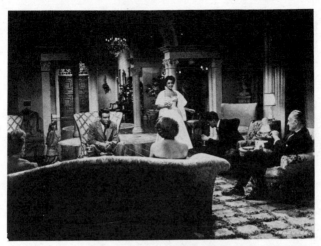

20. A cover shot for a scene in George Stevens' *A Place in the Sun* (1951). The setting and group of characters are established in a single long-shot composition. The cover shot reveals both the environment as well as the spatial relationship of characters to each other. Without an orienting cover shot, close-up views of actors in multicharacter scenes would result in confusion for the viewer.

tical, forward, or backward. The motion-picture camera is mounted on a studio crane which can be smoothly and noiselessly operated by electrical means (photo 21).

Creative geography A form of **montage of attraction** where the editing of shots taken in different locations suggests a spatial unity within a film.

In the climax of *Way Down East* (1920), D. W. Griffith used **crosscutting** among three separate but related

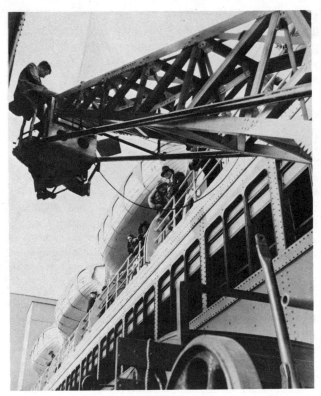

21. A crane lifting device permits an unusual shot perspective in *Letty Lynton* (1932), a film starring Robert Montgomery and Joan Crawford.

locations to depict the **last-minute rescue** of the heroine. Griffith employed shots of Lillian Gish on a cake of ice moving down a river, shots of her boyfriend searching for her, and shots of the falls toward which her ice cake

was apparently moving. For this last location, Griffith spliced in pieces of stock footage of Niagara Falls. Although the actress in reality was nowhere near that or any other falls, the audience believed her to be because the editing bound the locations together.

Lev Kuleshov, while teaching a Russian film workshop class in the early 1920s, studied the films of D. W. Griffith and then performed a series of experiments with geographic editing. In one of these, the audience saw a series of five shots: (1) a man walked from right to left, (2) a woman walked from left to right, (3) they met and shook hands, and the man pointed, (4) a shot of a white building, and (5) the two walked up a flight of steps. The audience connected these shots into a single narrative **sequence**. Actually, the two separate shots of the man and woman walking were made in totally different parts of the city, the white building was the White House snipped out of an American film, and the steps they ascended were those of a church in still another part of the city.

This experiment indicated how geographic unity in a film is not dependent on geographic unity in real space. The given spatial interrelationships are dissolved, and **images** are juxtaposed in such a way that their combination creates an illusion of spatial continuity.

Creative geography has become an integral part of modern filmmaking. **Special-effects films** such as *The Poseidon Adventure* (1972), *Earthquake* (1975), *Jaws* (1975), and *King Kong* (1976) are successful largely because of their effective use of creative geography.

An unusual, psychologically effective use of creative geography occurs in a film adaptation of August Strind-

berg's short play *The Stronger*. In this two-character film, actress Viveca Lindfors portrays both a wife and her husband's mistress who encounter one another at a sidewalk cafe. Through creative geography which allows the dual-role approach in *The Stronger* (1969), a psychological framework is effected to suggest the merger of the two women's personalities.

Credits The list of production personnel, including actors, who have made contributions to a motion picture. Credits for the major artists and technicians involved in the creation of the film usually appear at the beginning of the picture with a complete credit list at the film's conclusion. Until the 1960s, it was more common to include full credits at the beginning of the film rather than its conclusion. The design of introductory credits and the manner in which they are presented on the screen are often a means of setting the mood or **tone** for the film story that follows. The opening credits for *Bonnie and Clyde* (1967) are accompanied by a series of soft, fuzzy photographic shots of the Barrow-Parker gang. Throughout the film proper the gang members frequently take snapshots of one another. The credits and film plot are integrally related. Frequently the opening credits are a **superimposition** over or between **expository** scenes. In the case of *Foul Play* (1978) credits were interspersed between scenes that went several minutes into the film story.

Critical focus (see **Focus**)

Criticism The interpretation and evaluation of film; the study and elucidation of film form and content.

Many approaches to film criticism can be taken. Films may be grouped for study according to director (as in **auteur** criticism), by **genre** (the **gangster, western,** war film, etc.), by studio (Warner Brothers, Paramount, etc.), by subject matter (social themes), by technical evaluation (quality of cinematography), by time period (the **studio years**), or by nationality (French, Japanese), and lend themselves to new and differing insights in each instance. Films may also be analyzed for their cultural significance, how they serve as a mirror of or commentary upon a given society. A critical approach of this latter type is **structuralism,** an anthropological method of evaluating what films reveal about broad cultural patterns of human behavior.

Subjective film criticism judges motion pictures by their aesthetic and emotional qualities. In all cases criticism strives to enrich and deepen the film experience by increasing the understanding of what happens in a motion picture and how its effects are brought across in a **cinematic** way.

Crosscutting **Cutting** between two or more developing concepts or lines of action in a motion picture. Crosscutting may be used for the purpose of presenting simultaneously occurring events, or for thematic construction. Alain Resnais' antiwar film *Night and Fog* (1955) achieves its impact in part by presenting newsreel footage of concentration camps crosscut with **travelogue**like footage of the deserted camps as they appeared ten years after the war. Whether applied to dramatic films or to

films of another type, crosscutting implies that the **editor** has switched back and forth between units of the film. Extensive crosscutting appears in Milos Forman's *Ragtime* (1981) as the lives of several major characters are developed to reveal life in 1920s America.

Cut The splicing together of two pieces of film either to (1) maintain **continuity** (continuous action), (2) change scenes **(transition),** or (3) **insert** other relevant material into the film flow. A cut has both utilitarian and aesthetic value in film editing. By cutting on action in a scene it is possible to employ a variety of different types of shots **(long shots, medium shots, close-ups)** without disrupting the action. Most films are made up of standard cuts of this type. The use of cuts as transitions, rather than the use of **dissolves, fades** and **wipes,** can affect the **pace** of the film. The cut transition is the most direct and immediate editing device for introducing new screen information. One shot is followed immediately by a cut to another shot. A cut transition may place the viewer right in the middle of the action of the next scene without regard for a moment of confusion. This type of cut has been labeled "**dynamic cutting.**" More commonly the film **editor** will cut to an **establishing shot,** or informational close-up, to introduce a new scene so that the viewer becomes oriented to a change in time and location before important dramatic action begins. The cut has considerable value for providing **continuity,** rhythm, **transitions,** and dramatic emphasis.

Cutaway A shot, edited into a scene, which presents information that is not a part of the first shot. The cut-

away shot is usually followed by a return to the original shot, and is often used to condense time in a scene by eliminating undesired action or to cover a loss of **continuity** in the action. For example, a series of shots of a woman sitting alone in a room smoking a cigarette may not match correctly in editing because of the varied lengths of cigarette ash from shot to shot. A cutaway to a mantel clock, ticking away the time, would provide enough distraction to cover the loss of continuity. Or the cutaway of the clock could be **inserted** between a shot of the woman smoking a cigarette and one of the woman reading a book. The cutaway would permit the **editor** to advance the action in time.

Cut-in A shot which presents material in a scene in greater detail, usually through a **close-up** shot. A cut-in isolates and emphasizes an element of the *mise-en-scène* for dramatic or informational value. Each progressive movement through the shot sequence, from **long shot** to **close-up,** constitutes a form of cut-in. A cut-in made from a long shot to a big close-up can have a startling effect on the viewer because of its immediate magnification and is frequently an editing method of **suspense films.** See **Insert shot.**

Dada A literary/art movement founded in 1916 in Zurich, Switzerland. The descriptive term "Dada" had no logical meaning; the expressed aim of the school was to negate the traditional relationship between calculation and creativity in the arts by approaching expression in a more playful, **aleatory** manner. The Dadaists borrowed from other movements of the time such as cubism, paper **collage**, and the displaying of industrially made objects ("ready-mades") as works of art. The school was significant because of its influence on progressive artists throughout the world, and it was a stepping-stone to **surrealism**, which developed in the 1920s **avant-garde**.

Man Ray, working in France in the 1920s, is frequently referred to as a "Dadaist filmmaker" (photo 22). Ray used **collage** techniques in his films, spreading materials on the **emulsion** and then processing the film for whatever results occurred, e.g., *Le Retour à la Raison* (1923), *Emak Bakia* (1927). The early free-flowing, rhythmic films of René Clair, e.g., *Paris Qui Dort (The Crazy Ray, 1923)*, were also inspired by the playful interests of the Dada movement.

Daguerreotype The name given to a photographic **image** retained on silver or silver-covered copper plates, successfully realized through the efforts of Nicéphore Nièpce and Louis J. M. Daguerre. Daguerre publicly displayed

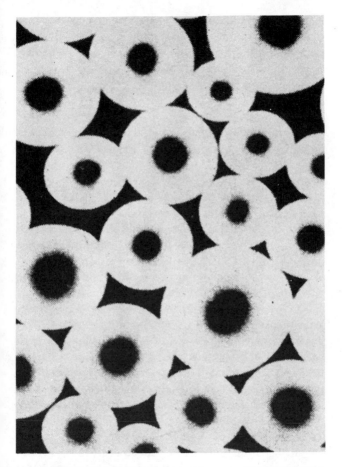

22. Man Ray's Dadaist work, *Le Retour à la Raison* (1923), was realized by the random placement of objects on raw film stock.

examples of the daguerreotype in Paris in January 1839, signaling the arrival of still photography. The development of still photography constituted an important step in the progress toward motion pictures.

Dailies (see **Rushes**)

Day-for-night photography A term for the photographic technique used to simulate night scenes which are shot in daylight.

Day-for-night filming requires underexposure; filtration; and a careful consideration of such factors as sky conditions, color and contrast of subject and background, and strength, quality, and direction of sunlight.

One of the most important requirements of day-for-night filming is to darken the bright daytime sky and balance it with the brightness of the objects or persons providing the foreground action.

Deep-focus photography A term for motion-picture **composition** with great **depth of field** (photo 23). In deep-focus photography the immediate foreground and the deepest parts of the background remain in critical **focus**. This range of critical focus permits the filmmaker to work with several areas of visual information within the same shot. Deep-focus composition is often accompanied by **long-take** photography where there is little or no **cutting** within a scene. The **director** includes all essential action and important character relationships in the deep-focus **frame**. Deep-focus, long-take direction such as that devised by Gregg Toland for Orson Welles' *Citi-*

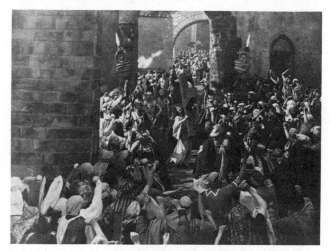

23. A deep-focus shot in D. W. Griffith's *Intolerance* (1916).

zen Kane (1941) was in part the inspiration of André Bazin's theories of *mise-en-scène* analysis (analysis of the photographic image). See **Composition in depth.**

Defocus transition A type of **transition** accomplished by rolling the lens **focus** until the scene becomes totally blurred. Passage of time within a scene can be suggested by refocusing the shot after alterations are made in the scene: change of costume, lighting, or other **continuity** elements. The defocus device has also been frequently employed in transitions to dream or **fantasy** sequences.

Denouement (see **Dramatic structure**)

Depth of field A technical term, with aesthetic impli-
cations, that refers to the range of distance within which
objects appear in sharp **focus** (photo 24). A lens which
provides great depth of field may have an object within
inches of the camera in sharp critical focus as well as ob-
jects or figures hundreds of feet away also in critical fo-
cus. An object being photographed is in critical focus
when each point on the object is reproduced by the lens
as a single point in the film **emulsion.** When more than a
single point is recorded for each point on the object, the
image is said to be "soft," or out of focus. The **aperture**
opening of the lens, light levels, subject-camera distance,
sensitivity of film stock, and focal length of lens all af-
fect depth of field and focus. These various factors may
be manipulated so that a character's eyes are the only
area of sharp focus in a **close-up.** A narrow-angle (**tele-
photo**) lens is most likely to produce this very limited
depth of field which focuses the viewer's attention on
the subject's eyes.

On the other hand, a shot through a **wide-angle lens**
provides great depth of field and allows, sometimes de-
mands, that the viewer choose the area of the **frame** on
which to concentrate his or her attention at any given
moment. This wide-angle, **deep-focus photography** is
sometimes referred to as "**composition in depth.**" Orson
Welles in *Citizen Kane* (1941) often used lenses with ex-
tremely wide angles of view in order to compose in
depth. One shot shows Charles Kane and Susan Alexan-
der Kane at opposite ends of a large room in Kane's pala-
tial home, Xanadu. Susan is sitting in the foreground,
playing with a jigsaw puzzle, and Kane is standing in the
background at the mouth of a giant fireplace. Both char-

24. In this shot from Woody Allen's *Interiors* (1978), only Diane Keaton is within the lens' depth-of-field range and, therefore, in sharp focus. The images of Kristin Griffith and Marybeth Hurt become increasingly "softer" as the distance away from the lens increases.

acters are seen in sharp focus. The creative use of the wide-angle, deep-focus lens here presents the scene in one unified view. Character relationships are clear. The huge space of the room and the considerable distance between the two characters, conveyed in one shot by the wide-angle lens, suggests the alienated nature of the Kanes' marriage and the separation these people feel even when in the same room.

A telephoto lens does not provide as great a depth of field as a wide-angle lens. If foreground objects are in sharp, critical focus in a telephoto shot, background figures usually are not. Because of the limited depth of field of telephoto lenses, it is possible to use narrow-angle lenses for compositional emphasis. In a two-char-

acter telephoto shot, one character can be placed in a plane that will put him out of the lens's depth-of-field range and in **soft focus**. The other character, if put within the lens's depth-of-field area, will be in critical focus and therefore more stongly emphasized than the soft-focus character.

It is possible to have a character so out of focus as to be totally obscured. Filmmakers will often roll focus to shift the area of sharp focus from one part of the scene to another. The roll focus is commonly used to change emphasis from one character to another or to reveal blurred, indistinct material in a scene.

A popular, effective use of the roll-focus technique is to show in a **subjective shot** a scene coming into focus as though a character's eyes are focusing on essential information.

Depth of focus A technical term often confused with, and used for, **depth of field**. The two concepts are related, but quite distinct from each other. Expressed simply, depth of focus is a measure of the lens-to-film-plane distance. According to the *American Cinematographer Manual,* "the depth of focus is an infinitely small range behind the lens at the focal plane within which the film is positioned during exposure. If the film moves out of this position, it will cause unsharp images. . . ."

Detail shot A shot which isolates an element of detail within a scene, usually through the use of a **close-up**. A detail shot is a method of giving emphasis to material phenomena which might otherwise go unnoticed, such

as a clenched fist or a revolver. When this type of shot is a detail filmed separately from the main action (e.g., a close-up of a letter which a character is reading) and intended to be inserted into the action during editing, it is referred to as an "**insert shot**."

Detective film A motion picture whose plot centers on the prowess of a confident, diligent private eye. This individual is usually shown carrying out his mission of seeking evidence against and tracking down a criminal within a large urban environment. Cool and methodical, the detective-hero eventually gets the job done — succeeding in completing a task which local police officers and law officers could not complete.

The detective film differs from a **gangster** picture. Emphasis and sympathy within the detective film are directed toward the heroic prowess of a law-enforcing intermediary, whereas in the gangster film the principal character is an antiheroic figure living and working in the underworld.

The detective film was widely popular during the 1930s and 40s, varying in style from the lighthearted Thin Man series (1934–1944) to the more serious *film noir* effort, e.g., *The Maltese Falcon* (1941).

Dialectical film A film which attempts through its methodology to present ideas for the purposes of intellectual investigation. Sergei Eisenstein created a dialectical approach in his films through an editing process known as "montage of conflict" or "**montage of collision**." In his films Eisenstein employed a variety of differing types of shots which, edited together, created new

meanings. One shot (thesis) would oppose another (antithesis) to produce meaning (synthesis) which did not exist in each separate shot. This dialectical system or thought process developed from Hegelian-Marxist theories which argue that change occurs when one entity passes into and is fulfilled by an opposite entity.

The antiwar **documentary** *Hearts and Minds* (1974) employs visual, aural, and structural devices of dialectical design. Through a combination of available newsreel footage and their own interviews and on-the-spot filming, directors Peter Davis and Bert Schneider in *Hearts and Minds* develop an inquiry into American involvement in the Vietnamese war. Pro and con positions are edited into the film along with scenes of the personal impact of the war on the Vietnamese people and on American veterans. The dialectical nature of *Hearts and Minds* is achieved principally through the development of ideas in conflict with one another, and thereby the work seeks to produce an understanding of the range of motivations that prompted and sustained American involvement in the war.

Dialogue Verbal exchange between two or more characters in a film or play. Dialogue may be presented **voiceover**. In the opening exchange between the French actress and the Japanese architect in *Hiroshima Mon Amour* (1959), the dialogue (two lengthy passages) is heard as the camera roams the museums of Hiroshima. More commonly, dialogue is shown in **lip sync**. The spoken lines are in synchronization with the moving lips of the characters.

Differential focus (see **Focus**)

Direct cinema A term most commonly applied to a type of **documentary** film made in the style' of **realist cinema**. Direct cinema shares many of the same interests as *cinema verité* filmmaking but is narrowly different because it avoids the fluid, spontaneous camera involvement usually associated with *cinema verité*. Camera presence is minimized in direct-cinema filming. **Wide-angle** views and **long-take** scenes, filmed on a stationary **tripod**, are more commonly the recording methods of direct cinema. **Narration** is also avoided.

Because of distanced camera involvement the aesthetic interests of direct cinema involve an *actualité*-like approach to the subject matter and an emphasis on the subjects in their environment. "**Naturalism**" is a word frequently applied to this documentary style which emphasizes the subject in the environment, e.g., *Farrebique* (1946) by Georges Rouquier (photo 25) and *Warrendale* (1966) by Alan King. Aesthetic distance between viewer and filmmaker in these two documentaries is maintained to such an extent that they are often cited as ideal examples of the direct-cinema technique. Ira Wohl's *Best Boy* (1979) employs direct-cinema methods to present a moving portrait of a middle-aged man whose educational development is that of a child.

Direct cut An instantaneous change of shots, usually to a new locale or time frame, and executed without an optical **transition** device. The direct cut is made by splicing together the last **frame** of the outgoing shot

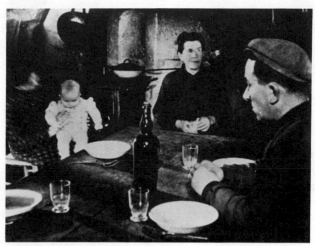

25. Georges Rouquier's camera peruses peasant life on a French farm in *Farrebique* (1946). The *actualité*-like recording constituted one of the early examples of a feature-length film employing direct cinema methods and revealed the peasant family in a detailed and sympathetic manner.

with the first frame of the new shot, and serves to replace, dynamically, one scene with another. See **Dynamic cutting.**

Director That individual in the filmmaking process who serves the principal function of developing the film story into an engaging experience that is artfully constructed. The artful construction of a film story involves the appropriate use of motion-picture techniques, the development of a consistent film style, and control of the dramatic elements of **acting, pace,** and **blocking**.

A second but equally important function of the film director is the coordination of the various technicians who must support the film's concept. The director usually confers on such important considerations as costumes, **lighting**, makeup, **camera movement**, locations, and **special effects**. Script changes, including additions and deletions, are often within the jurisdiction of the director, who in filming the story must determine whether a scene will or won't "play" and whether plot and character development are clear.

In a general way, it is possible to divide the motion-picture director into two broad types.

1 The craftsman director
2 The personal director

The craftsman director. That individual who is skillfully efficient at taking a motion-picture script and bringing it to life on the screen. The craftsman director knows all facets of film production thoroughly and is able to function with both dramatic and technical ease. A **shooting script** is closely followed as the director works with the actors and other technicians. The craftsman director is one employed to guide and coordinate the filming of a story with professional skill.

The personal director. An individual whose degree of involvement in the filmmaking process is pervasive. Most often this type of director selects the film idea and either alone or with other writers develops the idea into a screen scenario and eventually into a shooting script. The idea is chosen because the director has a strong artistic urge to bring the story idea to the screen. The per-

sonal director often both generates and develops the film idea. See **Auteur**, *Metteur-en-scène*.

Director of photography (see **Cinematographer**)

Disaster film A type of screen **melodrama** characterized by a narrative plot that is centered on the efforts of a number of characters to escape a manmade or natural disaster. In its primary goal of providing mass-appeal escapism, the disaster film usually combines extensive action sequences with a story containing character types that are chosen to represent a broad spectrum of society. Technical virtuosity in the display of screen special effects is also a critical element in the disaster film's formulaic design. The **genre** achieved popularity during the 1930s with such works as *San Francisco* (1936) and *In Old Chicago* (1938) where an earthquake and a fire, respectively, generated calamity. Beginning with *Airport* (1970) and *The Poseidon Adventure* (1972), the disaster film experienced an impressive revival that lasted throughout most of the 1970s.

Dissolve A gradual **transition** in which one scene fades out as the other fades in. Both the end of the outgoing shot and the beginning of the incoming shot are briefly seen on the screen simultaneously. The typical length of dissolves is two seconds, although they may be longer or shorter depending on the desired effect. In traditional filmmaking the dissolve came to be the accepted technique for indicating substantial geographic leaps from one place to another and for indicating passage of time from one scene to another or passage of time within the

scene itself. This was so because the **cut** was reserved for
scene **continuity** or for **crosscutting** to simultaneous ac-
tion. The dissolve separates units of action by adding a
note of finality to what has gone before and by offering
a momentary pause in the action flow. This is usually not
true of the cut transition, where new information is in-
stantly revealed and the pace unbroken by an optical
process. During the 1960s filmmakers increasingly moved
away from the dissolve as the standard convention for
indicating a scene change or passage of time, preferring
instead the more dynamic cut transition.

The optical nature of the dissolve can carry tonal im-
plications for a film. Extensive use of long dissolves is
frequently a device for adding a lyric, poetic quality to
a film story: *The Summer of '42* (1971).

A dissolve slowly links two separate moments of time
and therefore can be utilized for conceptual purposes. In
The Godfather (1972), for instance, the scene in which
the Hollywood producer awakens to find a severed horse
head under his bedcovers ends with a slow dissolve to
Don Corleone sitting at his desk in his home office. The
dissolve connects the horrified screams of the producer
with Marlon Brando's slight raising of an eyebrow before
the Don starts a conversation with a visitor. The raising
of the eyebrow, although part of a new scene that is un-
related to the one just ending, nevertheless seems also to
be a subjective, knowing signal to the viewer that Cor-
leone's will has been carried out in Hollywood.

In the days of motion-picture **censorship,** the dissolve
was also a popular means of suggesting, through ellipsis,
sexual activity that could not be depicted on the screen.

The dissolve may also be used in scenes of continuous

action to suggest the psychological state of a character's mind or to portray fantasies. Many experimental film-makers, such as Maya Deren, have employed the dissolve to indicate **psychological time** rather than real time. Often these dissolves are so lengthy as to become a **superimposition,** which is the holding of two shots on the screen simultaneously.

Docudrama A term applied primarily to made-for-television programs which present semifictionalized accounts of historical events. *The Missiles of October* (1974), a drama based on President John F. Kennedy's handling of the 1962 Cuban missile crisis, and *Franklin and Eleanor: The White House Years* (1976), a dramatized account of the Roosevelts' personal relationship during Franklin's presidential tenure, are examples of television docudramas. Docudramas utilize material that is focused on already familiar events or people and, in so doing, seek to combine the interests and appeals of the **documentary** with the structure of the drama.

Precedents for the docudrama, of course, can be found throughout the history of the motion picture—in the numerous **biographical films** of the 1930s (e.g., *The Story of Louis Pasteur,* 1936), in the popular semidocumentaries of the late 1940s (e.g., Elia Kazan's *Boomerang,* 1947), and more recently in the Watergate-related *All the President's Men* (1975).

Documentary A nonfiction film. Documentaries are usually shot on location; use actual persons rather than actors; and focus thematically on historical, scientific, social, or environmental subjects. Their principal pur-

pose is to enlighten, inform, educate, persuade, and provide insight into the world in which we live.

The World Union of Documentary has defined the documentary film **genre** in this manner:

> By the documentary film is meant all methods of recording on celluloid any aspect of reality either by factual shooting or by sincere and justifiable construction (reenactment), so as to appeal either to reason or emotion for the purpose of stimulating the desire for, and the widening of, human knowledge and understanding, and of truthfully posing problems and their solutions in the spheres of economics, culture and human relations.

Newsreel essays and **informational films** with unifying themes are often also categorized as a type of documentary film.

A documentary, more often than not, is a recording of physical reality which the filmmaker interprets for us by the edited arrangement of the material: "a creative treatment of actuality" (John Grierson). Among the early significant creative documentary filmmakers were Robert Flaherty (*Nanook of the North,* 1922) and Pare Lorentz (*The River,* 1937). Flaherty's films dealt with man in his environment. Lorentz in *The River* and *The Plow That Broke the Plains* (1936) produced poetic films aimed toward social persuasion about ecological problems of the decade. These films established the traditional documentary. In recent decades many subschools of documentary filmmaking have developed, e.g., *cinema verité,* **direct cinema, docudrama, ethnographic film.**

With the advent of television, the documentary film genre acquired the two principal elements needed to sus-

tain the form: (1) a mass audience and (2) financial support through institutional sponsorship. On television, the genre has been seen in a variety of different orientations: (1) journalistic: information and analysis (*CBS Reports, NBC White Papers*); (2) social: documentaries designed to reveal social problems and to persuade (*Harvest of Shame,* 1960; *I Want It All Now,* 1978); (3) poetic, educational: documentaries to entertain and teach (*America,* 1972); (4) magazine: a variety of short documentaries and newsreel essays included in a single program with a studio host or hosts introducing and commenting on different segments (*60 Minutes*).

Dolby sound (system) A patented noise-reduction sound system which is frequently used with theatrical motion pictures as an embellishment to the screen imagery. The Dolby system makes possible high-fidelity, **stereophonic-sound** accompaniment on the optical **sound track** rather than on a **magnetic sound track** as was once required for clean, noise-free reproduction. Dolby sound found wide application during the 1970s in screen spectacles as diverse as *Star Wars* (1977) and *Apocalypse Now* (1979).

Dolly shot A shot in which the camera, placed on a wheeled mount, moves closer to or away from a scene. The camera dollies in or the camera dollies out.

The dolly shot is an alternative to the **cut** in changing scope and **angle of view**. The camera moves dynamically and fluidly through space in a dolly, rather than jumping through it as happens in **shot-sequence editing.**

Because of the physical movements of the camera, the dolly-in shot moves fluidly and directly into the heart of

a drama. An important **reaction shot**, for example, seems
all the more important and dramatic when combined
with a dolly-in to a **close-up** of the actor's face. Such a
shot occurred in *Rocky* (1976) while the boxer was be-
ing told that he is to be given a chance to fight the heavy-
weight champion. The sustained movement of the camera
seems to allow the reaction to grow in impact. Similarly,
a dolly-out seems to take us away from the heart of the
drama but, depending on its speed, allows some time for
contemplation. Like **pans** and **tilts**, the dolly permits a
director to follow action with sustained, unedited **con-
tinuity**.

Double exposure Two or more **images** which have been
photographed separately but which appear over one
another or side by side on the same piece of film. A
double exposure may be achieved by running unpro-
cessed film through the camera more than once or by
optical printing at a processing laboratory. Georges
Méliès created illusory effects in many of his early **trick
films** through double exposures (photo 26). In contem-
porary filmmaking the technique appears most common-
ly in **experimental-film** efforts, e.g., Marie Menken's
Hurry, Hurry (1957) and Ed Emshwiller's *Relativity*
(1963–1966).

Double feature A motion-picture marketing practice
begun by the American film industry during the depres-
sion years of the 1930s. Two pictures, one usually better
in quality than the other, would be exhibited for the
price of a single admission. The double-feature bill was a
successful audience booster for almost two decades. Its

26. Through double-exposure shots, achieved by exposing the same piece of film to two different scenes, Georges Méliès produced numerous trick films—in this instance *The Man with the Double Head* (1902).

demise was brought about by two major events: (1) the advent of television, which served to satisfy general audience entertainment needs and (2) the antitrust decree of the U.S. Supreme Court. The latter event forced motion-picture producers to give up their ownership of movie theaters. Without the guarantee of assured booking **(block booking),** emphasis had to be placed on the first-rate film; the cheaper picture, which had been made for second place on the double-feature bill, became an uncertain commodity. This fact, coupled with dwindling box office receipts in the early 1950s, killed double features as a standard exhibition procedure. Contemporary

exhibitors occasionally present double-feature programs to attract audiences. Two films by a popular director are often played on a double-feature bill, e.g., two Ingmar Bergman films or two comedies by Woody Allen. Double-feature programming is also common at **drive-in theaters**.

Double-system sound Sound which has been recorded on a tape recorder that is not a part of the camera, and which is later added to the edited film—either as an optical or a magnetic sound track. When the sound track is recorded directly onto the film (either optically or magnetically) as the camera is filming an event, the procedure is referred to as "single-system sound." See **Magnetic film**.

Dramatic structure Refers to the composite body of elements which function as essential plotting conventions in the development and resolution of a dramatic play or motion picture. These elements are as follows:

Exposition. Early information in a developing screen narrative which reveals character and begins to set the plot in motion.

Inciting action. A situation, usually taking place early in the film narrative, which reveals the conflict around which the plot will revolve. Sometimes referred to as the "exciting force."

Rising action. Episodes and events within the film plot, occurring after the inciting action, which increase dramatic interest as the story's conflict builds to a climax. The events within the rising action are also referred to as "complications."

Climax. The moment of greatest interest or tension in a film story—bringing about a turning point in the

dramatic action. The climax usually occurs at a point of great crisis for the principal character or characters, at which time a crucial decision that affects the outcome of the dramatic conflict is made.

Falling action. Events or episodes which occur after a film's climax.

Denouement. The final moments of revelation in a film narrative during which time all loose ends, mysteries, and uncertainties unfold so that the plot is fully disentangled. Nothing within the plot complication remains unexplained.

See **Anticlimax, Antagonist, Protagonist.**

Dream balloon A method of visualizing a character's thoughts by including the desired information in a circle that usually appears above the character's head. The device was commonly used by filmmakers during the medium's silent era, and was achieved either through **rear-screen projection** or **double exposure**. Edwin S. Porter inserted a dream balloon in the opening shot of *The Life of an American Fireman* (1903) to show the wife and child of the fireman as he sleeps at his desk in the fire station. See **Photographed thought.**

Dream mode A term sometimes used to describe motion pictures or parts of motion pictures whose stories and techniques suggest the workings of the mind, resembling either dreams or situations which are derived from the imagination. Films operating in the dream mode are often so labeled because of their lack of **continuity** and the illogical, unconnected manner in which **images** come and go on the screen. *Un Chien Andalou* (1928), a sur-

realist film, is often described as a film which operates
in a dream mode. Some parts of the screen version of
Slaughterhouse Five (1972) function within a dream
mode.

Important critics such as Hugo Munsterberg and
Suzanne Langer have used the concept of dream mode
as a distinguishing characteristic of the film medium.
Langer maintains that films are like dreams, moving
rapidly through space and constantly changing the im-
ages for the viewer as in a dream.

Drive-in theater A form of open-air movie theater
which increased in number and popularity in the decade
following World War II. The development and growth of
this type of theater resulted in part from the postwar
baby boom and the increasing auto culture of new fam-
ily-oriented suburbanites. Drive-in theaters were de-
signed and equipped so that motion-picture viewing
would be possible from inside a parked automobile. The
average drive-in theater would hold 300 to 500 auto-
mobiles and larger ones held as many as 1,500 cars. In a
period when box office revenues were diminishing, drive-
in theaters spurred new interest in film going by making
group attendance possible at a lower cost than indoor
theater ticket prices. The number of drive-in theaters de-
creased after a peak in the late 1950s, but this form of
movie theater has remained popular as an alternative to
the traditional film theater.

Dubbing The process of adding sound, **dialogue,** or
sound effects to a film after the dramatic action has
been photographed. This is possible because sound in

most motion pictures is recorded on a separate system (**double-system sound**) rather than on the film itself and later edited to fit the edited images. When all desired sounds (**music, dialogue,** sound effects) have been edited and mixed into a single synchronized sound track, it is then printed on the edited film.

Some directors prefer to dub dialogue and sound effects rather than use the original on-the-set sound. This approach has become even more prevalent as **location shooting** has increased. By dubbing, it is possible to obtain better sound quality and even to change the original dialogue. "Dubbing" is also the term for converting foreign-language films to another language. The technique frequently used in dubbing a motion picture is that of **looping**. In looping, a section of film is spliced end to end so that it repeats its movement through the projector. A looped piece of **magnetic film** of equal length is interlocked into a projector-recorder system. Actors, through this double-looping process, are able to rehearse and record lines with the film images until the sound dubbing is satisfactory.

Dutch angle An angled shot in which the horizon and objects in a scene are canted (slanted, photo 27). Vertical and horizontal lines within the scene are photographed so that they are in an oblique relationship to the vertical and horizontal lines of the film **frame**. This unnatural, tilted view of a scene is disorienting and can suggest tension, confusion, and psychological imbalance. In *Arabesque* (1966), for example, Gregory Peck's loss of physical and mental orientation with his environment,

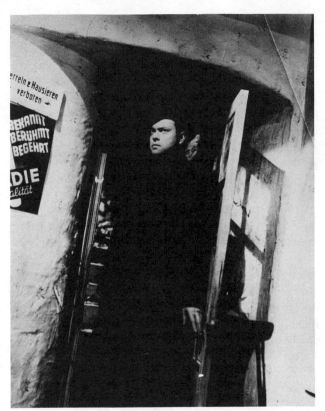

27. One of several Dutch-angle compositions used by Carol Reed in *The Third Man* (1949) to depict the shattered, unbalanced world of postwar Vienna. Orson Welles portrays Harry Lime.

after he has been drugged, is conveyed in part by a series of canted shots of his confused actions.

Dynamic cutting An approach to film editing in which the cutting from one shot to the next is made abruptly apparent to the viewer. In **matched cutting** or **invisible editing,** the cuts are not as obvious to the viewer because these approaches adhere to **continuity** procedures designed to hide the edit, e.g., cutting on action. Dynamic cutting, on the other hand, is self-conscious and will often startle the viewer by moving abruptly in time or space or by rapid cutting within a scene for expressive as well as narrative purposes. Bob Fosse's *All That Jazz* (1979) and Richard Rush's *The Stunt Man* (1980) employed dynamic cutting extensively.

Dynamic frame A term attributed to Sergei Eisenstein after the Russian director wrote an essay in 1931 in which he discussed the possibilities and values of changing **frame** size from the traditional 4 to 3 **aspect ratio** to other shapes (photo 28). In his writings Eisenstein advocated new **image** formats of any shape or size suitable to the treatment of diverse subject matter. In his own work Eisenstein had experimented with **masking** (imitating D. W. Griffith) and unusual **compositions** to vary image shape.

A British film, *The Door in the Wall,* created in the 1950s by Glen Alvey, Jr., experimented with masking techniques that permitted a constantly changing image size. A narrow vertical screen image would widen as a character passed from an interior location to an exterior setting. This process, while intriguing, was too complex

28. Sergei Eisenstein employed vertical masking to produce this dynamic frame in *The Battleship Potemkin* (1925).

technically to be practical. Filmmakers continue to achieve the effect of the dynamic frame through traditional methods: composition, **lighting**, or set shape and design.

Editor That individual responsible for the aesthetics of film construction in the postfilming stages. In dramatic filmmaking the editor determines cutting **style, transitions,** and the development of the narrative. Astute rearrangement of **scenes** to aid dramatic effect and enhance tempo, as well as the deletion of undesirable material, are within the jurisdiction of the film editor. It is not uncommon, however, for the **director** and the producer to work closely with the editor in making editorial decisions or in approving both the **"rough cut"** (first assemblage) and **final cut** of the motion picture.

Emulsion The layer of a film stock which contains light-sensitive particles of metallic silver. These particles **(grains)** at the moment of exposure are "tagged"; in **black-and-white** emulsions the film when processed produces **images** that are rendered in various shades of gray. These shades vary from light to dark according to the quality of reflected light from the color spectrum which "tags" emulsion particles. A **color film** is one in which the emulsion layer has been chemically developed to respond to reflected light in such a way that color images are produced rather than gray ones.

 Film emulsion particles are suspended in a clear gelatin substance on a flexible celluloid base (film base).

29. One of the most successful screen epics ever made: *Gone with the Wind* (1939).

Epic A motion picture characterized by its extensive narrative form and heroic qualities. The epic film generally covers a large expanse of time as it follows in an episodic manner the continuing adventures of a hero or set of heroes. Often the heroes of epic films are boldly courageous figures whose deeds are presented in the course of great historical events, e.g., *The Birth of a Nation* (1915), *Gone with the Wind* (1939, photo 29), *War and Peace* (1956), *Dr. Zhivago* (1965). Other epic films are more picaresque in quality, chronicling an extended portion of a character's life story, e.g., *Tom Jones* (1963), *Barry Lyndon* (1975), *Reds* (1981).

The production of epic films usually involves elaborate settings, authentic period costumes, and a large cast of characters. These elements are considered necessary in achieving the romantic aura expected of epic films.

Episodic (story development) A quality attributed to a motion picture which contains numerous dramatic incidents in the development of the story line rather than a single line of developing action. Epic or picaresque films such as *Gone with the Wind* (1939) and *Barry Lyndon* (1975) are highly episodic whereas *High Noon* (1952), a western whose story follows actual time and moves inexorably toward a gunfight, is not episodic in plot construction.

Establishing shot A **shot** which establishes the location of a film story or scene. The establishing shot usually presents a long, wide-angle view of an area to identify the location either generally or specifically. Shots of the New York skyline or the Eiffel Tower are specific in establishing location. A wide-angle shot of a busy street scene will in a more general way establish the location as that of any big city. Establishing shots may also identify specific activity areas through **long shots**, e.g., of a courthouse, police station, state capitol building, etc. See **Master shot**.

Ethnographic film A film of an anthropological nature which attempts to describe or visualize the social and cultural experiences of one group of people for another. The goal of interpreting one society for another distin-

guishes the ethnographic film from other types of **documentaries** which are more concerned with a country's internal problems. All of Robert Flaherty's major films are ethnographic studies: *Nanook of the North* (1922), a heroic view of Eskimo life in the Hudson Bay area of Canada; *Moana* (1926), a picture of Samoan traditions; *Man of Aran* (1934), an account of the harsh realities of life for a family living on an island off the coast of Ireland; and *Louisiana Story* (1948), a poetic view of bayou life in the southern United States.

Other early pioneering ethnographers included Merian C. Cooper and Ernest Schoedsack, whose *Grass* (1925) charted the nomadic life of herdsmen in the Middle East. Like Flaherty, these documentarists sought to record and describe the unique culture of their subjects as objectively as possible without any preconceived bias—a particular requirement of the ethnographic film. Modern ethnographers, of which there are many, follow this demand, often filming in **long shot** in a spontaneous manner so as to record accurately the raw visual data needed for cultural preservation and interpretation. John Cohen's *Queros: The Shape of Survival* (1978) employs these methods in presenting a stark ethnographic study of Queros Indians who live in primitive isolation in the Andes Mountains of Peru.

Expanded cinema A general term referring to the inquiry into the exploration of highly technological approaches to film art. Ranging from the use of multiple projectors to **computer-generated films** to simple shadow plays, the artist attempts to create a moving, kinetic art experience and mixed-media environments which affect

the senses. Often expanded-cinema artists deal with the essence of motion which has always intrigued the film-maker, and also seek a reexploration of three basic principles of cinematic art: light, time, and space. Removing itself from the popular concept of a "**canned**" film projected onto a screen in a movie house, expanded cinema seeks to make each production a totally self-sufficient and original experience. Expanded-cinema programs have included (1) mixed-media presentations including "live" performers; (2) video technology, and (3) multi-projection systems. The term expanded cinema was first used by the critic Gene Youngblood.

Experimental film A film term with a number of different meanings. The term "**avant-garde**" is generally used to describe the first experimental film movement, which began in France in the 1920s. Many of the avant-garde filmmakers were artists who came to the cinema from other arts, particularly from painting and literature. The movement began as a reaction against the narrative motion picture of the time. It was also an extension of contemporary art into the medium of cinema, where artists such as Hans Richter, Viking Eggeling, Salvador Dali, and Fernand Léger could continue their experiments with abstract, expressionistic, and surrealistic art. Painters such as Richter and Léger were particularly interested in the motion picture as a means of bringing their abstract images to rhythmic life. In *Rhythmus '21* (1921) Richter rhythmically alternated black and white geometric shapes on film. Léger in *Ballet Mécanique* (1924) placed common objects into rhythmical and mechanical

motion. These films are also commonly classified as **abstract films**.

Because they believed that the film story was too closely allied with the theater and literature, the avant-garde filmmakers experimented extensively with cinematic techniques and camera tricks—an approach referred to as *cinéma pur* (pure cinema).

Leading a second experimental film movement was Maya Deren, a Russian-born director whose important work was done in the United States in the 1940s. Her *Meshes of the Afternoon* (1943) was a subjective self-study that mixes dream and reality in an ambiguous manner. Deren's work stimulated numerous filmmakers to create highly personal self-projections on celluloid, including Curtis Harrington (*Fragments of Seeking*, 1946) and Kenneth Anger (*Fireworks*, 1947). The frank quality of these films and the necessity of self-distribution and exhibition led to the use of the term "**underground film**" in the 1950s to denote the work of experimental American filmmakers. However, by the time the term came into use the range of experimental approaches was far greater than the subjective model introduced by Deren. "Underground" came to mean any film which was made for noncommercial, personal purpose; sought to break with the traditions of commercial cinema; treated subject matter which was taboo in commercial films; and exploited the pure-cinema possibilities of the medium.

Other terms emerged in the 1960s to denote experimental film. **New American Cinema** appeared briefly in reference to works by an organized group of film-

makers, most of whom were located in New York City. The term "**expanded cinema**" was coined by critic Gene Youngblood in reference to multimedia experiments, often including live performance. Generally speaking, contemporary experimentalists—whatever their intentions or their methods of cinematic expression—are referred to as "**independent filmmakers**." See **Psychodrama**.

Exploitation film A term used to describe a commercial motion picture whose subject matter has been chosen and developed to appeal to a particular type of audience. Sensationalism is usually a major ingredient. Two types of films falling under the label are the **sexploitation film** and the **blaxploitation film**. The term "exploitation" is to some extent redundant since the vast majority of feature-length motion pictures are designed to draw audiences through particularized appeals.

Exposition (see **Dramatic structure**)

Exposure The act in motion-picture photography of exposing a sensitized film material to light for the recording of **images**.
 Exposure is the product of both time and intensity of illumination acting upon the photographic material. Exposure takes place when light from the subject, **focused** by the lens system, strikes the film **emulsion**, usually very briefly. The photochemical reaction of the light with the silver halide compounds in the film emulsion forms a latent image which is converted into a permanent visible image when the film is processed.
 Exposure of film in the production of a motion pic-

ture is usually very closely controlled in order to yield shots that photographically reproduce reality as closely and consistently as possible. Deviations from what might be termed "normal" exposure usually are scrupulously avoided.

However, the ability to control the degree of exposure presents the cinematographer with valuable creative possibilities. Both underexposure and overexposure have been intentionally used in many films to enhance scenes visually and dramatically.

Underexposure. The act of exposing each frame of film to less light or for a shorter period of time than would be required to produce a "normal" exposure of the same subject. Underexposure yields a picture which tends to be dark overall, the degree of darkness depending on the degree to which the shot is underexposed. There is little or no visible detail in the shadow areas of the picture, and in **color films** colors look muddy and somewhat indistinct.

Underexposed shots have been occasionally used when it is the director's intention to keep the viewer uncertain of the identity of persons or objects in the shot, as is often necessary in mystery and suspense films. Carefully underexposed shots filmed at dusk can often simulate a later time of evening.

Overexposure. The act of exposing each frame of film to more light or for a longer period of time than would be required to produce a "normal" exposure of the same subject. There is little or no visible detail in the highlights—the bright areas of the picture—and colors appear pastel, more or less washed out.

The washout. The most extreme form of overex-

posure is the washout. The visual manifestation of the washout is a screen that goes completely white (or very nearly). This effect is usually accomplished by directing the camera at a bright light source that will fill most, if not all, of the **frame** area.

Expressionism A stylistic movement within film, drama, painting, fiction, and poetry which uses nonrealistic, nonnaturalistic methods in an attempt to reveal inner experience. In the expressionistic film, and in expressionistic drama, actors, objects, and scenic design are treated not as representational but as elements which function to convey mood, emotion, and psychological atmosphere. *The Cabinet of Dr. Caligari* (1919) is a well-known film which employs expressionistic devices (photo 30). In this German motion picture the settings are wildly distorted. The actors move in concentric circles, and lighting is unusually dark and somber. The *mise-en-scène* of *The Cabinet of Dr. Caligari* underscores in a psychological rather than a realistic manner the film's story, which occurs in the mind of an inmate in a mental hospital. Similar in expressionistic and thematic interests is Alain Resnais' *Last Year at Marienbad* (1961), a film presenting the viewpoint of a single character. The use of stylized settings, costumes, and special effects **(fast motion)** also lend an expressionistic quality to Stanley Kubrick's *A Clockwork Orange* (1971). At one point character movements in this film are choreographed to classical music in a nonrealistic manner that may be described as expressionistic.

Expressionistic sound A term for film sound which has

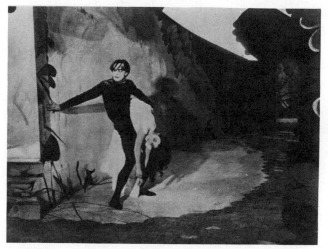

30. Dark, foreboding shadows, distorted set designs, and stylized makeup were common elements in expressionistic films of psychological import. Robert Wiene's *The Cabinet of Dr. Caligari* (1919), shown above, is perhaps the best known example of screen expressionism.

been stylized by distortion, volume, or great **presence** or has been **asynchronously** arranged with disparate images. In Robert Enrico's *An Occurrence at Owl Creek Bridge* (1961) the sounds of footsteps, a musical pocket watch, and dialogue are all intentionally distorted through volume and technical manipulation to suggest the intense, confused awareness of the condemned spy's mind. Ken Russell's *Altered States* (1980) employed expressionistic sound elements in presenting a science-fiction account of the uncertain world of human subconsciousness.

External rhythm Rhythm within a motion picture achieved through editing. A form of external rhythm through editing common in chase and action stories is that called "accelerated **montage**." Usually this effect is achieved by using shorter and shorter shots of a depicted movement. A long-distance runner, for example, can seem to be increasing his speed at an incredible pace by the editor's use of a sequence of shots which continually decrease in length. The contrast of shorter, more staccato shots following earlier shots more prolonged in length creates an illusion of accelerated movement.

D. W. Griffith employed accelerated montage in his famous **last-minute-rescue** films. In addition to rapid **crosscutting** between the beleaguered victim and the approaching rescuer, Griffith would gradually decrease the length of shots to make the action appear even more exciting.

External rhythm can also be applied to achieve a more **lyrical film** quality. In a motion picture, as in a poem, lyricism evolves in part from rhythmic patterns designed to enhance impressions of beauty, romance, ecstasy, mood, and other sensory perceptions. The editing rhythm of film images can serve essentially the same function as phrasing in poetry. Films such as Alain Resnais' *Night and Fog* (1955) and Claude Lelouch's *A Man and a Woman* (1966) employ editing rhythms for a lyrical effect.

Extra An individual appearing in a motion picture who has no speaking role or pointed dramatic significance. The extra is merely an embellishment within the *mise-en-scène.*

Fade A transition device for moving from one scene or sequence to another in a motion picture. A fade-out occurs when the image on the screen fades to black to end the scene. The scene which follows may suddenly appear, or it may gradually fade in from black. The first is a fade-out/cut-in transition, while the second is the traditional fade-out/fade-in. The use of a fade-out/cut-in has a different effect than the slow, more contemplative movement of the fade-out/fade-in. The fade-out/cut-in gives the fade-out a feeling of finality and separation to the scene just ending, while the cut-in introduces the new action in a dynamic, attention-getting way. In *Small Change* (1976), François Truffaut uses the fade-out/cut-in transition to separate the longer sequences of his delightful film about children. The use of this technique separates the parts of the film like movements in a musical composition or stanzas of a poem, without significantly slowing the pace of the whimsical film.

Falling action (see **Dramatic structure**)

Fantasy A type of film story or film experience which occurs within the imagination, dreams, or hallucinations of a character or within the projected vision of the storyteller. Siegfried Kracauer defined film fantasy as story-

telling or visual experience which is "outside the area of physical existence." The term "fantasy" is also often used to describe a work which is set in an unreal world or which includes characters which are incredible or unreal. Many of the early trick films of Georges Méliès, such as *A Trip to the Moon* (1902), are fantasy films, as are *The Blue Bird* (1976) and *Star Wars* (1977). Fantasy has been used both for light entertainment (*Mary Poppins,* 1964) and as a vehicle for social commentary (*It's a Wonderful Life,* 1946; *Heaven Can Wait,* 1978).

Fast motion A motion-picture effect which occurs when fewer than twenty-four frames per second are taken of an action and are projected at normal projector speed. The effect is that of herky-jerky, speeded-up motion. Fast motion is most commonly associated with comedy, because early screen comedies were often undercranked slightly to enhance their slapstick pace.

Feature film A full-length motion picture made and distributed for release in movie theaters as the principal film for any given program. **Shorts** were those films which accompanied the feature film and which were shown to fill out a theater's program. By tradition the feature film and the shorts have comprised a program approximately two hours in length. The evolution of the feature film in the period 1913–1916 brought with it larger, more comfortable movie theaters and refined systems for motion-picture exhibition. By the early 1920s the economic success and popularity of feature-length films had led to the development of movie-house

chains owned and operated by the major Hollywood production studios.

Film craftsman (see **Director**)

Film criticism (see **Criticism**)

Filmic A descriptive term that may be used interchangeably with "**cinematic**." "Filmic" is often applied in film criticism to suggest that subject matter and film methods are deemed particularly appropriate to the medium. A **chase** sequence might be described as filmic or the use of **crosscutting** in the development of plot can be called filmic. Like the term cinematic, filmic is often used as an analogy for describing literary or dramatic methods which resemble the methods of the motion picture.

Film noir A type of American film which evolved in the 1940s whose unusual visual style came to be called "*film noir*" or, literally, "black film." This descriptive label has been applied to motion pictures, often **gangster films** and psychological stories, whose **lighting** schemes were heavily **low key**. The use of **black-and-white film** stock, standard in the 1940s, allowed a wide range of black-to-white shadings, and permitted directors to experiment with the darker end of the scale in photographing stories and characters of a sinister, brooding quality. Interior settings were lit to look dark and gloomy, as though photographed at night. Exteriors were often shot at night to add to the dreary environments. Story locations in *films noir* were commonly the dark streets and dimly lit apartments and hotel rooms of big cities.

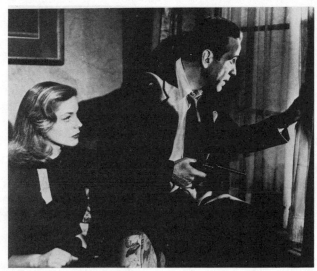

31. An adaptation of Raymond Chandler's novel *The Big Sleep* (1946) resulted in one of the finest examples of the many *film noir*-style detective pictures made during the 1940s. Humphrey Bogart portrayed the cynical detective Philip Marlowe and Lauren Bacall was his girlfriend Vivian. The unforgettable first-person, voice-over narration—a distinguishing characteristic of the genre—was written, in part, by William Faulkner.

The *film noir* style was found in film adaptations of Raymond Chandler novels, in many of the private-eye films of Humphrey Bogart, and in works by Howard Hawks (*The Big Sleep*, 1946, photo 31), John Huston (*The Maltese Falcon*, 1941), Robert Aldrich (*Kiss Me Deadly*, 1955) and Orson Welles (*The Lady from Shanghai*, 1948; *Touch of Evil*, 1958). The inspiration for *films*

noir came in part from Welles' bold, expressive use of low-key lighting in *Citizen Kane* (1941) and *The Magnificent Ambersons* (1942). *Films noir* also had earlier precedent in German **expressionism** and in the psychological films of the German directors E. A. Dupont, G. W. Pabst, and F. W. Murnau, where mood was often matched by shadowy lighting and darkly oppressive settings. Interest in *film noir* styles and themes can be noted in many of the policeman-hero films of the 1960s and 70s: *Madigan* (1968); the *Dirty Harry* series (1971–1976); the Raymond Chandler remake *Farewell, My Lovely* (1975); and Lawrence Kasdan's *Body Heat* (1981).

Filmography A bibliographic listing of a group of films, most commonly the listing of a director's or an actor's full body of work.

Film speed A term used to designate a particular film **emulsion**'s sensitivity to light. Film speeds in the United States are regulated by the American Standards Association and hence are supplied with an ASA rating. The higher the number of the ASA rating (e.g., ASA 400), the faster the speed of the film or, expressed another way, the more receptive the emulsion is to recordings made where little light is available. Because high-speed films tend to show **grain** when printed, film speed becomes an important consideration in a director's choice of emulsions. As a general rule of thumb, directors will choose the slowest possible film stock for a sharply defined, low-contrast image. Higher speeds, however, may

be chosen if the desired look of the processed film is intended to simulate grainy, newsreel-like footage.

Filter Usually a glass or gelatin material through which light is altered as it passes to the film **emulsion**. Neutral density filters are employed most commonly to retard amounts of light and sometimes to darken areas of the frame in **day-for-night photography**. Neutral density filters come in varying shades of gray. Correction or conversion which the **director, editor,** and other members of light so it matches the emulsion characteristics of the film. Polarizing filters rotate so as to alter the angle of light rays as they hit the lens and thereby can function to darken sky areas in color photography and to reduce in black-and-white and color photography undesired natural reflections.

Contrast filters are filters which come in a variety of colors and are most frequently used in black-and-white photography to reproduce colors in lighter or darker shades of gray than they would reproduce without a filter by allowing the film's color to pass through the filter and by holding back the filter's complementary color. Other types are haze filters and diffusion filters.

Final cut (fine cut) A term for the edited version of a motion picture as it will look when printed and released for exhibition. A final cut usually follows a **rough cut** version which the **director, editor,** and other members of the production team may examine with the intention of offering suggestions about the final cut. In many instances final cuts have been made after gauging audience reactions at sneak previews, or in some cases after screen-

ing a rough cut for media specialists, e.g., *Nashville* (1975). Altman's work, in longer form, was shown to selected critics in advance of the final cut.

Fish-eye lens (shot) An extreme wide-angle lens whose glass element resembles a fish eye (photo 32). The **focal length** range of fish-eye lenses varies from 1 to 7 mm in 16-mm filmmaking and of slightly greater range in 35-mm cinematography. Fish-eye lenses commonly serve as special-effect lenses because of their ability to distort objects at close proximity to the camera and to greatly expand the sense of space in longer views. An arm extended toward a fish-eye lens can appear twice its length. Horizons will have a curved quality.

Lina Wertmüller in *The Seduction of Mimi* (1975) employed a fish-eye lens for comic and dramatic effect in a scene where Giancarlo Giannini, to avenge his wife's affair with a city official, tries to make love to the official's overly large, unattractive wife. The woman's grotesqueness is severely emphasized by a distorting fish-eye lens, and its use conveys in a subjective manner Giannini's repulsion while attempting to carry out the sex act.

Flashback A scene or shot in a motion-picture story which deals with an event that has occurred prior to the film's principal time period. Flashbacks are often inserted into a story line for the purpose of recalling a situation which is relevant to the developing plot, or to clarify points of information as in the concluding scenes of a mystery film. In many films flashbacks become a principal plotting device for revealing character by **cross-cutting** among scenes of past and present time. *Citizen*

32. The distorting qualities of a fish-eye lens are evident in this shot from Jim McBride's *David Holzman's Diary* (1967).

Kane (1941), *Rachel, Rachel* (1968), *The Godfather Part Two* (1975), and *Valentino* (1977) are examples of motion pictures which have made extensive use of flashbacks for plot and character development.

Flash-forward An editing technique where scenes or shots which occur in a future time are inserted into the developing story line of a film. Flash-forwards are often employed to anticipate a critical dramatic situation toward which the plot is progressing. the technique can also provide an element of mystery because of ambiguous relationships of the flash-forward to the film's time continuum; often flash-forwards are recognized as such only after the story has proceeded to the scene or shot (the flash-forward) which has appeared earlier in the film. *They Shoot Horses Don't They?* (1969) repeats throughout the film an ambiguous flash-forward shot of a young man as he stands in the presence of a judge. The meaning of this flash-forward does not become clear until the end of the film, after the man has committed a "mercy killing." A similar use of the flash-forward occurs in Nicholas Roeg's *Don't Look Now* (1973).

Flash pan (see **Swish pan**)

Flat lighting Lighting within a motion-picture scene which is so evenly diffused across the scene that no sense of depth or visual relief is provided. Control of light quality and light placement are employed to eliminate flat lighting by increasing light and shadow contrast in the scene and by separating actors, objects, and set pieces through light modeling.

Flickers A colloquial term for motion pictures. The term developed in the medium's formative years as a result of technical imperfections in early motion-picture projection devices. A pulsating, flickering effect accompanied the projected images, thus giving rise to the term "flickers" or "the flicks."

Flood (floodlight) Both a type of lighting instrument and a quality of light. A floodlight is a lamp which disseminates a broad, nondirected area of light onto a scene. The uncontrolled quality of floodlighting can give a washed-out look to a scene, and is sometimes used to create a stark effect. Floodlights, available in various sizes and intensities, are commonly used to provide the generalized light in a lighting scheme which includes other types of aesthetically controlled lamps.

Flow-of-life film A term applied to a motion picture when development of the narrative appears accidental and casual. The concept is often associated with **neorealist** films and other types of **realist cinema** which have deemphasized dramatic crisis and climax. Dramatic plotting evolves from the milieu in which the characters function. Common situations as the characters move through life are used to reveal the story. Often these films are set in the streets or on the road. Both *The Bicycle Thief* (1948) and *Harry and Tonto* (1974) contain elements that fit the flow-of-life concept.

Fluid camera A term used to describe the constant movement of the camera during the filming of a motion-

picture scene or shot. The camera dollies, **tracks**, **arcs**, or
cranes so frequently that its use is said to be fluid. The
use of fluid camera techniques marks the camera as an
active participant in the recording process, usually pro-
viding a more subjective **point of view** than that acquired
by a stationary camera. Fluid, roving camera techniques
were popular with innovative German directors of the
1920s: E. A. Dupont (*Variety,* 1925); F. W. Murnau (*The
Last Laugh,* 1924). These directors in dealing with sto-
ries of basic human emotions—love, jealousy, loss of
pride—employed a fluid camera as a means of giving
dramatic importance to space. The fluid camera allows:
scenes to be played out without **cuts,** thus providing a
unity of spatial relationships; the following of character
movement through space, thus revealing the immediate
environment; the discovery of new information through
camera movements. Most film directors have employed
fluid camera techniques to a certain degree; many direc-
tors make the moving camera a dominant expressive ele-
ment of their shooting style, e.g., Visconti (*Death in
Venice,* 1970), Lelouch (*Another Man Another Chance,*
1977), Kubrick (*The Shining,* 1980).

Focal length A **lens** designation usually expressed in
millimeters and sometimes in inches. The focal length of
a lens is the distance from the optical center of the lens
to the point of the film plane when the lens is focused
on a distant subject or object. Lenses of longer focal
length produce narrower **angles of view.** The focal length
of a lens determines whether it is a **wide-angle lens,**
normal lens, or **telephoto lens.** A lens with a set focal

length is referred to as a "fixed-focal-length lens"; a lens with a variable focal length is commonly called a "**zoom lens.**"

Focus The point at which rays of light converge to form an image of a subject after having been reflected or transmitted by that subject and passed through a **lens.** A point on the subject is considered to be in focus when it is registered as a point on the film by the lens, rather than as a circle or blur of points.

Beyond its technical consideration, focus can be manipulated as a creative tool by the filmmaker interested in conveying subjective or psychological reality. Scenes intentionally shot out of focus, for instance, may show the world from the point of view of a character who is experiencing mental aberration.

Differential focus is the emphasis through sharp focus of one of several elements in the frame while other elements are intentionally out of focus.

A camera operator may **roll focus** during a shot to change the area of differential focus within the frame from the heroine in the foreground, walking down a dark alley, to the escaped killer approaching her in the background, or from the stalks of corn in the background field to the box of cornflakes on the table next to the cornfield. In this way one can generate suspense or surprise or effect a transition by controlled discovery. In Clint Eastwood's *Play Misty for Me* (1971), a murderess is revealed in a scene hiding behind a bush where she is stalking two picnickers. The woman's presence, unnoticed in the early part of the scene, is made known through a slow **zoom** in to the bush which simultane-

ously brings the blurred background and the hidden murderess dramatically into focus.

Follow focus The shifting of focus within a shot so that a character or an object moving toward or away from the camera **lens** remains in critical **focus**. The lens focal ring is adjusted to keep the character or object within the **depth-of-field** area at all times. Sharpness of image is retained and the moving object is supplied with a visual emphasis.

Foreground music Another term for **source music**—music which originates from a source within the film scene: a record player, a radio, or "live" musicians. The term "foreground music" (source music) distinguishes indigenous music from nonindigenous music, the latter being music which appears on the **sound track** but which has no actual relationship with the film's narrative or its scenic elements.

Formal balance The symmetrical arrangement of elements within the film frame so that both sides of the frame and the center are equal in visual attraction (photo 33). A formally balanced composition appears restful and without dramatic conflict.

Formal criticism Film criticism which examines an individual motion picture for its techniques and organization in order to illuminate the work's total effect. Formal critics separate form from content, viewing form (method and structure) as the means by which the film-

33. Ingmar Bergman's *Winter Light* (1963) opens with a formally composed shot of a nearly empty church—a composition which emphasizes the minister's view of his church as a place of worship that is lacking in spirituality.

maker has expressed content. Form is seen as a vital, organic link to a film's ultimate impact. Critics applying this analytic approach often examine a particular film in relationship to the methods of other works, especially those of a similar type or **genre**.

Formal editing An approach to film editing where length of shots remains consistent and unvaried, so much so that the rhythm of the film produces a formal, dignified pace in the action flow. The editing pace of Stanley

Kubrick's *Barry Lyndon* (1975) was consistently or-
dered and formal in an attempt to convey the moods
and rhythms of eighteenth-century life in Europe. See
External rhythm.

Formalism Artistic, literary, or dramatic expression in
which the emphasis is on form (technique) rather than
subject. Formalism emerged as a dominant factor in the
theater and in cinema in the Soviet Union during the
1920s. The practices and theoretical writings of Eisen-
stein, Pudovkin, and Kuleshov in cinema and Vsevolod
Meyerhold in theater were based on formalist concepts.
Their work was a revolt against the traditional responses
that marked pre-Revolutionary treatment of narrative
material. The Russian filmmakers of the 1920s ap-
proached subject matter in a highly calculated, scientific
manner while Meyerhold treated the actor on the stage
as a "biomechanical" puppet. Editing, pictorial compo-
sition, and aural-visual arrangements consumed the in-
terests of the formalist filmmaker.
 As a general concept, formalism has come to mean an
approach to film expression or film analysis which em-
phasizes the importance of form over content, with the
film artist or critic maintaining that it is through cine-
matic technique that a film's meaning is communicated
and understood.

Formula film A phrase used to describe a motion pic-
ture which has used familiar plotting devices and tested
subject matter in the development of a film story. For-
mula films imitate successful works by following precise-
ly the elements which characterized the more original,

earlier films and are usually recognizable as having been patterned after specific films or film types. Many film **genres**, especially the **western** and **gangster film**, lend themselves to formularized variations.

A formula film, despite its lack of originality, has often enjoyed considerable popularity because of its well-known, easily understood plot and theme.

Four-walling A motion-picture exhibition procedure in which the distributor rents a theater for a fixed price rather than releasing a film on a shared-percentage basis. When the practice of four-walling became popular in the United States in the early 1970s, rental of theaters would often be extensive and a nationwide advertising campaign on television and in the newspapers would precede the opening of the film. The concept of four-walling proved highly successful in generating box office sales for both first-run and re-release motion pictures. The Robert Redford picture *Jeremiah Johnson* (1974), for example, had had little success in its first release but, when four-walled a year later, became a commercial success.

Frame Each individual photograph recorded on motion-picture celluloid is referred to as a frame (photo 34). The frame is the basic visual unit of motion pictures, printed on a strip of celluloid material of varying widths: 8 mm, 16 mm, 35 mm, 65 mm, 70 mm. In sound motion pictures twenty-four separate frames are photographed and projected per second to create the effect of natural movement on the screen.

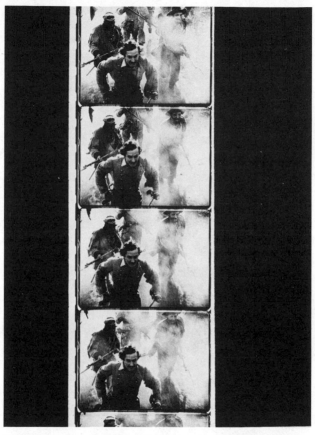

34. Motion pictures are made up of a series of still photographs, called frames, which depict a continuous action through rapid projection of the individual frames. The series of film frames above are taken from the final war scene in D. W. Griffith's *The Birth of a Nation* (1915).

Frames per second (fps) A term used to designate camera shooting speed or motion-picture projection speed. Most sound motion pictures are photographed at speeds of twenty-four frames per second (fps) and projected at the same speed. **Slow motion** is achieved generally by photographing at speeds greater than twenty-four fps and projecting at twenty-four fps. **Fast motion** involves shooting at a slower camera speed and projecting at a faster projector speed: filming action at eight or sixteen fps and projecting at twenty-four fps.

Framing The act of composing through the viewfinder of the camera a desired view of the images to be photographed. Framing includes choice of camera **angle, angle of view** (scope), and **blocking**. The end result of the photographed **scene** or **shot** is also referred to as the filmmaker's framing, and is an important consideration in film analysis which examines photographic style.

Free Cinema (Britain) A term coming from the Free Cinema programs presented by the National Film Theatre beginning in 1956. Altogether six programs were offered between 1956 and 1959, consisting primarily of documentary films with personal, social points of view. Because many of the Free Cinema documentaries dealt with the realities of life for working people in contemporary Britain, the term was carried over as a descriptive label for the feature-film movement (introduced by *Room at the Top* in 1958) which similarly examined the everyday lives and ambitions of Britain's working class. The aims of the Free Cinema movement extended not only into the British film but into theater and fic-

tion as well, appearing notably in the class-conscious works of the country's "angry young men" and in novels by such writers as Alan Sillitoe (*Saturday Night and Sunday Morning,* published in 1958).

Freeze-frame A motion-picture effect which stops (freezes) the motion of the film on a single frame and allows the chosen image to continue as though a still photograph. Because of its abrupt interruption of action, the freeze-frame technique isolates and emphasizes the dramatic moment within the repeated frame. The viewer examines a "frozen" action until the filmmaker "frees" the frame. The device is also often employed to give impact to the concluding shot of a motion picture, e.g., *The 400 Blows* (1959, photo 35), *Butch Cassidy and the Sundance Kid* (1969), and *The Apprenticeship of Duddy Kravitz* (1975). In *Small Change* (1976) François Truffaut used brief freeze-frames as a transitional device for ending scenes.

As a technique for concluding a scene or an entire film the freeze-frame is both dynamic and emphatic because of the visual contrast it provides as "still photography" functioning among "moving" pictures.

French New Wave (see **New Wave**)

F-stop An indicator for the size of the diaphragmatic opening of a camera **lens,** also often referred to as the "f-number." The size of the diaphragmatic opening controls the amount of light allowed to pass through the lens to the film **emulsion.** The larger the f-number (e.g., f/22), the smaller the opening and the lesser the amount

35. An image of ongoing juvenile frustration is captured through a freeze-frame of Antoine Doinel (Jean-Pierre Léaud) as he romps on the beach in the concluding shot of François Truffaut's *The 400 Blows* (1959).

of light that passes through the lens. A small f-number on the other hand (e.g., f/2) results in a large opening and, hence, permits a great deal of light to enter the camera. When the camera operator reduces the size of the diaphragmatic opening by adjusting the f-stop setting to a larger number, this is referred to as "stopping down." Adjusting for a larger opening (smaller number) is called "opening up."

The size of the opening of the lens diaphragm (f-number) and the **exposure** time (shutter speed) together affect **depth of field** (that range of distance in front of the camera in which elements remain in sharp **focus**). Shutter speeds in motion-picture photography are determined by the **camera speed**, e.g., 24 fps, which is standard for sound films. A large f-stop number (e.g., f/22) and a standard shutter speed will provide a greater depth of field than a small f-number (f/2) and a standard shutter speed. When camera operators wish to control the f-number to achieve a **deep-focus** shot, they may increase the amount of light in the scene or use a faster film stock which will allow the lens to be stopped down. Exposure time in motion-picture photography can be manipulated on cameras with a variable shutter, which permits an increase or decrease in the size of the shutter opening. By diminishing the size of the shutter opening, less light hits the emulsion of the film. The reduction of light aids in resolving objects at a greater distance.

F-stop numbers appearing in sequence on a lens (f/2, f/2.8, f/4, f/5.6, f/8, f/11, f/16, f/22) indicate that an adjustment from any one number to the next will either double the exposure light or reduce it by one-half. Ad-

justing the f-stop from f/4 to f/5.6 (stopping down) decreases the exposure by one-half; an adjustment from f/4 to f/2.8 (opening up) doubles the exposure light.

Futurism An artistic movement, closely associated with cubism, which began in Italy in the early 1900s and characterized by an interest in giving expression to the movement and energy of mechanical processes. Futurist painter A. G. Bragaglia produced a film, *Perfido Incanto*, in 1906 which posed actors before futurist settings. Futurist interests can be assessed as closely allied with the interests of the later avant-gardists, who placed objects in motion for formally expressive intentions, e.g., *Ballet Mecanique* (1924). The movement also had an impact on Russian filmmakers of the 1920s.

Gangster film A film classification in which story, plot, and **conventions** are developed around the actions of criminals, particularly bankrobbers and underworld figures who operate outside the law. Like the **western film** genre, the gangster film evolved its own mythology in consideration of both locations and characterization. Prototypically, the gangster film is set in a large city where the criminal functions in a clandestine world of dark nightclubs, seedy living quarters, and speeding automobiles. The prohibition era has been a popular time placement for the American gangster film, largely because of associations of legendary underworld figures with the era.

Typical traits of gangster film characters include (1) the desire for recognition and success, (2) a tough, crude facade, (3) hints of gentleness and sensitivity beneath the toughness, and (4) an intimation that the gangsters are victims of circumstance.

Gangster films such as *Public Enemy* (1931), *Dead End* (1937), and *Angels with Dirty Faces* (1938) present characters who have grown up in neglected neighborhoods and who spend the remainder of their lives seeking to compensate for the neglect. In some instances the gangster is malicious, callous, and greedy by nature, e.g., *Little Caesar* (1930).

During the late 1940s the gangster film faded because

of decreasing audience interest. In 1967 Arthur Penn's *Bonnie and Clyde* reintroduced with great popular success many of the conventions and ideas that had characterized the gangster films of the 1930s and 40s. Francis Ford Coppola's *The Godfather* (1972) and *The Godfather Part Two* (1975) also fell within the confines of the gangster genre, but were **epic** in structure. The success of these sensational pictures in the 1960s and 70s resulted in a number of imitative works of lesser note. Particularly meritorious in quality, however, were Robert Altman's *Thieves Like Us* (1974) and John Cassavetes' *Gloria* (1980).

Generation A reference term for various printings of motion-picture film. The film that is run through the camera is the "original" or "first-generation" film. A "second-generation" print is one made from the original, first-generation print. A "third-generation" print would be one made from the second-generation print. Each successive generation affects image definition and contrast range. Film directors will sometimes print footage through several generations to achieve a nontheatrical look within a shot or scene. Raoul Coutard, cinematographer for Godard's *Les Carabiniers* (*The Riflemen*, 1963), reprinted numerous shots several times in order to match the look of **stock** newsreel **footage** which was also included in the film.

Genre A term for any group of motion pictures which express similar stylistic, thematic, and structural interests. There are numerous narrative film genres: the **western film** (photo 36), the **gangster film**, the **musical film**,

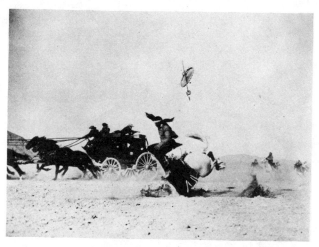

36. John Ford's classic rendering of the western genre film, *Stagecoach* (1939).

the **screwball comedy.** "Genre" is also used to distinguish other film classes such as the **documentary,** the **experimental film,** and the **animated film.**

The study of the various film genres has given rise to genre criticism. By isolating the various filmic elements which characterize a particular motion-picture genre, it is possible to employ those elements in evaluating a film that falls within the genre. Through an examination of the manner in which the recognizable generic elements have been copied or varied, genre criticism seeks to determine how the film's thematic intentions have been achieved. Many western films, for example, have made topical statements by their varied arrangement of generic

37. In D. A. Pennebaker's *Don't Look Back* (1968) large grain appeared as one of the filmmaker's realist methods of suggesting an honest, open portrait of singer Bob Dylan.

elements. *High Noon* (1952), a film about the bravery of a small-town sheriff, also made a timely statement about individual courage during the McCarthy committee investigations. *Lonely Are the Brave* (1962), a western film story placed in a modern time and in modern settings, presented a statement about loss of individual freedom in a technological society, as did *The Electric Horseman* (1979).

Genre criticism (see **Genre**)

Grain The term commonly used to refer to the minute crystals of silver halide contained within the **emulsion** layer of a film stock. These crystals (grains) vary in size, with the larger ones more sensitive to light than the smaller ones. Generally, emulsions with a considerable distribution of large grains result in fast film speeds (film stocks requiring less light for exposure) and tend toward "graininess." Graininess is the rainlike appearance, in the screen **image**, of coarse clumps of large grain. Grainy film images, when intentionally derived, can serve as a convention of **realist cinema** (photo 37).

Group shot **Shooting-script** terminology for a **shot** which contains several characters within the composition of the **frame**.

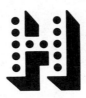

Haiku (see **Imagist film**)

Hand-held camera A term used to describe a type of motion-picture filming where the camera noticeably has not been mounted on a stationary or mechanical securing device. Hand-held cinematography is often intentionally used to add a spontaneous, free-style quality to a motion picture. The technique has been employed extensively in *cinema verité* documentaries and often in narrative films as well. A lengthy fight scene in Franco Zeffirelli's *Romeo and Juliet* (1968) was filmed with a hand-held camera to make the camera appear a participant in the action.

Head-on, tail-away A type of **transition** marked by actor or object movement toward and away from the camera **lens**. A character walks to the camera lens until the screen **image** is blurry and indistinct. A simple **cut** is then made to another indistinct image as the character or another character moves away from the camera to reveal a change in time and place. The head-on movement wipes away the preceding scene, while the tail-away movement reveals a new one. The head-on, tail-away can be an effective means of changing scenes while dynamically linking an individual to two moments in time.

38. One of the screen's best known "heavies," Jack Palance, as he appeared in George Stevens' *Shane* (1953).

Heavy Another term for a motion-picture villain, usually a male character whose amoral qualities are immediately apparent (often through physique) to the viewer. The term "heavy" is most commonly used in reference to a villainous character in a *film-noir*-style **gangster film** or a **western**. Many Hollywood performers became stereotyped as screen heavies, e.g., Ralph Meeker, Peter Lorre, and Jack Palance (photo 38).

High-angle shot A **shot** in which the **scene** has been photographed from above (photo 39). Sometimes the camera is mounted on a boom or a crane device which

39. A high-angle shot from *Crossfire* (1947), an angle which emphasizes the character's fear.

elevates the camera into a high-angle position. If we see the upward or downward movement of the camera into or out of a high-angle shot, it is referred to as a boom shot: a boom up (crane up) or a boom down (crane down). The boom shot usually does not provide as high an angle of view as does the crane device, which will lift the camera into an extreme high-angle position.

The essential value of a high-angle shot comes from the privileged, dominant view of the scene it produces. The famous **crane shot** of wounded soldiers in *Gone with the Wind* (1939) shows the dramatic use of a high-angle shot.

The scene in which Scarlett O'Hara makes her way through the hundreds of wounded Confederate soldiers at the Atlanta train station ends as the camera cranes up to a spectacular, high-angle view of the mass of soldiers. The height and scope of the shot, combined with the gradually smaller figure of Scarlett moving among the sea of war victims, suggests in one powerful image the price of war and the impending defeat of the South.

In *Psycho* (1960) Alfred Hitchcock evokes horror in one instance by the placement of a high-angle shot. As Martin Balsam climbs the stairs of the gothic house where Bates and his "mother" live, Hitchcock employs a standard straight-on shot of Balsam's ascent. At the moment that Balsam reaches the top of the stairs, where a bedroom door stands slightly ajar, Hitchcock cuts to a high-angle shot taken from directly over Balsam's head. The bedroom door opens suddenly, and a figure leaps out to stab Balsam. The moment of the stabbing is full of surprise and shock.

Hitchcock's choice of the bird's-eye, high-angle shot adds to the intensity of the scene because of certain qualities inherent in the overhead angle of view. An overhead, high-angle shot tends to increase the amount and importance of space around a character and presents a privileged view of an environment. In situations where a character is alone or apart from others, the sense of aloneness and insignificance is often heightened by shots taken from above the figure. The "aloneness" of an individual in a large city, for example, is frequently suggested with high-angle shots of the character walking the city streets.

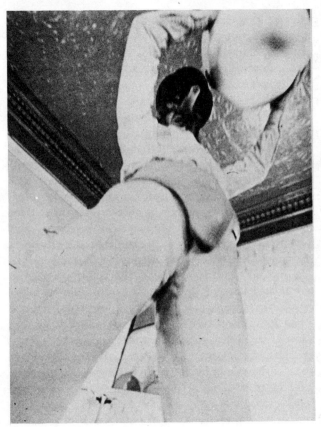

40. A high-hat shot of Alex (Malcolm McDowell) in Stanley Kubrick's *A Clockwork Orange* (1971) is one of many expressionistic shots used to suggest the terrorizing gang warfare that dominates the earlier parts of the film.

High-hat shot A shot taken from an extremely low camera position and looking upward (photo 40). It is so named because of the special camera mount called a "high hat" used for the shot. The high-hat device allows the camera to be placed only inches above the studio floor.

High-key lighting (see **Lighting**)

High-speed film (see **Film speed**)

Horror film A film whose plot is centered on strange, alarming events which threaten the principal character or characters. The terrorizing threat often occurs as a result of extraterrestrial powers (the devil in *The Exorcist*, 1974), at other times as a result of scientific experimentation which gets out of hand (Proteus 4, the deviant, computerized brain in *The Demon Seed*, 1977). Conflict within the horror film pits these monsters—supernatural or man-made—against the naive and the weak. Superhuman effort or supernatural forces (the priest in *The Exorcist*) are necessary to destroy the evil that resides in the monster and which threatens those less strong.

Horse opera Another term for a **western** film that is intended as escapist entertainment. In such a film the standard elements of the western **genre** prevail according to audience expectations. "**Oater**" is another term frequently used to describe this type of western.

Humanistic realism "New American humanistic realism" is a phrase which was used in film criticism to describe a kind of film which evolved in the 1960s.

This phrase was applied to films whose themes are similar to those found in screen stories about alienated characters or in what might be described as "**antihero** pictures." The notable characteristics of humanistic realism are (1) the presentation of characters who are social "black sheep," or alienated from society, (2) a value scale which is concerned principally with the search for self-liberation in a milieu of social and moral decadence, and (3) an emphasis on the environment as a major thematic element.

Humanistic realism as a critical-philosophical term has been applied to *The Graduate* (1967), *Midnight Cowboy* (1969), *Easy Rider* (1969), *Five Easy Pieces* (1970), and the early dramatic films of Andy Warhol and John Cassavetes.

To a large extent, humanistic realism in the cinema had its beginnings with Italian **neorealism,** which emphasized technical simplicity and human truth. This movement initially approached its stories with positive human values as in *Paisan* (1946) and *The Bicycle Thief* (1948). Later in the 1950s and 1960s Italian filmmakers such as Federico Fellini and Michelangelo Antonioni turned to more negative views of human nature. *La Strada* (1954), *La Dolce Vita* (1960), and *Juliet of the Spirits* (1965) presented decadent views of modern behavior. These films, like *The Graduate, Easy Rider, Trash* (1970),

and *The Chelsea Girls* (1966), are principally concerned with a breakdown of humanistic values as their major themes. It is this latter trend in the United States which has been critically labeled as "new American humanistic realism."

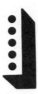

Icon A pictorial representation of an object; a film **image** that is taken to represent an object because of its similarity to the object. A photograph of a tree resembles a tree and is, therefore, an iconographic representation of a tree. The icon is one of the three principal signs or images examined in **semiological criticism**.

Iconography The imagery within a motion picture which conveys the meaning of the work; iconographic representations may be intentionally chosen by the filmmaker for specific expressive value, or the imagery may be of a random, ambiguous nature. The study of film iconography, or **icons**, is an integral part of **semiological criticism**, which examines the motion picture as a system of signs.

Image The concrete or abstract representation of filmed material as it appears on the screen. In a general sense a film image is the total effect of any photographed material, including its artistic and symbolic manifestations. The images in motion-picture criticism are generally regarded to be the visual components of the film as distinguished from the aural (sound) components. Motion-picture images most often are in a constant state of kinetic motion unlike the image within a still photograph or painting, and come to the viewer through light reflec-

tion. These physical characteristics of motion and reflected light give to the film image unusual powers of expression that are both artistically and psychologically affective.

Imagist film A type of film which employs a series of related **images** to effect a mood or to create an abstract concept. In his theoretical writing on the cinema Sergei Eisenstein discussed at some length the filmmaker's ability to use **montage** for imagist effect. Eisenstein's inspiration came from the Japanese *haiku,* a brief poem whose combination of images results in a psychological or emotional impression, e.g.:

> A lonely crow
> On leafless bough
> One autumn eve.
> *(Bashō)*

This concentrated sequence of phrases was likened by Eisenstein to a **shot** list for a film montage, and he saw in the haiku process traits similar to some of his own editing theories.

The imagist filmmaker attempts to use visual and auditory details of related value so that the accumulation of shots and sounds for a **scene** or an entire film gives impressions of larger meaning without offering a direct statement. Imagist films go beyond the purely **abstract** or rhythmic film exercise and strive for a communication experience (often poetic and lyric) that has the symbolic effect of simile or metaphor. The final **sequence** of Pudovkin's *Storm over Asia* (1928), in which a driving

41. Natural imagery in Gustav Machaty's *Extase* (1933) acted to symbolize, through accumulative effect, erotic stimulation.

storm symbolizes the powerful force of the Russian Revolution, is one of imagist inspiration.

Gustav Machaty, a Czech director whose films were laden with symbolic imagery, e.g., *Erotikon* (1929) and *Extase* (1933, photo 41), has often been described as a "pure imagist." The arrangement of naturalistic details and erotic symbols in *Extase* is highly lyrical and one which in accumulative effect becomes a representation of sexual desire. In the film a brief series of natural images (horses mating, bees swarming, and plants waving in the wind) are used by Machaty to suggest a woman's newly discovered erotic feelings.

Makers of **experimental films** have been especially attracted to the connotative possibilities of the imagist

film. *The Mechanics of Love* (1955), a short work by Willard Maas and Ben Moore, arranges Freudian symbols which, together, suggest the act of lovemaking.

Impressionism A style of artistic expression in which the creator seeks to suggest emotions, scenic mood, and sensory impressions through a fleeting but vivid use of detail that is more subjective in intent than objective. Impressionism as a stylistic theory was first applied to the work of nineteenth-century painters such as Degas, Monet, and Renoir. These artists were particularly interested in the visual effects of objects and light in a painting rather than in the realistic representation of a scene.

The movement extended into literary circles and theater scene design and eventually had a significant impact on French silent film-makers, including Louis Delluc, Germaine Dulac, Jean Epstein, Abel Gance (photo 42), Marcel L'Herbier, and Jean Renoir.

L'Herbier's use of impressionistic methods was first particularly notable in *Eldorado* (1921). In this work **image** distortion, **soft-focus** photography, **superimpositions**, and unusual camera **angles** were incorporated as methods for suggesting how moments in the film impressed either L'Herbier or one of the story's characters. As in the work of other filmmakers of the impressionist school, L'Herbier's personal impressions about the story and its characters are not hidden as would be the case with a realist, objective filmmaker.

In impressionism the director's eye is made obvious to the viewer as it explores real settings and locations for subjective effect. It is this latter fact, the creation of

42. Lighting and special-effect lenses supplied Abel Gance's *Napoléon* (1927) with visual qualities associated with French impressionism.

subjectivity from genuine settings, which separates impressionism from **expressionism**. Expressionism employs intentional artificiality and obvious distortion of the real world to project mood and a sense of inner experiences.

While impressionism as a distinct school is most often associated with the French **avant-garde** of the 1920s, impressionistic techniques have appeared liberally in the works of numerous motion-picture directors, especially those interested in the use of light, colors, and camera effects to suggest environmental or character mood. For example, Louis Malle's *Pretty Baby* (1978), a study of a young girl's life in a New Orleans bordello, is a film rich in impressionistic detail.

Improvisation The act of spontaneous, nonscripted action and **dialogue** during the making of a motion picture. Many feature-film directors (Robert Altman, John Cassavetes, Jean-Luc Godard) are well known for their willingness to allow screen actors to improvise during shooting and thus to contribute to the development of the story. Such directors appreciate the naturalistic, spontaneous effect which can be derived from improvisation. Sometimes improvisation during the rehearsal period has been used as a means of acquiring comic or dramatic situations which are then formally scripted. Scripts for the classic Marx Brothers films of the 1930s were in part realized through improvisation during rehearsals.

The inclusion of a spontaneous, nonscripted line of dialogue into a comic or dramatic situation is referred to as an "**ad lib**."

In-camera editing Editing performed within the camera itself. **Shot** and **scene** changes, as determined in the filming process, are left exactly as they have been filmed. The stop-and-start procedure of filming the various camera **takes** also serves as the editing process. In-camera

editing has often been an integral part of **realist** film-
making where a spontaneous quality is desired; it is also
often seen in the work of **experimental** filmmakers who
prefer to leave the shots and scenes exactly as they have
been filmed, without regard for subsequent restructuring
or refining of the recorded material. See **Minimal cinema.**

Inciting action (see **Dramatic structure**)

Independent filmmaker A more recent designation for
the **avant-garde, underground,** or **experimental** film-
maker. The term "independent filmmaker" has come to
mean any filmmaker who works outside the commer-
cial mainstream, creating films of personal styling and
expression. The resultant film may or may not be dis-
tributed for commercial purposes.

Independent production (indie) A term used to describe
an American film that has been produced without spon-
sorship of the Hollywood studios or produced outside an
organized production house that is regularly engaged in
the making of motion pictures and television programs.

Independent productions often utilize Hollywood
technicians and well-known actors who are assembled
for the production through individual negotiation.

Distribution of independently produced films fre-
quently is handled by the major studios because of the
costs involved in promoting a film and the uncertainties
of film exhibition. See **American studio years.**

Index Within **semiological criticism,** a sign which de-
notes meaning for an object through interrelationship

43. In François Truffaut's *The 400 Blows* (1959) a heavy wire fence, with its strong diagonals, presents a concrete image of entrapment. Hence, the fence serves as an index of Antoine Doinel's (Jean-Pierre Léaud's) frustrations as a result of an oppressive and restricting life at home and at school.

(photo 43). The indexical sign offers a representation or measurement of an idea through concrete association. The severe, emotionless settings of *Interiors* (1978) are indexical signs within the film **frame** for the mother's rigid personality and subsequent unhappiness. A thermometer is an indexical sign for temperature. See **Semiological criticism**.

Indigenous sound Sound (or music) originating from an actual source within the film setting. Indigenous sound comes from the location, whereas supplied sound or mu-

sic is added to the **sound track** after filming. See **Foreground music**.

Industrial film (see Informational film)

Informational film A type of nonfiction film made for the purpose of communicating facts or ideas, usually conceived and constructed around specific points of information which the filmmaker seeks to convey with clarity to the viewer. A "how-to" film, one which visualizes methods and processes, e.g., *How to Make a Simple Loom and Weave* (1959), is the most direct type of informational film. The television "white paper," which seeks to present facts on government-related or public issues, is another type, e.g., *Cuba: Bay of Pigs*, NBC, 1964. Often specific points of information may be contained within a documentary which has also been designed to entertain, e.g., George Stoney's *All My Babies* (1953), an informational film made to assist public-health nurses in teaching and supervising midwives. Stoney's film employs a liberal use of folk music and a carefully constructed narrative which communicates the film's points.

An industrial film is yet another kind of informational film, one produced specifically for the purpose of presenting information on a manufacturing business or manufacturing processes. Industrial films may be made for general use or solely for in-house consumption. Robert Flaherty's *Industrial Britain* (1933) was an early example of this type of informational film. A more recent example is *The Factory* (1972)—a study of life in an American woodworking plant.

Ingenue A young female character whose appeal is derived from fresh good looks and a demure personality. During the **American studio years** actresses who could portray ingenues were considered an important staple in a studio's stock company of contract players, along with character actresses and romantic leads. Deanna Durbin (Universal Studios) and Loretta Young (Twentieth Century Fox) were among the many young actresses who achieved fame in ingenue roles during the 1930s.

Insert shot A **shot**, containing visual detail, that is inserted into a **scene** for informational purposes or to provide dramatic emphasis. A **close-up** view of printed material in a book, **intercut** as a character reads, is a type of informational insert. The intercutting of a close-up view of a gun resting on a desk within a room where a violent argument is occurring constitutes a type of dramatic insert. **Detail shot** and **cut-in** are terms which are sometimes used interchangeably with "insert shot."

Instructional film (see **Informational film**)

Intercut (intercutting) A term frequently used interchangeably with **crosscutting** and **parallel development**, editing concepts which are all derived from the motion picture's ability to move back and forth among narrative elements that are occurring either at the same time or at different times. Technically, "parallel development" and "crosscutting" are more correctly used when referring to an editing structure which develops two or more narrative elements that are taking place simultaneously or

within an approximately similar time period, e.g., the robbery, robbers' flight, posse formation and pursuit in Edwin S. Porter's *The Great Train Robbery* (1903). Parallel development, or crosscutting, picks up simultaneously developing parts of the story.

Intercutting may be more generally used to describe editing structures which include two or more separately developing segments that have no immediate time relationship to one another. The development of the four separate stories in D. W. Griffith's *Intolerance* (1916) is more correctly called "intercutting," as is the Vito Corleone (Robert De Niro) story in *The Godfather Part Two* (1975). Coppola intercuts Corleone's earlier development as an underworld figure with the contemporary ascendance of Michael (Al Pacino) to gangster status.

A provocative form of intercutting occurs in the development of the modern and the historic romances in *The French Lieutenant's Woman* (1981).

Intermittent movement (camera, projector) The stop-and-go movement of a motion-picture camera or a projector that enables each **frame** to be either exposed or viewed while stationary and then replaced by the next frame. It is a necessary requirement of motion-picture photography and projection that only one frame at a time be exposed or projected. A continuous movement through a projector of the series of individual pictures that make up a motion-picture film would result in a continuous blur on the screen. A continuous movement of film in the camera during photography would yield an indistinguishable blur on the film itself after **processing**. Individual exposure or projection of each

frame or picture combined with the **persistence-of-vision** phenomenon make possible the illusion of motion.

Internal rhythm Rhythm within a motion picture achieved through the movement of actors or objects within a **frame** as distinct from **external rhythms** which are achieved through editing and length of **shots**.

Invisible cutting (editing) A method of film editing which follows precise **continuity** procedures. **Shots** are edited for the purpose of reconstructing an event, and for placing scenes in their desired chronological order. This editing is said to be "invisible" because it does not call attention to itself as does dynamic or conceptual cutting. The process of invisible cutting is sometimes referred to as "academic editing." Within a **scene**, invisible cutting is most commonly achieved by cutting on motion. A **matched cut** from a close-up to a **medium shot** is made on character movement so that the internal movement, rather than the cut, attracts the eye.

Invisible cutting may also refer to the technical process of A and B printing for the purpose of hiding splice lines which are made in assembling the film. Black, nontransparent leader is spliced to each scraped **frame** line so as to retard light when the separate rolls of film are processed as a composite print. Areas that have been scraped away from the picture frame no longer show, and thus the cutting (splicing) is invisible.

Invisible cutting can play an important role in a director's realization of film **style**. The naturalistic quality, for example, of G. W. Pabst's *The Love of Jeanne Ney*

(1927) is sustained by skillful matched cutting for dramatic emphasis. Editing for a change of angle or to present a longer or closer view of a scene is performed only on a character's movement. Pabst is able to place emphasis exactly where it is desired without disrupting viewer concentration, and, thus, retains the film's naturalistic style.

Iris A laboratory transitional effect, occurring when an existing **image** moves into a circle which rapidly decreases in size until it disappears. Often a new **shot** simultaneously has taken its place. If the image has been wiped to black, and a reversal of the process then brings in a new image, this is referred to as an "iris-in/iris-out." The iris, like the optical **wipe**, is a rapid means of **transition** that sustains the pace of the story.

In the early development of the motion picture the iris served as a transitional device as well as a means of altering the shape of screen images and of isolating dramatic material. D. W. Griffith frequently employed a partial iris shot for the purpose of dramatic framing, e.g., the close-up photograph of Lillian Gish in *The Birth of a Nation* (1915) as the Little Colonel pauses in the cotton fields (photo 44). Griffith's framing through the iris added a subjective quality to the insert of the photograph. In Robert Wiene's *The Cabinet of Dr. Caligari* (1919), an iris shot narrows in on the young storyteller's face to increase audience awareness of his anguished state.

The iris effect frequently appears in contemporary films which have imitated earlier film **styles**, e.g., Herbert Ross' *Pennies from Heaven* (1981).

44. The iris-in effect is employed by D. W. Griffith in *The Birth of a Nation* (1915) to focus attention on Elsie Stoneman (Lillian Gish).

Irony (dramatic) A term of literary parentage referring to a meaning that is understood by the reader or audience but which goes unnoticed by a character or characters in the work. Dialogue and dramatic situations in motion pictures are also said to be ironic when they achieve significance for the plot or for characterization through indirect methods, especially methods where the meaning comes through the contrast of one idea with its opposite meaning. In *Room at the Top* (1958), for example, dramatic irony is achieved at the moment when

Laurence Harvey learns that his rejected lover (Simone Signoret) has committed suicide. Harvey overhears talk of Signoret's death while he is attending a party announcing his engagement to another woman, a younger woman of status whom he has pursued for social and personal gain rather than for love. Seconds after hearing the tragic news of Signoret's death, the party guests burst into a round of "For He's a Jolly Good Fellow." The contrast between the words of the song and the real nature of Harvey's character—perceived by the audience to be ambitious to a point of destroying others—provides an intense moment of dramatic irony.

For Vito Corleone's death scene in *The Godfather* (1972), Francis Ford Coppola employed objects for ironic effect. While playing with his grandson in his vegetable garden, Corleone (Marlon Brando) engages in "gunplay" with the child, using a spray gun containing insect repellent as his weapon. Later in the scene the grandfather stops to rest and eats an orange—a favorite fruit which earlier had nearly caused his death by ambush at a fruit stand. The grandfather fashions a ghoulish set of teeth from the orange peelings to amuse the child. The playful use of these objects, which are perceived more ominously by the viewer as death symbols, provides Coppola with an ironic means of portending Corleone's imminent demise.

The use of irony is a primary means by which the filmmaker creates dramatic meaning in a sophisticated, satisfying manner.

Italian neorealism (see **Neorealism**)

Jump-cut The cutting together of two noncontinuous **shots** within a **scene** so that the action seems to jump ahead or back in time. A jump-cut is the opposite of a **matched cut,** where action appears continuous.

The jump-cut has been used widely by contemporary filmmakers for varying effect. In Jean-Luc Godard's *Breathless* (1959) extensive time **sequences** were compressed into a few moments by selecting the peaks of a conversation or action and by discarding the boring parts. The effect of this jump-cutting was similar to that of comic-strip panels where information is conveyed in a sequence of single-frame images rather than in fully played-out scenes.

The radical, time-shattering jump-cut has been extensively used in films such as *Breathless* with modern, existential themes. The contemporary look and "feel" of the jump-cut serves as an appropriate device for expressing the scrambled lifestyles of modern screen characters. In Truffaut's *Small Change* (1976) the jump-cut technique is effectively used in the eating scene at the hairdresser's home. The young boy's voracious appetite is suggested humorously by using jump-cuts as the ample meal is served.

A jump-cut may also be used to advance the action in a scene without regard for transitional devices. In *A Day Off* (1974), a short, award-winning dramatic film, two

men go to a phone booth and call their bosses to "report in sick." The first man makes his call with the other waiting outside the booth. After a line of dialogue by the first man in which he says that he will not be in for work, there is a jump-cut to the second man in the booth saying the same thing to his boss, with the first man now on the outside. The abrupt jump-cut makes the phone calls a single act of rebellion.

A jump-cut may also occur in an unintentional editing mistake. An attempt to match action between two shots without exact continuity results in an unintentional jump-cut. A commonly recognized jump-cut occurs when, in continuous action scenes, the length of a cigarette, the volume of wine in a glass, or another detail mistakenly varies as a cut to another angle is made. These jump-cuts are the result of poor attention to **continuity** detail in filming or editing shot sequences.

Juxtaposition A term which refers to the expressive arrangement in film of any number of cinematic elements: visual and aural **images** within a **shot**; the editorial arrangement, through **montage**, of individual shots; time elements; and various color, sound, and musical elements as they come in contact with one another. A juxtaposition of past and present occurs in *The Godfather Part Two* (1974) as the stories of both Michael and his father, set some fifty years apart, are told in the same film. Sergei Eisenstein's dialectical editing, achieved through **montage** of collision, involved the juxtaposition of nu-

45. Personal reality and theatricality are in constant juxtaposition in Bob Fosse's *All That Jazz* (1979), a dynamic study of a self-destructive choreographer-filmmaker.

merous contrasting film elements. In Alain Resnais' film about German concentration camps, *Night and Fog* (1955), sharply defined color **sequences** are juxtaposed with grainy black-and-white sequences, and sound **scenes** are juxtaposed with extensive periods of silence. Within Ingmar Bergman's *Cries and Whispers* (1972) the pure, white costumes of the actors are juxtaposed against the deep, passionate red of the set decoration. Bob Fosse's *All That Jazz* (1979) juxtaposes the somber realities of the principal character's illness with the theatrical world of dance (photo 45).

Kinestasis A filmmaking technique in which still photographs rather than moving **images** are used as the source of visual information. The word "kinestasis" is derived from two Greek words: *kine* ("movement"), implying that the images are to be projected by a motion-picture projector, and *stasis* ("static"), indicating that the images within the **frames** themselves do not move. The movement of the images through a projector gives the still photographs a rhythmic flow, hence the origin of the term "kinestasis." The technique of kinestasis was employed in the New York City and boat sequences of *Butch Cassidy and the Sundance Kid* (1969).

Like the **freeze-frame,** kinestatic images can present moments in a contemplative state, rather than in a state of rapid flux. The short, award-winning, science-fiction film *La Jetée* (1964) employs kinestatic techniques entirely except for a brief moment when a character opens her eyes and blinks at the camera. It is a motion picture about the efforts of scientists to project human beings into the past and the future, a subject for which the technique of kinestasis seems especially appropriate.

Kinetograph A motion-picture camera developed at the Edison laboratories in 1889 and patented in 1891. The Kinetograph was the first practical motion-picture camera and used a celluloid-base film roll which had been

46. An inside view of an Edison Kinetoscope.

patented in 1888 by George Eastman. The celluloid strip passed through the Kinetograph laterally, recording **images** in a horizontal position on perforated 35-mm film. The biggest drawback to the camera was its huge size (weighing nearly a ton). Many of the early, simple films

made at the Edison laboratories were photographed in a specially built studio, "The Black Maria," constructed in 1893 and containing a room at one end to house the bulky Kinetograph.

W. K. L. Dickson, a British-born inventor, supervised the development of the Kinetograph as well as its companion viewing device, the Kinetoscope (photo 46). The Kinetoscope, a peep-show machine that accommodated a single viewer, carried by motor a continuous loop of film (25 to 50 feet in length) past a viewing slot. Images were illuminated by electric light. The Kinetoscope was demonstrated publicly at the Chicago World's Fair in 1893. A "Kinetoscope Parlor" opened in New York City on April 14, 1894.

Kinetoscope (see **Kinetograph**)

Last-minute rescue A plotting-editing device common to screen **melodramas** and one in which **crosscutting** is often used extensively to build dramatic tension before a hero's rescue. Crosscutting reveals the imminent fate of the victim and the simultaneous efforts of the rescuer to reach the victim in time. The rescue occurs at the last possible moment. D. W. Griffith incorporated last-minute rescues as a standard feature of his silent films, further enhancing the build-up of tension by the use of accelerated editing within the crosscutting, e.g., *Way Down East* (1920). A form of the last-minute rescue appeared as an essential element in many of the suspense melodramas of the 1970s, e.g., *Two-Minute Warning* (1976), *Rollercoaster* (1977), and *Black Sunday* (1977). In these latter films a hostile individual is attempting mass violence in a highly populated area. Counterforces discover the plot and attempt to prevent the violent act — succeeding at the last minute.

Law-and-order film A type of contemporary, action-oriented motion picture in which crime and disorder are conclusively brought to an end, often by a single individual who must take it upon herself or himself to correct societal wrongs. The law-and-order film shows individual courage succeeding in correcting crimes when law officials at large have refused to act or have been in-

effective at getting the job done. During the 1970s the law-and-order film proliferated on American screens, e.g., the Dirty Harry series (1971–1976), *Walking Tall,* I and II (1973, 1978), *Macon County Line* (1974), *Trackdown* (1976).

Lens A device through which **images** are directed and focused on the film in photographing a **scene**. Lenses provide filmmakers with numerous optical and aesthetic possibilities for recording dramatic action. The choice of a lens for any given **shot** determines both **angle of view** and image quality.

Lenses are usually identified and described according to their angle of view. There are (1) **wide-angle lenses,** (2) **normal lenses,** and (3) **telephoto** (narrow-angle) **lenses**.

The wide-angle lens is one which provides a broad angle of view. It is most commonly used for long establishing shots or in situations where considerable depth of field is desired. An optical characteristic of the wide-angle lens causes moving objects to appear to speed up as they approach the lens of the camera, and, therefore, the use of the wide-angle lens for this purpose in film chases and action scenes has been common.

Another optical quality of the wide-angle lens is its ability to make limited spaces appear larger. A wide-angle lens causes the distance between background and foreground to appear greater than it actually is, and thus increases the sense of space. Wide-angle lenses, because of their tendency to distort objects in unusual ways, are also popular with experimental filmmakers interested in special effects.

The extreme wide-angle lens will distort perspective in distant shots. Horizons will appear curved, and at close range an extended arm will appear elongated. The extreme wide-angle lens is frequently employed for comic effect by distorting a character's face. For a subjective **point-of-view** shot of a dentist's distorted face looking down on a terrorized patient, the extreme wide-angle lens will be used. The lens makes the dentist's face appear quite narrow, and the nose and eyes seem to protrude sharply from the face. Because its glass element resembles the shape of a fish's eye, the extreme wide-angle lens is sometimes popularly described as a **fish-eye lens.**

The telephoto or narrow-angle lens has the opposite optical effect of a wide-angle lens. In telephoto photography, background and foreground appear compressed and the scene has a flat look. This effect is increased with extremely narrow-angle telephoto lenses.

A telephoto lens, in addition to flattening space, makes moving objects appear to move more slowly. The compression of background and foreground in a telephoto shot gives a character less visible space to move through, and therefore the action seems slower.

The principal uses of the telephoto lens have been for (1) intimate closeup views of dramatic material, (2) compositional emphasis through control of **depth of field,** and (3) the aesthetic manipulation of spatial perspectives.

A normal lens is one which provides a normal angle of view and perspective, and shows normal speed of motion as objects or figures move to or from the camera. A normal lens has a depth-of-field range somewhere be-

tween that of the wide-angle and telephoto classifica-
tions. It is the standard lens used for most camera setups
which do not call for special angles of view.

Library footage (shot) Another term for **stock footage**
—filmed material of locations and action that has been
retained for use in future productions.

Lighting The control of light in a motion picture for
purposes of **exposure** and artistic expression. Motion-
picture light may come from either **available-light** sources
or from artificially produced sources.
 Available light. Light coming from an already existing
source of illumination, as opposed to that provided by
the filmmaker through portable or studio lighting instru-
ments, is referred to as available light.
 Until interior studios and artificial lighting instruments
were developed, dramatic films were photographed out-
doors with interiors shot in boxlike settings built with
an open front and no roof. The available light provided
sufficient illumination for satisfactory exposures, but
little creative use was made of the light. For this reason
the dramatic and documentary films made in the first
decade or so of motion-picture history had a flat, bland
look. In **flat lighting** the light is evenly washed across the
scene without artistic relief, and the light has not been
controlled to achieve a sense of depth by aiding in the
separating of areas or actors.
 To provide depth and visual dimension through light-
ing in a scene, film artists control the quality, amount,
and placement (angle) of light. Light as a quality may be
described as soft light or hard light. Soft light is an even-

ly diffused, nonfocused light that washes softly over a scene. Hard light is a focused, highly directed light which will produce intense shadows as it strikes objects or characters in a scene.

Set light. The combination of controlled hard and soft light in a lighting scheme allows the filmmaker to achieve satisfactory illumination for exposure while adding artistic shadings to the setting. Architectural detail in the setting is achieved by throwing a hard light at a $90°$ angle across the set. The hard light produces shadows at points where there is varied texture and structural shape on the set wall. Lighting technicians frequently begin with this setting light as the first step in arranging light to create the desired atmosphere for a scene. The moody, gothic quality of the Xanadu scenes in *Citizen Kane* (1941) is in large part attributable to Gregg Toland's artful use of setting light.

Actor light. The characters in a scene may also be lighted for dimensional interest and for artistic shading. The general procedure in actor lighting with artificial instruments is to provide the character with a key light, a back light, and, depending upon desired mood, additional fill light for purposes of general illumination. The key light, generally a hard light, is the light which indicates the principal source and angle of illumination. It is the most intense light in the scene. If a character reads by a table lamp, and that is the major source of illumination, the lamp becomes what is referred to as the "ostensible" source of illumination or "apparent" source of light. Although the light in the scene might be further controlled or added to by technicians, the aesthetic guide for light quality and light angle becomes the table lamp. The *key*

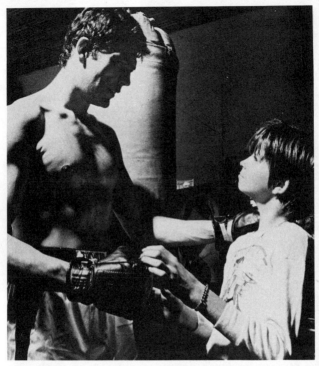

47. The nature of high-key and low-key lighting is shown in two shots from Haskell Wexler's *Medium Cool* (1969). The shot above, with its heavy shadows, is an example of low-key lighting; the shot to the right—brightly lit and relatively free of shadows—shows high-key lighting.

light will be focused on the actor to match the throw of light from the lamp. A *back light*, which may have no apparent source of illumination, will then be added. This light falls on the head and shoulders of the character. It

comes from the back, also usually at a 45° angle, and serves to add dimension to the scene by separating the actor from the background. A *fill light,* usually a softer light than key, back, or setting light, may then be used to add some general illumination to the scene and to reduce the harsh shadows provided by the hard light sources.

High-key, low-key lighting. Terms for describing the quality of illumination in motion-picture lighting schemes (photos in 47). When a scene has a bright general illumination, the lighting is referred to as "high-key lighting." This is a lighting scheme designed so that illumination of the scene has a bright, general quality. Low-key lighting has the opposite quality. There is less general illumination in the scene, heavier shadows, and a more atmospheric quality to the scene.

By tradition, high-key lighting has been employed for comedies, musicals, and standard dramatic situations where dialogue and action are the critical concerns of the scene or film. Low-key lighting has been used to add atmosphere to dramas and suspense stories where visual underscoring of mood is a critical consideration. Whether high key or low key, in both cases the lighting sets the dramatic mood of the scene. See **Chiaroscuro lighting**, **Rembrandt lighting**, **Selective key light**.

Limbo lighting A type of motion-picture lighting where light falls only upon the actors within a set area (photo 48). Space surrounding the actors remains in total darkness. Limbo lighting removes all visual references to a physical setting and, hence, is a means of emphasizing

48. Katharine Ross is shown in a limbo lighting scheme in Mike
Nichols' *The Graduate* (1967).

characters exclusively. The public figures who serve as
"witnesses" in Warren Beatty's *Reds* (1981) are stylisti-
cally separated from the fictionalized elements of the
story through interviews with these people who were
filmed "in limbo." A limbo lighting scheme or partial
limbo effect is also frequently employed in film produc-
tions with limited budgets, e.g., John Ford's *The Inform-
er* (1935).

Lip sync The precise synchronization of dialogue to an
actor's lip movements. Lip movements and their corres-
ponding sounds can appear out of sync because of faulty
editing. Since sounds and **images** are usually recorded
separately (double-system recording), it is the responsi-

bility of the sound-film editor to line up dialogue and lip movements during postproduction so that the two are synchronized. Improper threading of a sound film in a motion-picture projector can also cause the sound to be out of sync, especially when the threading loop becomes too large.

Live-action film A film with real people or animals as opposed to a hand-drawn or puppet-animated film. The term was particularly useful for the Disney Studios after the 1950s when studio output alternated between animated and live-action features and advertising distinctions had to be made between the two types of films. A live-action feature came to mean, in the Disney context, a type of narrative film or comedy designed for general audiences and emphasizing fantasy and escapism as its primary appeals, e.g., *Mary Poppins* (1964).

Location shooting (picture) The shooting of a film or film **scenes** in a real setting as opposed to the controlled environment of a Hollywood shooting stage or studio back lot. The term came into use after the establishment of the studio system and the arrival of talking pictures had forced film production almost entirely indoors. Better technical control of sound recording and lighting was possible within the studio setting, thus greatly diminishing the outdoor shooting which had dominated early film production.

Occasionally, important directors of the 1930s and 40s would venture off the studio lot for location scenes, e.g.,

49. Sidney Lumet is a director who is known for his location films, particularly films set in the streets of New York. The still above shows action outside a Brooklyn bank in *Dog Day Afternoon* (1975).

John Ford (*Stagecoach*, 1939), Jean Renoir (*Swamp Water*, 1941).

Following World War II, location shooting became increasingly common, spurred by the experiences of filmmakers who had served in the armed forces during the war and by the inspirational work of Italy's **neorealists** who broke from the studio altogether.

With improved technology and a growth in **independent production** during the 1950s the number of films made entirely on location continued to grow. Sidney Lumet's police-related films *Serpico* (1973), *Dog Day*

Afternoon (1975, photo 49), and *Prince of the City* (1981) were shot in actual interior and exterior settings in and around New York City.

Long shot A **shot** which provides a wide-angle view of a filmed area. The long shot's wide angle of view enables the viewer to delineate relative proportions with regard to various elements in a scene: their sizes, shapes, and placement. A long shot of a **scene** with several characters is considered necessary at some point in order to achieve viewer orientation. This type of long shot is referred to as the "obligatory **cover shot**."

The long shot also conveys basic relationships of characters to their environment and as a result can be used to reveal narrative and thematic information. In *The Joyless Street* (1925), for example, G. W. Pabst employs wide-angle long shots to convey the impoverishment of an old professor living in bleak isolation within his nearly barren quarters. These shots provide one of the film's many telling images of social injustice in post-World War I Vienna.

If a long shot takes in an unusually wide angle of view, it is termed an "extreme long shot." In John Ford's *Stagecoach* (1939) extreme long shots help to emphasize the vulnerability of the small stagecoach as it makes its way across the open plains of Monument Valley.

If a long shot is used to establish locale through recognizable visual data such as the New York skyline or the Eiffel Tower, it is referred to as an "**establishing shot**."

Long take A term describing a filming procedure in

which the photographing of a **scene** or **shot** is unbroken
by additional camera **set-ups**. The camera films the scene
or shot in its duration without a repetition of the action
as is the case with **triple-take filming**. A long take is dis-
tinguished from a **master shot** because the action of a
master shot is repeated for additional angles of view. The
long take serves as the desired recording of the action
and is edited into the film narrative as a single **take**. A
long take has aesthetic implications for film art because
its use in varying degrees affects **pace, tone,** and direc-
torial emphasis. See **Direct cinema, Ethnographic film**.

Looping The continuous running of footage while ac-
tors rehearse and match voice-to-lip movement for pur-
poses of **dubbing**. In looping, the tail end of the scene or
shot is joined to the head so that this loop can be run
continuously through the projector until sync sound is
precisely matched to the **image**. This practice is common
in both feature-length films where original sound is not
used and in the preparation of **sound tracks** for filmed
commercials.

 Looping is also sometimes used for the repeated show-
ing of short **informational films** and in the creation of re-
peated images for **experimental films**, especially **struc-
tural cinema**.

Love interest That situation within a motion-picture
script which has been included to provide romance.
Early motion-picture producers quickly discovered the
popularity of romance and amply supplied their films
with romantic elements; after a while audiences came to

expect romance in the film story. As a result writers often seek to fulfill this expectation even when the story might be otherwise unromantic. The love interest in *On the Waterfront* (1954), a film about union corruption and courage on the docks of New Jersey, is provided by an evolving relationship between Eva Marie Saint and Marlon Brando. In *Absence of Malice* (1981), a film about newspaper ethics, the love interest occurs when Sally Field, a reporter, and Paul Newman, the subject of a criminal investigation, become attracted to each other.

Low-angle shot A **shot** which looks up at a character or characters from a camera position set below eye level. Frequently, the ceiling of the set—if an interior scene—shows in low-angle shots.

 Low, up-looking shots make a subject appear more dominant, more imposing than straight-on or **high-angle shots**. The lower angles of view allow the screen figure to tower over the viewer. A sense of arrogance and superiority can be achieved by low-angle shots of a subject. Much of Gregg Toland's innovative photography in *Citizen Kane* (1941) is taken from low-angle camera positions (photo 50). The approach was one ideally suited to a film, in large part about bourgeois pomposity.

 In action scenes, low-angle shots taken from a 45° side angle of view are often used to add to the intensity of the action. This is especially so as moving objects or figures approach the camera position. A low-angle, "acute" view of an auto race makes the race appear more exciting than would a straight-on front view or a non-angled side view. Moving objects seem to gain speed and appear more dynamically charged in sharp, low-angle shots.

50. One of the many up-looking, low-angle shots which appeared in *Citizen Kane* (1941).

The wider the **angle of view** of the **lens,** the greater the apparent increase in speed of the moving figure as it nears the camera.

An extreme example of low-angle action photography

is that achieved by placing the camera in a beneath-the-surface position. For *The Birth of a Nation* (1915), D. W. Griffith filmed from holes in the ground as the Klansmen's horses charged forward toward their **last-minute rescue** of the Cameron family. See **High-hat shot**.

Low-key lighting (see **Lighting**)

Lyrical film (see **External rhythm**)

MacGuffin (McGuffin) A term whose origin is attributed to Alfred Hitchcock and one used to describe a plotting device for setting a story into motion. The term is frequently applied to that object or person in a mystery film which at the beginning of the plot provides an element of dramatic curiosity. The MacGuffin can be something that all the characters are trying to get their hands on, e.g., a falcon in *The Maltese Falcon* (1941) or a gem in *The Pink Panther* (1963). The MacGuffin can also be someone or something that is lost and is being sought. In Hitchcock's *Family Plot* (1976) the MacGuffin is a missing heir. The ensuing search for the heir leads to a larger, more involved mystery story. Once the dramatic plot is under way in a Hitchcock film, the MacGuffin often ceases to be of major importance.

The search for the meaning of "Rosebud" in *Citizen Kane* (1941) has been described by some critics as a plotting device like that of the MacGuffin. "Rosebud" becomes the element of dramatic curiosity which motivates the mosaic investigation that helps explain the meaning of Kane's life.

Magic lantern An amusement device which predated the motion-picture projector. In the seventeenth century, Athanasius Kircher, a German priest-scientist, employed mirrors and candlelight to cast **images** onto a wall

from a boxlike apparatus labeled a "magic lantern."
Later, Kircher added a **lens** so that the projected images,
usually drawn on slides, could be focused. The magic
lantern served as a popular source of visual entertainment
well into the twentieth century, with many refined mod-
els allowing the presentation of highly sophisticated slide
programs. Photographs were added to magic-lantern
shows during the 1850s.

Magnetic film A film coated with an iron oxide stripe
(near the film's edge) on which the **sound track** is re-
corded and reproduced. With magnetic striped film,
sound can be recorded directly onto the film since the
iron oxide is essentially the same as magnetic recording
tape. The simultaneous recording of sound and image is
referred to as single-system sound recording. See **Double-
system sound**.

Magnetic sound track A **sound track** which has been
recorded on an iron oxide stripe that appears on the
edge of the film opposite the sprocket holes' side. Be-
cause the iron oxide stripe is quite similar in quality to
a magnetic tape recording, reproduction of the sound
track is generally superior to the photographically re-
produced **optical sound track**.

March of Time, The (see **Newsreel**)

Masking The blocking out of the **frame** edges through
devices which give emphasis to the remaining **image**.
Masking has also been a popular method for varying
image size and shape within the traditional frame param-

eters. **Irises** and black masks were frequently used by
D. W. Griffith in *The Birth of a Nation* (1915) and *Intolerance* (1916) to vary image shape and to achieve dramatic emphasis. Masks are also employed to give the impression of a character looking through binoculars or a keyhole. See **Dynamic frame**.

Master shot (scene) The technique of filming a single, **long take** of a piece of dramatic action and then repeating the action for closer views. The long take or master shot provides the basic unit of action into which **medium shots** and **close-ups** are inserted. The process of filming a master shot of an action and then repeating elements of the shot for medium and close-up views is often referred to as **triple-take filming** or the master-scene technique. This process, common during the studio years and in filming for television, provides numerous options for the editor in placing dramatic emphasis. Triple-take filming also permits unobtrusive **matched cutting**.

Matched cut An editing cut made on two identical points of action after **master shot** and **triple-take filming** so that continuous action is achieved in the **scene**. Match cutting is sometimes referred to as **invisible cutting** because cutting on identical points of action draws attention away from the cut.

Matte shot A **shot** in which part of the **scene** was **masked** so that additional action or background/foreground material could be supplied later, usually by optical printing (see photos in 51). See **Traveling matte**.

51. Three images from Victor Fleming's *The White Sister* (1933)
illustrate the process of a matte shot. The top still (left) shows
the inside of a large church. The bottom still reveals the chapel
shot after it has been masked. The shot above shows the final
effect of the matte process after a boys' choir has been "matted"
by optical printer into the masked area. The illusion is that of a
choir loft set far in the back of and above the church sanctuary.

Medium shot A **shot** which in scope and **angle of view**
falls somewhere between a **close-up shot** and a **long shot**.
Generally, a medium shot emphasizes an object or subject
in some detail; in a medium shot of a person, the area of
view most typically shows the subject from the waist up.
Medium shots isolate the subject from the environment
to a greater extent than do long shots. In **shot-sequence
editing** the medium shot serves the utilitarian function
of a logical step between long shot and close-up. A me-
dium shot is also often referred to as a midshot.

Melodrama Any type of film, play, or television program characterized by a sensational plot that has been designed principally to provide thrills and to appeal to the emotions of the audience. The term "melodrama" translates literally as a "play with music," a throwback to the origins of the **genre** in English theater during the nineteenth century. As the form developed it became customary to include incidental music with the dramatic action to enhance the emotions and thrills, thus "melodrama."

Film melodramas similarly seek to engage the emotions of the audience and provide thrills; often they are characterized by the liberal use of music to underscore the developing plot. The form has been popular in the motion picture since the evolution of the fictional film, particularly in **mystery thrillers** and in **westerns**. In melodramas characters are often one-dimensional, appearing in action plots in which good eventually triumphs over evil.

Metaphor A term describing the use of imagery by which an analogy can be drawn between one object and an abstract idea so that the two are imaginatively linked. The initial idea is reinforced by its association with a concrete object.

Metaphorical expressions are possible in motion pictures through **montage** of attraction. As W. C. Fields in *The Dentist* (1932) applies his drill to a patient's mouth, an insert cut is made to a construction worker's pneumatic gun tearing at the side of a steel beam. A satirical metaphor is effected.

Metaphors in motion pictures may be of a more ex-

tended type than that used in *The Dentist*. In *The Battleship Potemkin* (1925), for example, the battleship serves as a metaphor for the entire Russian state under the Czarist regime. The oppression, rebellion, and ultimate efficiency of the sailors aboard the Potemkin together represent a metaphorical account of the conditions leading to the overthrow of the Czarist regime and also suggest the subsequent public attitude needed to sustain the new government.

Both the title and settings of Woody Allen's psychological film *Interiors* (1978) are associative metaphors for the characters' internal conflicts.

Method actor A popular term used to describe actors who have studied the Stanislavsky method of naturalistic **acting**. Popularized in the United States in the 1930s by director Richard Boleslavski and Stella Adler, and eventually a principal approach at the Actors Studio under Lee Strasberg and Elia Kazan, Method acting sought to combine a psychological attitude with learned technical skills. The ultimate goal was greater realism in character interpretation. Method acting began to make an impact in Hollywood with the arrival of Actors Studio graduates (Marlon Brando, Julie Harris, James Dean, Karl Malden, Kim Stanley) in the early 1950s. This new acting style coincided appropriately with a partial move in American filmmaking toward more psychological, introspective stories: *A Streetcar Named Desire* (1951), *East of Eden* (1955), and *The Goddess* (1958).

Metteur-en-scène A term sometimes used for "**director**," from the French meaning "placer-in-the-scene."

The term is often applied to a director of modest talents as if to suggest that the director has essentially moved actors into their places within the **scene**. The **blocking** and **composition** are effected without noteworthy aesthetic appeal.

Mickey Mousing (music) The exact synchronization of a visual **image** in a motion picture with an associative musical sound. This technique was common in the cartoon films of Walt Disney, with musical sounds accompanying every movement of the animated characters. Hence, the technique has sometimes come to be described as "Mickey Mousing" or "Mickey Mousing the music," especially when overworked in coordinating **music** with image. Use of the technique, particularly in comedies and suspense stories, has proved an effective device for wedding sound to visual image.

Millimeter (mm) A measurement designation used in describing (1) the **focal length** of photographic **lenses** and (2) the width of celluloid filmstrips. The focal length of lenses ranges from approximately 1 to several hundred millimeters. 25 mm is the equivalent of 1 inch. Film widths used in motion-picture photography also vary: 8 mm, 16 mm, 35 mm, 65 mm, 70 mm.

Miniature A motion-picture setting or set piece which has been rendered in a scaled-down model rather than in actual size. The miniature is a cost-saving approach to set design which, with artful photography and lighting, can provide the illusion of a real environment. Through **matte**-screen processing, it is also possible to combine

effectively "live" foreground action with background shots taken of miniature settings.

Minimal cinema An approach to motion-picture expression where extreme realism dominates. Imagery and structure are simple and direct, in a manner reminiscent of the *actualité* films of the Lumière brothers made in the 1890s. Artistic intervention through varied camera **setups** as well as editing are kept to a minimum, thus reducing the film expression to a scientific-technical recording of an event. **Long-take** photography is often the principal method of minimal cinema, as in Andy Warhol's *Sleep* (1963–1964), *Eat* (1963), and *Empire* (1964).

Mise-en-scène A term which generally refers to the elements within a **scene**, i.e., the physical setting which surrounds a dramatic action. In a theatrical situation, the term refers to the total stage picture — the scenery, the properties, and the arrangement of the actors. In France, the term is used for the film's "direction." In film criticism *mise-en-scène* has sometimes been used to describe an approach to cinematic art which places greater emphasis on pictorial values within a shot than on the juxtaposition of two **shots (montage)**. According to the American critic Andrew Sarris, this theory of *mise-en-scène* developed as an effort to counteract the popular editing (montage) theories of Sergei Eisenstein and V. I. Pudovkin. André Bazin, a French theorist and proponent of *mise-en-scène* tenets, noted that the dynamic editing devices used by the Russian filmmakers did not present events on the screen fully, but only alluded to them. Bazin argued instead for dramatic actions which were

more unified in time and space through sustained shots and **camera movement**. Events to him were more effectively presented when the filmmaker showed the actual waiting period in a dramatic situation; furthermore, dramatic space existing between characters or objects in the scene can be maintained so as not to lose the importance of preexisting relationships. An examination of film works shows that throughout the history of the cinema filmmakers have fluctuated between montage and pictorial *mise-en-scène* in telling their stories.

Montage A French word meaning "mounting," frequently used to describe the assemblage of a film through editing. Numerous subcategories of montage have developed to denote particular methods of editing. Among them are the following terms:

Accelerated montage. The use of editing to add to the effect of increased speed of action in a motion picture. By decreasing the length of individual **shots** in an action or chase sequence, it is possible to impose an external pace on the rhythm of the film. The quickening of pace through editing is termed "accelerated montage." The climax to a screen chase is often accompanied by accelerated montage, where the excitement of the event seems to quicken with shorter shots and staccato editing. In D. W. Griffith's *The Lonedale Operator* (1911) accelerated montage is achieved through rapid crosscutting among three locations until a young engineer on a speeding train arrives to rescue his girlfriend from invading robbers. The scene in Godard's *Breathless* (1959) in which Jean-Paul Belmondo kills a policeman seems un-

52. American montage is frequently seen in the rapid cutting together of newspaper headlines to reveal progressive information, here illustrated in *Citizen Kane* (1941).

usually fast because of accelerated montage. Three quick shots are cut together in a brief, four-second span of time.

> *American or Hollywood montage.* A term sometimes used to describe a **scene** in which a series of short, quick shots are edited so as to suggest in a brief period the essence of events occurring over a longer span of time.

The cinematic cliché of newspaper headlines, presented in a rapid succession of shots, to capsulize in time the major developments in an event and to serve as a transition between dramatic sequences, is an example of American montage. *Citizen Kane* (1941) employs this type of device on several occasions (see photos in 52).

> *Conceptual montage.* The cutting together of shots for the purpose of creating meanings which exist only by the arrangement of the various shots. The theories and application of conceptual montage were major concerns of the Russian filmmakers of the 1920s, particularly Sergei Eisenstein and V. I. Pudovkin. These filmmakers believed that montage (editing) was the very essence of film art and sought to exploit its most expressive possibilities. Eisenstein and Pudovkin were less interested in matched editing and more interested in the overall effect of an assortment of shots. They arranged their material for emotional-intellectual impact as well as for narrative flow.

In the Odessa steps sequence of *The Battleship Potemkin* (1925) Eisenstein intentionally distorts time and space by expanding the actual time of the scene and employs dynamic long shots of the fleeing victims beside close-up shots of the pounding boots of the Cossacks. The contrast provided by this editing of close shots of

53. In *The Battleship Potemkin* (1925) Sergei Eisenstein cuts from a shot of the ship's guns firing into the city of Odessa to shots of marble lions in various stages of repose. This montage of attraction symbolizes the uprising against the Czarist government that would occur as a result of the Odessa steps massacre and other such atrocities.

marching feet and helpless victims becomes a powerful visual **metaphor** for authoritarian persecution in Russia. To end the scene a shot of a soldier lifting his rifle saber to slash a baby in a perambulator is followed by a dynamic cut to a startled woman who has just been hit in the eye by a Cossack's bullet. The woman's shocked expression of horror becomes a realistic one for her own fate and a symbolic, conceptual one for the baby's fate, as it is edited in immediately after the stabbing which is not visualized. A larger concept of the horror and tragedy of the event is achieved by the joining of the two shots.

> *Montage of attraction.* An editing method whereby two separate **images** on the screen become related to one another because of visual and contextual similarities (photos in 53).

Montage of attraction is often used for expressive or conceptual purposes. In *Ten Days That Shook the World* (1928) Eisenstein employed this method of montage of attraction so extensively as to make the film a virtual burlesque. For example, a shot of an arrogant Czarist politician is followed by a shot of a peacock spreading its proud tail feathers. This type of satirical, expressive editing is common throughout Eisenstein's film.

The advantages of montage of attraction for suggesting feelings have also been exploited by filmmakers. In the early 1920s a Russian film experimenter, Lev Kuleshov, edited a single shot of an actor's expressionless face between shots of an empty soup bowl, a dead woman in a coffin, and a child playing with a toy. In each return to the shot of the actor's face film viewers who were shown the short film said that the actor's emotions had changed. They saw hunger after the shot of the empty bowl, sad-

ness after the shot of the coffin, and happiness after the insert of the playful child. The belief that the actor had changed expressions was a direct result of montage-of-attraction editing.

Narrative montage. The editing together of shots and scenes which have been arranged in a desired chronological order according to a prescribed **shooting script** or **master-shot** procedure. The **editor**'s goal has been to reconstruct the semblance of events and to structure the narrative flow of the film story. Narrative montage is more concerned with the development of a story, whereas conceptual montage seeks to produce ideas and effects through the joining or collision of shots.

Rhythmic montage. Editing for rhythmic variation to effect the thematic intentions of a **film** or a film scene. The length of shots, movement within a frame, and types of **transitions** employed between scenes most significantly affect editing rhythm. The actual length of shots determines **external rhythm** while movement within a frame determines **internal rhythm**. Eisenstein employed the term rhythmic montage to describe editing methods used in his films. The Odessa steps sequence, for example, combines external and internal rhythms to create a montage of powerful effect.

A short film called *Values and Interpretations,* produced by the American Society of Cinematographers, illustrates the role of the film editor in determining dramatic effect through cutting rhythms. *Values and Interpretations* shows a shot **sequence** being filmed for the television series *Gunsmoke*. The scene opens with a man assaulting a young woman and concludes with a fistfight between the man and the town marshal. The

woman and various other townspeople watch the action. The **director** of the scene, Ted Post, employs a standard approach in filming the material. He begins each action with long shots and then repeats the action for closer views and reaction shots of the onlookers.

The *Gunsmoke* sequence of shots is then given to three different film editors and we are allowed to see how each edits the scene. The most striking and revealing contrast occurs between the work of the first two editors. The first editor breaks the material into short, staccato shots, frequently cutting in the middle of sentences of dialogue rather than at the end of sentences. As a result the **pace** of the action is dynamic and metronomic. Obviously this editor interpreted the scene as intense and active and sought to use quick cutting to complement that interpretation.

The second editor on the other hand is less dynamic. He makes extensive use of **close-up** reaction shots and "holds on" these shots for a more extended period of time than did the first editor. Because of this less dynamic approach, the second version appears more contemplative. The onlookers seem to be absorbing the impact of the violent action rather than passively viewing it.

The length of the shots is the key difference between the tempos of the two sequences. By using shorter shots the first editor imposes a dynamic, external rhythm on the scene.

Russian montage. A reference to the various editing approaches of prominent Russian directors during the 1920s, namely, Sergei Eisenstein, Lev Kuleshov, V. I.

Pudovkin, and Dziga-Vertov. Spurred by extensive post-revolutionary experimentation in all the arts, Russian film directors sought new methods of expression as the motion picture acted to achieve its assigned task of educating and rallying the country's citizens. Montage — expressive editing — was viewed as the very essence of cinematic art, particularly the linkage and collision of shots to produce emotional, physical, and ideological meaning. In his effort to produce socially useful statements, Dziga-Vertov's early editing experiments in the *Kino-Pravda* newsreels (1922–1925) often juxtaposed scenes of the past (taken from vintage footage) with newly recorded shots of more favorable current conditions. Kuleshov's **creative geography** and **montage-of-attraction** experiments reveals how separate shots when linked together through editing could suggest geographic and emotional realities which in fact did not exist. Pudovkin developed a theory of "constructive editing" in which the precise selection and arrangement of narrative details were seen as the primary means by which the filmmaker seized attention and guided the viewer's "thoughts and associations." Eisenstein advocated **"montage of collision"** — the class and contrast of shots for a dialectical effect. Montage of collision, Eisenstein said, could be achieved through rhythmic clash, temporal-spatial conflict, and within image composition, including the clash of mass or volume. The application of these latter methods appears most noticeably in Eisenstein's *The Battleship Potemkin* (1925).

By employing editing as their primary means of film expression, Russian directors of the 1920s gave new

54. Unusual multi-image shots of Steve McQueen and Faye Dunaway appeared in Norman Jewison's *The Thomas Crown Affair* (1968).

meaning to the concept of montage, while establishing themselves through their dynamic methods as important motion-picture formalists. See **Formalism**.

Montage of attraction (see **Montage**)

Montage of collision (see **Montage**)

Multiple-image shot A **shot** in a motion picture which includes two or more separately recorded **images** within a single **frame**. Most multiple-image shots are achieved through laboratory processes such as the **superimposition**

and **split-screen** techniques. By use of multiple-image shots it is possible to present simultaneous action or several different segments of visual information, e.g., *The Thomas Crown Affair* (1968, photo 54). The multiple-image technique has been a popular device with experimental filmmakers (*N.Y., N.Y.,* 1957), and with the producers of filmed commercials.

Multiscreen projection The presentation of a single motion-picture **image** or several different images onto more than one screen. In the concluding **sequences** of *Napoléon* (1927), Abel Gance used three separate projectors with synchronized motors and three separate screens to achieve an extremely wide panoramic view of the action (photo 55). Gance called his triple-screen effect Polyvision. Experimental multiscreen presentations are often seen at amusement centers and in **expanded-cine-**

55. Two multiscreen projections from Abel Gance's *Napléon* (1927).

ma exercises for the purposes, respectively, of novelty and innovative visual experiences.

Music (film music) Music appearing as a part of the **sound track** of a motion picture. Film music may be either realistic or functional, sometimes both. Realistic film music, generally, is music which appears on a film as a part of the story, and its source is visible, or made known, to the viewer. A filmed concert, ballet, or opera are examples of realistically recorded music. The music here is fully or partly derived from the dramatic action. Functional film music, on the other hand, is most often a background **score** designed to enhance mood, to intensify emotions and actions, and to aid film structure by supplying aural unification. In achieving these goals the music serves several expressive functions. Scenic music sets the scene for the action that will follow. The musical sound of the French Can-Can in a clichéd manner sets the scene for a Paris location; the clichéd sound of American Indian music, suggested by the rhythmic beat of a tomtom, signals the old West while sounding an ominous note; the music coming from the flute of an Indian snake-tamer suggests India and the exotic nature of the far East. Stephen Foster folk music often accompanies film stories set in the old South.

Time periods may also be a functional goal of film music. Film stories set in Renaissance Europe are often scored with music dominated by blaring trumpets, cornets, and other brass instruments. Later periods, set in the more genteel seventeenth and eighteenth centuries, will utilize harpsichords and harps to suggest the time. Contemporary films with modern themes, such as *Medi-*

um Cool (1969) and *Mickey One* (1965), both set in Chicago in the 1960s, contain modern jazz scores to suggest both their contemporaneity and their urban settings.

In addition to its scenic functions, film music may also punctuate and reinforce screen action. A chase scene is often accompanied by a rhythmic, dynamic piece of music, which is coordinated to match the **pace** of the dramatic action, and is thus reinforcing. Music to reinforce action may be generally synchronized to the **scene**, or it may be synchronized precisely. This exact synchronization of visual image with an associative musical sound was a common technique in many of Walt Disney's cartoon films. Mickey Mouse and other Disney characters often had musical sounds accompanying their every movement. This technique, when prominent in coordinating music with **image**, is sometimes referred to as **Mickey Mousing** or "Mickey Mousing the music."

Another function of film music has been to heighten dramatic tension and to convey mood. Music for mood and dramatic tension is common in suspense scenes, romantic scenes, and landscape scenes. These scenes are often intensified by unobtrusive **background music**, which will, without calling attention to its presence, become the principal element that establishes and maintains the mood of the scene.

Another function of music is to provide a musical motif for a motion picture. The various parts of *Gone with the Wind* (1939) are unified by the lyrical music of "Tara's Theme." "Lara's Theme" in *Dr. Zhivago* (1965) provides a unifying musical motif throughout the picture. Musical motifs, sometimes used for character

association, are often employed to bridge segments of the story while sustaining mood and film flow. In epic films such as *Gone with the Wind* and *Dr. Zhivago,* motif music plays an important part in conveying the epic quality of the story.

Film music can provide a method for structural unity in scenes that are visually fragmentary. An **American montage sequence,** which presents rapid shots of dramatic actions for the purpose of condensing a period of time into a brief, capsulized view, will usually be accompanied by a unifying piece of music. The sustained quality of the music gives structural unity to the brief, fragmentary images.

Because music is present on the filmstrip and can be coordinated precisely with any single film **frame,** it is also possible to use music to change dynamically the scene or the mood and to "key" essential dramatic information. Soft, romantic music may accompany a fireside living-room scene where a man and a woman are enjoying an evening together. A psychopathic killer makes his way down a corridor leading to the living room. The **editor** crosscuts between the couple and the killer's feet, and each time inserts dramatic suspense music for the feet shots and returns to the romantic music for the fireside shots. The intercutting has both visual and aural impact. The crosscutting of music serves as a common means of rapidly indicating for the viewer different qualities of mood in abrupt scene changes.

The direct coordination of film music with image allows music to serve as an expressive **sound effect.** Frequently musical notes are substituted for the human voice for a stylized, comic effect.

A single, sustained musical note or combination of notes used to punctuate a dramatic moment in a film is called a "stinger" because of the aural conclusion it provides. A stinger calls dramatic attention, in a heightened manner, to a moment of resolution.

Film music often conveys psychological and subjective states not communicable by pictures alone. Musical instruments in film may evoke impressions of happiness, gaiety, sadness, or depression. The film music may convey mood; it may also suggest interior states through its associative relationship with characters and with the emotional climate of a story. A confused state of mind can be conjured up by using a cacophonous, chaotic piece of electronic music. In Carol Reed's *The Third Man* (1949), the quality of life and spiritual mood of the entire city of Vienna during the period following World War II were indicated by a musical score played on a zither.

Musical film (1) A fictional motion picture which deals in a significant manner with the subject of music and which uses musical performance as an integral part of the narrative, e.g., *Yankee Doodle Dandy* (1942), *The Great Caruso* (1951), *The Buddy Holly Story* (1978). (2) A motion picture which incorporates the conventions of song and dance routines into the film story and in which the musical numbers serve as an accepted element of the film narrative, e.g., *An American in Paris* (1951), *Hello Dolly* (1969), *Grease II* (1982).

The conventions of the musical **genre**, in general, include liberal use of musical numbers, choreographed dance, expressive costuming and scenery, and abstract

color and lighting – particularly in the song-and-dance routines.

A subcategory within the musical-film genre is the backstage musical, a type of film where the plot centers on characters who are stage performers. The dramatic plot in backstage musicals invariably develops around the intricacies and tensions of producing a successful stage musical. Integration of elaborate musical numbers into this type of film is justified by the nature of the story, e.g., *42nd Street* (1933). The backstage musical was especially popular during the 1930s.

Mystery thriller A film **genre** whose story centers on a tale of suspense that is generated by some type of strange or terrorizing adventure. Often the principal character is caught in a menacing situation from which escape seems impossible, e.g., *Wait Until Dark* (1968), *When a Stranger Calls* (1980). Frequently the mystery thriller revolves around the **protagonist's** efforts to unravel a crime or suspected crime – leading the character toward an unknown menace which will ultimately become life-threatening, e.g., *Coma* (1978). As suggested by each of the above films, the protagonist of the mystery thriller is often a woman.

Myth A type of story, usually of unknown origin and containing supernatural elements, which has been handed down through a country's literary heritage. The myth's supernatural emphases spring from the need to examine and explain, dramatically and philosophically, deeply complex areas of human concern or thought: life, death, religion, the gods, creation, etc. Popular Greek and

Roman myths have frequently been employed by modern playwrights and filmmakers in explaining personal views of life. Jean Cocteau, for example, appropriated the Orpheus myth as the dramatic framework for his motion pictures, which investigate the complex existence and nature of the "poet" (artist), e.g., *Orphée* (1924), *Blood of a Poet* (1930), *Orpheus* (1950), and *The Testament of Orpheus* (1959). Mythic figures have also evolved within certain **genre** films, e.g., the American **western**. The "loner" gunfighter (Alan Ladd in *Shane*, 1953) and the prostitute with a heart of gold (Claire Trevor in *Stagecoach*, 1939) are among the familiar figures who have become a part of the western mythology.

Narration A term for the spoken words of a person who relates information in a film directly rather than through **dialogue**. A narrator may be a character in the film, or an anonymous, unseen "voice" who narrates the action of the story or the **documentary**. A narrator may talk directly into the camera as does Liv Ullmann in *Hour of the Wolf* (1968) or more commonly speak in "**voice-over**" narration.

Naturalism A stylistic approach in literature, drama, or film with an emphasis on stark reality. All suggestion of artifice is avoided, and environment in its fullest representative form becomes a central force in shaping social conditions and the destiny of characters. Hence, the naturalist also avoids value judgments in depicting character behavior, which is viewed as socially and biologically predetermined. The naturalistic school was greatly influenced in the 1870s by the French novelist-playwright Emile Zola with his *tranche de vie* ("slice of life") approach to stage expression. A pessimistic, tragic view of everyday life dominated Zola's work and that of his follower, André Antoine, at the Théâtre Libre. In cinema, naturalistic intentions have appeared in the films of Louis Delluc (*Fièvre*, 1921), Erich von Stroheim (*Greed*, 1924, photo 56), G. W. Pabst (*The Joyless Street*, 1925),

56. Erich von Stroheim's *Greed* (1924) was a film in which naturalism underscored the theme of uncontrolled personal ambition. Numerous naturalistic details, taken from actual locations, served as symbols in *Greed's* dissection of human degradation. A coarse wedding celebration, shown above, depicted the animal-like appetites of the film's characters.

Jean Renoir (*Toni*, 1934), and in the body of post-World War II Italian neorealist films.

Natural wipe **A transition** technique accomplished by an element within the *mise-en-scène* rather than by a laboratory process. A character or an object is brought to the **lens** of the camera and wipes away the **scene** by completely blocking or blurring the **frame**. This natural wipe will be followed by a new scene. **A head-on, tail-**

away transition is a type of natural wipe that is used to end one scene and to reveal another.

Negative image A photographic **image** in which light and dark areas are reproduced in reverse tones (photo 57). In a negative image dark areas appear light and light areas are dark. Because of their unusual (ghostlike) appearance, negative images are sometimes employed in **fantasies, mysteries,** and psychological films. Negative **sequences** appear in F. W. Murnau's *Nosferatu* (1922), in Jean Cocteau's *Blood of a Poet* (1930) and in Jean-Luc Godard's *Alphaville* (1965).

The nonreality of negative images has been responsible for their popularity with experimental filmmakers: in the abstract, negative images of Len Lye's *Musical Poster Number One* (1939); in Maya Deren's dreamlike dance images in *The Very Eye of Night* (1959); and in Michael Snow's sustained **zoom shot** in *Wavelength* (1967).

Neorealism (Italian) A film movement which began in Italy near the end of World War II. Roberto Rossellini, Vittorio de Sica, and Luchino Visconti were among those Italian **directors** of the time who produced films described as neorealistic. Their approach to technique and theme rejected the well-made studio film and the happy-ending story. Neorealism was characterized by social consciousness, simple stories of the common worker, and location shooting. The neorealist directors often used nonactors as performers and took their cameras into the streets and into real settings for visual authenticity and thematic credibility. Among the outstanding films produced during the height of neorealism

57. In Disney's *Darby O'Gill and the Little People* (1959) a headless coachman, beckoning Darby O'Gill into a world of leprechauns and love, is suggested by a negative image.

between 1945 and 1952 were *Open City* (1945), *Paisan* (1947), *La Terra Trema* (1948), and *The Bicycle Thief* (1948).

Italian neorealism as a film **style** developed as a result of the social unrest in Italy that accompanied the end of World War II as well as out of economic necessity. Vittorio de Sica, describing neorealism's birth, wrote that the lack of an organized film industry in Italy at the end of the war and "the problem of finance . . . encouraged filmmakers to create a kind of movie that would no longer be dependent on fiction and on invented themes . . . but would draw on the reality of everyday life."

Because of the efforts of the neorealist filmmakers to place their characters in natural settings and to build their stories around "everyday life," the structure of their films has led to their being described as "found stories" or **flow-of-life** films (photo 58). Narrative incidents and flow of action appear so casual and spontaneous as to give the impression the filmmaker has simply followed a character and discovered the story rather than having invented it. The found-story, flow-of-life structural style of Italian neorealism can be seen in more contemporary films, e.g., *Blow-up* (1967), *Harry and Tonto* (1975).

The thematic interest of Italian neorealism in the personal struggles of common people is evident in films such as *Sounder* (1973) and *Blue Collar* (1978).

New American Cinema A term often used to refer to the **underground** or **experimental film** movement in the United States during the 1960s. It is derived from the New American Cinema Group, an organization founded in 1960 by various filmmakers and producers, including Lionel Rogosin, Peter Bogdanovich, Jonas Mekas, Shirley Clarke, and Robert Frank. Their interests included experimental and **avant-garde** as well as commercial film. The group's published statements opposed constraints on subject matter, in both underground and commercial filmmaking.

Newsreel A popular type of motion-picture **short** which appeared as a part of film programs until television brought about its demise in the 1950s. Newsreels were

58. Location shooting underscored the social treatment of common people in Italian neorealistic films such as Roberto Rossellini's *Paisan* (1947), an episodic study of individual experiences in war-torn Italy.

usually ten to fifteen minutes in length and contained a compilation of timely news stories and at their conclusion a human-interest feature or two.

The newsreel impulse existed from the beginning of motion-picture exhibition. Early Lumière and Edison programs (1896) were filled with short *actualités* of events and people, lifted from everyday life. By 1900 *actualité*-gathering film units and exchanges had been set up in most large cities around the world to record and distribute short films of important events and famous people.

Fox Movietone News introduced the talking newsreel in 1927, showing movie audiences such dramatic events as Lindbergh's departure for his solo flight across the Atlantic and his tumultuous welcome home.

Eventually the newsreel concept was expanded into interpretive presentations of the news, with the best-known example being *The March of Time* series (1935–1951). Each supplement of *The March of Time* series was approximately twenty minutes in length and usually dealt with a single news topic in an editorial manner. This series was produced in the United States by Louis de Rochemont. The National Film Board of Canada produced a similarly styled series, *The World in Action* (1941–1945).

The newsreel served a particularly useful function during World War II when visualization of allied efforts was considered critical to national morale. This role and the other functions served by the newsreel for more than half a century would increasingly fall to television after 1948. Eventually the newer medium killed the movie-house newsreel altogether.

New Wave A general term for a body of films which came out of France in the late 1950s and which were characterized by their break with traditional cinema. The French New Wave, or "nouvelle vague," film grew out of a keen critical interest in the art of the film by important **directors** such as Jean-Luc Godard, François Truffaut, Claude Chabrol, Alain Resnais, and many other French filmmakers who are less well known. Although it is impossible to define precisely the methods

and themes of the French New Wave directors, their films were often highly personal efforts which on the one hand exhibited an awareness of film history and on the other broke with the conventional cinema in both theme and technique. Using traditional **genres** and often drawing on the **styles** of Hollywood directors, the New Wave filmmakers experimented with innovative approaches to editing and structure. Some of their films intentionally employed **jump-cuts**, moved ambiguously through time and space, and often alienated viewers by use of elements which were contradictory, self-conscious, or private. Others copied established film forms, finding inspiration in the work of Hollywood's **B-picture** directors. The New Wave director frequently worked with only the sketch of a script, preferring improvisation and spontaneous filming to a preconstructed shooting plan.

The themes of the New Wave pictures were often existential in philosophy. Plots dealt with characters who are caught in a world of chaos and disorder. In Resnais' *Hiroshima Mon Amour* (1959) and Godard's *Breathless* (1959, photo 59) characters are set against great events: the atomic bomb at Hiroshima and World War II, respectively, which they attempt to comprehend. The emphasis in each picture rests ultimately with the individual rather than the event. The emotional recollection of lost love dominates in *Hiroshima Mon Amour* despite the memory of the atomic bomb's devastation at Hiroshima where the picture is set. In a scene in *Breathless* Jean Seberg and Jean-Paul Belmondo pass by a parade on the Champs Elysées that involves two great World War II generals, de Gaulle and Eisenhower; but the emphasis

59. The spontaneous treatment of contemporary characters, a quality of many New Wave pictures, is suggested in this shot from Jean-Luc Godard's *Breathless* (1959).

remains with the actions and feelings of the two lovers rather than with the historic figures. There is a clear indifference on the part of Godard toward the larger event of World War II.

Since its initial use in conjunction with the French cinema of the late 1950s and early 1960s, the term "New Wave" has been frequently applied to cinema revivals in other countries where activity in film production is extensive and intense, e.g., in Yugoslavia, Hungary, and Poland during the 1960s, and in Germany during the 1970s.

Nickelodeon A popular name for an American movie

theater in the early period of motion-picture exhibition (photo 60). The name came into use after the turn of the century when the conversion of shops and stores into makeshift film theaters was widespread. "Nickelodeon" was derived from combining the cost of admission (a nickel) with the Greek word for theater (*odeon*). Two businessmen in Pittsburgh, Pennsylvania—Harry Davis and John P. Harris—opened a converted store theater in 1905 which they called the "Nickelodeon." The financial and popular success of this specially decorated movie house, which showed regularly scheduled film presentations from morning to night, resulted in the proliferation of nickelodeons throughout the United States.

Noncamera film, out-of-camera film A motion picture

60. The exterior view of an early nickelodeon.

61. The noncamera film is shown in this short segment from Len Lye's *Colour Box* (1935). Lye's abstract images were produced by painting the designs directly onto the film without using a camera.

created without passing the film through the camera (photo 61). Most noncamera films consist of abstract **images**, sometimes achieved by placing material on the raw stock and exposing it to light (e.g., Man Ray's *Retour à la raison,* 1923). Other methods include the scratching of the film **emulsion** to create abstract patterns, or the drawing of images directly onto clear celluloid. In Norman McLaren's *Pen-Point Percussion* (1951) both the images and the **sound track** are produced by hand drawings (the visuals consist of the sound-track patterns, drawn a second time within the film **frames**). The use of color **filters** combined with in-printer solarization (random exposure of the film to light) has also

been employed to create nonphotographic, abstract images.

Normal lens A lens of certain **focal length** which produces a natural perspective of the area being photographed. The area of space does not appear to increase as sometimes happens with **wide-angle lenses** of short focal length, nor does it appear to be magnified as is the case with long focal-length lenses. The 50-mm lens is the standard normal lens used in 35-mm filming and a 25-mm lens is standard for 16-mm filmmaking.

Novel into film (see **Adaptation**)

Oater Another term for a **western** film, especially one which follows the conventions of the **genre** closely and whose purpose is solely that of providing escapist entertainment.

Objective point of view (see **Point of view**)

Obscured frame Compositional treatment within a film **frame** so that part of the picture is obscured by an object, an actor, or by **soft-focus** photography. Obscured-frame composition (photo 62) is a device employed to direct visual emphasis to specific areas of the frame, to add visual variety and a sense of depth to the **composition,** and to block from view parts of the screen **image.** See **Blocking.**

Offscreen space–onscreen space References for those **images** which appear within the film **frame** (onscreen) and those which are not visible but which are apparent as existing beyond the edges of the frame (offscreen). See photos in 63.

Opening up (see **F-stop**)

Optical printer A machine, consisting of a camera and projector, which is used in making additional prints from

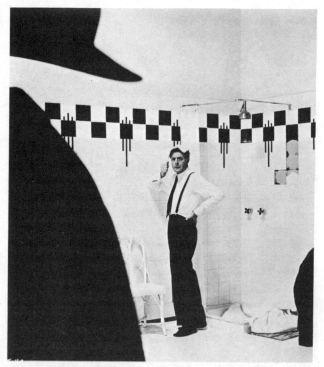

62. An obscured frame in Federico Fellini's *8½* (1963).

a master **image** or composite prints of two or more images. The projector part of the optical printer projects light through the master image or images to expose raw stock which is contained in the camera portion. The optical printer is also used to produce such effects as **matte shots, dissolves,** and **fades** and for reducing and enlarging image size.

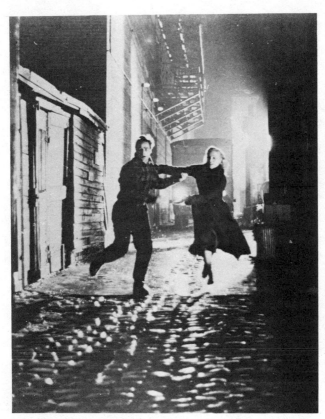

63. The manner in which a director employs onscreen space and offscreen space carries varied dramatic possibilities. In *On the Waterfront* (1954) Elia Kazan creates an unforgettable scene by having Marlon Brando and Eva Marie Saint chased through an alleyway by a truck. The building walls on either side of the frame close off the area so that no sense of offscreen space exists. The image suggests that no means of escape is possible and thus

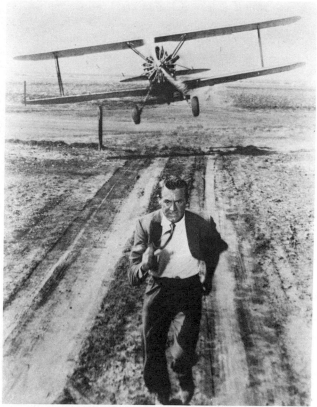

the suspense is intensified. Conversely, Alfred Hitchcock in *North by Northwest* (1959) creates a chase in which Cary Grant is being pursued by an airplane overhead. By suggesting that the off-screen space (an open field) is unlimited and that there's no place for Grant to seek cover, the chase has the effect of a horrible nightmare.

Optical sound track A **sound track** appearing on the edge of the film (opposite the sprocket holes' side) and consisting of a photographic **image** of sound modulations. An exciter lamp on the motion-picture projector picks up these modulations and through electrical conversion reproduces the original sounds.

Original screenplay A **screenplay** developed from an idea conceived by the screenwriter, based on the writer's imagination or on an incident which provokes the writer's imagination: an historical event, a newspaper item, an interesting human being, or a story idea for a particular film **genre**. See **Adaptation**.

Out-of-camera film (see **Noncamera film**)

Outtake A term for filmed material which is deleted in the editing process and which does not appear in the **final cut**. Outtake material may be removed because of flaws in the filming of a **shot** or a **scene** or simply because the film's **editor** opts not to use the material in the final cut. There is a particular fascination for outtake material because of what it can reveal about actors and the filmmaking process, often in very human or humorous ways. Consequently, outtakes are frequently screened on television programs. In a rare gesture, Hal Ashby inserted closing **credits** for *Being There* (1979) over an outtake of Peter Sellers attempting to control his laughter during the filming of a scene. Outtake material from **documentaries** and **newsreels** is also frequently used by the makers of **experimental films** for satirical effect, e.g., Henri Erlich's *My Way* (1975), a humorous view of Rich-

64. Matched over-the-shoulder shots from *A Place in the Sun* (1951). These shots avoid jump-cuts by keeping Montgomery Clift on the right side of the frame in each shot and Elizabeth Taylor on the left. Because of the position of the camera, the over-the-shoulder shot suggests a subjective point of view of the foreground character.

ard Nixon made up largely of outtakes from government-produced newsreels.

Overcrank (see **Slow motion**)

Overexposure (see **Exposure**)

Overlapping sound Sound, usually a **sound effect** or speech, which continues briefly from one **shot** into the next. Or overlapping sound may be a **sound advance**, where a speech or sound effect in an incoming shot is heard briefly in the outgoing shot. Overlapping sound may be used to connect dynamically two separate pieces of dramatic action or to enhance the **pace** of story development.

Over-the-shoulder shot A **shot** taken over the shoulder of a character or characters looking toward another character or characters (photos in 64). Most commonly, over-the-shoulder shots are taken at medium or medium-**close-up** range. By cutting between matching over-the-shoulder shots of two characters **(reverse-angle shooting)**, the film **image** changes to achieve desired emphasis within an action-reaction situation. The over-the-shoulder shot also adds a sense of depth to the **frame composition** by blocking into the frame. See **Point of view**.

Pace The rhythm of the film. "Pace" refers to both the internal movement of characters and objects within the film **shot**, and to the rhythm of the film that is supplied by editing. Frenetic movement within the **frame** and brief, staccato shots give a sense of considerable pace to the film. Little internal movement and lengthy shots add a measured, leisurely pace to the film's progress. See **External rhythm**, **Internal rhythm**, **Formal editing**.

Pan The movement of the camera across a **scene** horizontally (left to right or right to left) while mounted on a fixed base. A pan, like the **tilt**, is frequently used to scan a scene and to follow character movement in a limited location. **Establishing shots** will often include pans, and sometimes tilts, to provide a more extensive view of an environment.

In character movement, the camera can pan to follow an actor's walk across a room and then tilt down when the actor sinks into an easy chair.

Pans and tilts, while for the most part utilitarian, allow the **director** to present a scene or follow actions fully without edits which might destroy a desired mood.

Rapidly effected pans are also often used dynamically to reveal character reactions or to reveal and emphasize important information ("revelation pans"). Pans can also be incorporated into **subjective shots** as the camera as-

sumes the eyes of a character, and surveys a room or exterior location. The use of pans and tilts in this way makes the subjective, mind's-eye **point of view** more obvious by activating the camera. An extremely rapid pan, referred to as a **swish pan**, is a method of effecting a **transition** from one scene to another. The rapid swish pan blurs the **image**, thus wiping out the scene. A new scene then begins.

Parallel development (editing) The development of two or more separate lines of action which are occurring simultaneously. Parallel development is achieved by **crosscutting** from one location to another to pick up the action as it progresses. This technique in the early years of cinema was referred to as the **switchback** because parallel editing usually does switch back in time to visualize an event; in many instances of parallel editing, however, the crosscutting will show the event in an advanced stage of time from the point where the earlier action left off.

Parody A motion picture which makes fun of another, usually more serious film (photo 65). The intention and design of the parody are ridicule of the style, conventions, or motifs of a serious work. The comedies of Mel Brooks are often parodies of familiar American **genres**: the **western** (*Blazing Saddles,* 1974); the horror film (*Young Frankenstein,* 1974), the Alfred Hitchcock thriller (*High Anxiety,* 1977).

Pathos A term derived from the Greek word for "suffering." Its application to dramatic, literary, or cinemat-

65. *Airplane* (1980) parodied the *Airport*-styled disaster films of the 1970s, e.g., *Airport '75* (1975). Familiar plotting elements (singing nuns) and clever editing juxtapositions such as the one illustrated above were employed to provoke laughter.

ic expression refers to the feelings of compassion or pity evoked for a character or group of characters. In its most common application, pathos refers to aroused emotions that result from the unrelieved suffering of a helpless but dignified character. The hero is an unfortunate victim of general conditions rather than innate character flaws.

Persistence of vision A physiological phenomenon whereby the human eye retains for a fraction of a second longer than it actually remains any **image** which appears before it. The persistence-of-vision phenomenon allows the connection of rapidly projected photographs (**frames**) so that they seem a continuous single image, thus per-

mitting the illusion of "moving" pictures. Peter Mark Rôget is noted for having presented the persistence-of-vision theory in 1824 in a paper to the Royal Society of London titled "The Law or Persistence of Vision with Regard to Moving Objects." See **Frames per second**.

Personal director (see **Director**)

Photographed thought The photographing and inserting into a film story **shots** of what a character thinks or imagines. The device is often used to suggest a character's mental and psychological state. Joanne Woodward, for example, in *Rachel, Rachel* (1968) engages in mental fantasies as she walks to the school where she teaches (photo 66). As others greet her, she imagines her skirt falling to the sidewalk. She sees a male teacher arriving in his automobile and imagines the two kissing passionately. These imaginings, triggered by the situation at hand, are photographed thought that is given to the viewer as a means of depicting a mind at work. *Looking for Mr. Goodbar* (1977) also employed the technique of photographed thought to convey the principal character's fantasies.

Pixilation A type of **animated film** which employs objects or human beings in a frame-by-frame animation process. It is a descriptive label which distinguishes the animation of material objects from that of hand-drawn **images**. The process of pixilation is that of **stop-action cinematography**, where objects or subjects are moved between **frames**. Georges Méliès incorporated pixilated action into his early **trick films**. Pixilation has been a

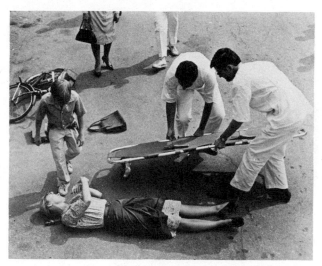

66. One of several instances of photographed thought in Paul Newman's *Rachel, Rachel* (1968). Here, Rachel (Joanne Woodward) imagines an embarrassing accident while walking to the elementary school where she teaches. These visualized fantasies are intercut with memories of Rachel's childhood to suggest a woman plagued by middle-age crisis.

highly imaginative technique of the experimental Canadian filmmaker Normal McLaren: *Neighbors* (1952, photo 67), *A Chairy Tale* (1957). It also appears from time to time in dramatic films, e.g., *Nosferatu* (1922), *A Clockwork Orange* (1971).

Point of view A term used to describe the filmmaker's relative positioning of the viewer into an objective or

67. Norman McLaren's *Neighbors* (1952) used single-frame filming to pixilate objects in an allegorical film about the need for brotherly love. Here fence pickets are moving to enclose the graves of the two warring neighbors.

subjective relationship with the recorded material.

An *objective point of view* is one where the camera appears to be an uninvolved, unnoticed recorder of action. Although long, medium, and close **shots** may be taken of the action, the camera remains a viewer of the **scene** rather than a participant in it. The objective point of view attempts to call as little attention to the camera as possible or to character point of view. The filmmaker instead attempts to reproduce surface reality and movement without obvious artistic manipulation.

A *subjective point of view,* on the other hand, puts the camera into the action as though the camera **lens** has become the eyes or mind's eye of one of the characters.

Some **subjective shots** are more obvious than others. The most obvious is the one in which a character's eyes scan a room, followed by a camera **pan** across the room to suggest what the searching eyes see.

The purpose of this type of subjective shot is to put the viewer into the mind's eye of a character. Certain German directors of the 1920s, such as F. W. Murnau, E. A. Dupont, and G. W. Pabst, made extensive use of the mind's-eye, subjective camera shot to convey subtle emotions and interior feelings in films like *Variety* (1925) and *The Last Laugh* (1924).

In *Variety,* for example, director Dupont uses the mind's-eye shot to suggest the movement of a trapeze artist through the air. The camera was actually mounted on a trapeze to photograph the effect. Later in the film, as a romance develops between Emil Jannings' wife and the new, third member of their trapeze act, Dupont employs subjective shots to show what Jannings sees as he watches the other man interacting with his wife.

Another use of the subjective-point-of-view shot was seen in one of the segments of the television series *Roots* (1977). As Kizzy (Leslie Uggams) is put on the back of a wagon, to be separated from her mother and father, subjective shots of both Kizzy's point of view and her mother's are **crosscut.** The camera takes Kizzy's view, showing the mother as she begins to disappear in the background as the wagon moves away. This shot was taken from a wide **angle of view,** with the camera mounted on the moving wagon to suggest both point of view and movement through space. The mother's view of the disappearing wagon was taken from a static position; the **intercutting** of the two subjective shots suggested the

powerfully felt emotions of the characters, while depicting the beginning physical space that would separate mother and daughter.

A form of subjective shot occurs in certain **reaction shots.** When two characters are conversing with each other and the camera cuts back and forth between **over-the-shoulder shots (reverse-angle shots),** the editing gives the impression that we are seeing a subjective, action-reaction view of the two characters as they interact.

Point of view (abbreviated POV) is a common designation in motion-picture shooting scripts to indicate a camera **setup** which will assume a character's angle of view.

Polyvision (see **Multiscreen projection**)

Presence (sound) An aesthetic-technical term for the relationship of an actor's voice or a **sound effect** to a recording microphone. When an actor speaks directly "on mike," the **dialogue** is recorded at "full presence." Principal characters in a film **scene** usually have full presence while background characters do not. Robert Altman, however, in *California Split* (1975), a film about habitual gambling, gave full presence to crucial dialogue as well as to mid- and background sounds. Several different **sound tracks** allowed this uncommon presence on various areas of sound. The effect provided a heightened sense of awareness of the gambler's intense world.

Presence and **volume**, the recorded level of sound, are principal means by which sounds in a motion picture are given emphasis. See **Selective sound**.

Presentational blocking The **blocking** of characters into a film **scene** so that they appear to "present" themselves directly to the camera **lens** (photo 68). More commonly, actors are positioned at an angle so that they do not look toward the lens. This angling minimizes the presence of the camera. The use of presentational blocking reduces the objective distance between viewer and dramatic action. In Ingmar Bergman's *The Seventh Seal* (1956) Death, one of the principal characters, frequently looks directly into the camera lens so as to bring the viewer into a more dynamic relationship with the life-death game occurring within the story. Presentational moments also occur in Tony Richardson's *Tom Jones* (1963) as Albert Finney winks and shrugs at the camera to make the audience seem accomplices in his roguish capers. The entire cast of *Stevie* (1978), a British-made film taken from a stage play, addresses the audience in a presentational manner as the life and writings of poet Stevie Smith (Glenda Jackson) are revealed.

Processing The chemical conversion of an invisible latent **image** on exposed film into a permanent visible image. The four primary steps in processing film are development, fixing, washing, and drying. Development is a chemical procedure in which the halide particles that have been exposed to form the latent image are reduced to metallic silver. Fixing is the process by which the silver halide that has not been reduced to a silver image by development is converted to a water-soluble salt complex (silver thiosulfate). Washing removes the thiosulfate salts from the film. The film is then dried, completing the processing of motion-picture film.

68. In Ingmar Bergman's *Hour of the Wolf* (1968) Liv Ullmann
"presents" herself directly to the camera in an effort to try to
explain how her husband disappeared from the island on which
they have come to live.

Process shot (Process Cinematography) The technical
term for a motion-picture shot in which "live" fore-
ground action has been filmed against a background
image projected onto a translucent screen (photo 69). In
process cinematography the shutters of both camera and
rear projector are regulated by electrical means to open
and close simultaneously so that frame-line flickers do
not appear.

Technical considerations of process cinematography require (1) that the angle and quality of light on the set proper match that of the projected image, and (2) that the projected image be absolutely stationary so as not to be discernible.

Process shots are common to motion-picture studio filming where unusual locations must be achieved, e.g., boats, airplanes, and foreign settings. See **Rear-screen projection, Traveling matte.**

Producer (film) That individual who serves as the "executive" supervisor of a film, standing prominently beside the **director** who is the "artistic" overseer of the

69. A studio-filmed boat scene in *A Place in the Sun* (1951) that has been achieved through process cinematography.

production. In contemporary filmmaking the producer often secures the money for the project, purchases the film script, and hires the director and other primary artists involved in the making of the film. Producers can be autocratic forces in the filmmaking process, making both logistic and artistic decisions that affect the ultimate quality of the released film. Producers such as Irving Thalberg and David O. Selznick achieved legendary status in the film world during the **American studio years**. In more recent times producers have also been able to achieve a dominant position in film production — turning out works which are considered to have their own special creative stamp, e.g., Dino de Laurentis. During the 1970s and 80s increasingly more actors turned to producing their own films, e.g., Robert Redford, *All the President's Men* (1975) and *Ordinary People* (1980).

Production values A trade concept used in reference to the quality of set design, costumes, lighting, and sound in a particular motion picture (photo 70). Usually there is a direct relationship between production values and budget expenditure. Lavish musicals, screen **spectacles**, and other types of films where a highly polished romantic look is desired usually give strong emphasis to production values.

Protagonist The principal hero of a motion picture or a play; that individual or group of individuals with whom the audience empathizes. Dramatic conflict and empathy occur when another character or force (war, nature, a shark, personal weakness) challenges the protagonist,

70. A still from George Cukor's screen adaptation of Dumas' *Camille* (1936) reveals the degree to which production values (settings, costumes, lighting, glamorous stars) added to the romantic appeal of motion pictures during the American studio years.

driving the hero into a crisis or series of crises. This challenging opponent is referred to as the **antagonist**.

Psychodrama A term often used to describe a type of **experimental film** characterized by Freudian approaches to self-exploration. The filmmaker is frequently concerned with subconscious states and personal sexuality. A strong dreamlike, surreal quality often dominates the film experience as the result of an abrupt, fragmented

71. *Meshes of the Afternoon* (1943) presents a psychologically inspired self-portrait of filmmaker Maya Deren.

flow of imagery. The term "psychodrama" is most commonly used in reference to highly personal works produced in the United States during the late 1940s, early 50s. Maya Deren (*Meshes of the Afternoon,* 1943, photo 71) inspired the psychological film movement in America, although its foundations had been laid by the first European **avant-garde**. Three California-based filmmakers earned reputations in the 40s for their personal-experience psychodramas: Kenneth Anger (*Fireworks,* 1947), Curtis Harrington (*Fragments of Seeking,* 1946), and Gregory Markopoulous (*Psyche,* 1947–1948). Willard

Maas' work on the East coast (*Images in the Snow*, 1943–
1948) was of similar Freudian character. Later work by
these filmmakers often took the form of symbol-laden,
ritualistic exercises (e.g., Anger's *Scorpio Rising*, 1962–
1964).

Psychological time A term referring to the use of film-
ic devices which, in the continuity of a motion-picture
narrative, suggest not chronological time but time as it
is perceived by a character's mind. A **dissolve**, for ex-
ample, most commonly reveals a passage of time when
used within an ongoing **scene**. The dissolve, by tradition,
serves to exclude intervening time and action. If, how-
ever, a dissolve rather than a **cut** is used in a continuing,
uninterrupted action, its unorthodox placement carries
psychological implications. Subjectively inspired **psycho-
dramas** by experimental filmmakers, e.g., *Meshes of the
Afternoon* (1943) by Maya Deren, often exploit the
psychological dissolve for a mind's-time effect.

Psychological time can also be suggested by the re-
peated use of a piece of action. The condemned traitor's
final, desperate effort in *An Occurrence at Owl Creek
Bridge* (1962) to reach his wife is conveyed in psycho-
logical time by a repeated telephoto **shot** of the man
running down the road to his home. He appears sus-
pended in time and place, which in fact he is; shortly
after these shot repetitions, the viewer discovers that the
traitor's entire flight has been a fantasy revealed through
an extended use of psychological time.

Pure cinema (see **Cinéma pur**)

Rack focus (pull focus) The shifting of focus from one area of a **shot** to another. Through rack focus an area that is "soft" or out of focus can be brought into critical focus for the purpose of shifting emphasis or calling attention to otherwise indistinct material. Rack focus, sometimes called pull focus, or roll focus, is used most frequently in telephoto shots with limited **depth of field** so that the focus change is immediately and sharply apparent.

Reaction shot A **shot** within a **scene** which shows a character's reaction to a dramatic situation. The reaction shot is usually achieved through a **close-up** or medium shot of the character.

Realist cinema A **style** of filmmaking which in a general sense creates a semblance of actuality. Realist films avoid techniques that impose subjective or directed attitudes on the recorded material. Artistic lighting and expressive camera techniques usually are kept to a minimum. The realist film also often includes **long-take scenes** rather than carefully edited **sequences**.

Realist cinema stresses, most commonly, the subject in interaction with the surrounding environment. For this reason the themes of realist films often develop

within a "flow of life" format, where the casualness of common events reveals their content.

The Lumière *actualités* are early examples of realist cinema in the purest sense. Italian **neorealism** approached a realist style within the narrative film. **"Direct cinema"** is a term for a type of contemporary **documentary** film which can be labeled "realist cinema."

Rear-screen projection The use of projected **images** within a motion-picture **scene** to suggest background location. Rear-screen projection allows the semblance of location shooting within the film studio. Edwin S. Porter incorporated two rear-screen projections in *The Great Train Robbery* (1903), one of a train arriving at a depot (photo 72), and the other of a passing landscape, visible through the open door of a train mail room.

The lack of dimension in rear-screen projection requires careful use of the technique; the device works best when the projected images are atmospheric rather than sharply defined elements of the scene.

"Process shot" is the technical term used to describe the procedure for combining rear-projected images with "live" foreground action.

Remake A motion picture made from a film story which has been produced at an earlier time. *Stagecoach*, originally produced in 1939, was remade in 1966. *Heaven Can Wait* (1978) was a remake of *Here Comes Mr. Jordan* (1941), with certain plot changes being made in the 1978 version to update the story and include topical material.

72. A rear-screen projection, showing the arrival of a train, is visible through the set window in Edwin S. Porter's *The Great Train Robbery* (1903).

Remakes have been subjected to intense critical comparison with their originals, particularly when the original is regarded as a screen classic.

Rembrandt lighting A somewhat obscure term for a type of special-effect backlighting used in motion-picture and still photography (photo 73). Rembrandt lighting takes its name from the artist who, in painting portraits, attempted to suggest character and personality by use of light and shadow. Vivid contrasts of light on a figure, including a soft light coming from behind the person, were used by Rembrandt. The soft backlight seemed to highlight character mood in a strikingly sympathetic manner.

D. W. Griffith experimented with the expressive possi-

bilities of Rembrandt backlighting in **close-up shots** where he wanted to enhance character or add a romantic, ethereal quality to a figure, usually one of his leading actresses. Rembrandt backlighting in motion-picture

73. Rembrandt backlighting adds a romantic touch to this production still of Scarlett O'Hara (Vivien Leigh) in *Gone with the Wind* (1939).

photography usually comes from a low back-angle. This positioning causes the light to filter through the hair and to encircle the head with a halolike effect. The same effect can be achieved outdoors by strong backlight from the sun. Ingmar Bergman frequently uses strong sunlight for a Rembrandt effect.

Rembrandt backlighting, as a dramatic and romantic lighting effect, was most common in the studio films of the 1930s and 1940s. The effect is seen frequently in filmed television commercials where romance and glamour are important.

Reverse-angle shot A **shot** which changes the **angle of view** and reveals subject matter from the opposite direction. The switching between **over-the-shoulder shots** for varying points of view in a two-character **scene** is achieved through reverse-angle shooting.

Reverse motion (shot) A trick visual effect in a motion picture achieved during editing by reversing the head and tail of the **shot**. By so doing, any motion in the shot will appear in reverse. Eisenstein employed the reverse-motion technique in *Ten Days That Shook the World* (1928) so that a fragmented statue magically appears to reassemble itself. In Jean Cocteau's *Beauty and the Beast* (1946), reverse motion is used to show Beauty being drawn backwards through a wall (made of paper) which then seems to reseal itself.

Rhythmic montage (see **Montage**)

Ripple dissolve A type of **transition**, characterized by a

wavering **image,** that is usually employed to indicate a
change to **flashback** material, commonly a character's
memory of an event. Sometimes the ripple dissolve is
used as a transition to an imagined event or action. See
Photographed thought.

Rising action (see **Dramatic structure**)

Rough cut An early version of an edited film in which
shots and **sequences** have been placed in general order.
Precise cutting points have not yet been made. When the
latter step has been completed, the edited film is referred
to as a **"final cut."** The rough cut is an important phase
of the film editing process since it gives the **editor, direc-
tor, producer,** and musical composer a sense of how the
final version will look.

Running gag A repetitive comic element in a motion
picture. The running gag has long been recognized as a
standard ingredient of **slapstick comedy,** and may be
either a repeated comic line of **dialogue** or a repeated
comic action. In *Silent Movie* (1976) Mel Brooks repeats
the gag of a newspaper vendor being constantly knocked
down by a bundle of newspapers that are thrown from a
delivery truck. Each time that one of these slapstick in-
cidents occurs, a **close-up** of the bundle of newspapers
also reveals through a headline a new development in the
film's zany plot. Thus the repetition serves as a running
gag and an informational device.

Scene A unit of a motion picture usually composed of a number of interrelated **shots** that are unified by location or dramatic incident.

Science-fiction film (sci-fi film) A motion-picture **genre** characterized by a plot that involves scientific fantasy. The story is often a tale set in a future time that is visualized through a lavish display of imagined settings and gadgets, and sustained in part by spectacular special effects. Georges Méliès' *A Trip to the Moon* (1902) was an early notable, albeit primitive, science-fiction film which visualized future space exploration. Fritz Lang's *Metropolis* (1927) was a science-fiction film about an autocratically run city of the future and extended the genre into the area of social commentary. More recent examples such as *Star Wars* (1977) and *The Empire Strikes Back* (1980) are futuristic adventure stories which also function as mythic tales about confrontations between good and evil.

Score Music which has been composed or arranged for a motion picture.

Screen-direction continuity A standard method of achieving continuity by establishing patterns of move-

ment within the film **frame.** A series of **shots** with con-
stant screen-left to screen-right movement by a perform-
er will suggest a continuous journey without a loss of
viewer orientation. If a screen-left movement of the
performer is followed by a screen-right movement, con-
fusion can result. Traditional continuity procedures pre-
scribe a neutral movement directly toward or away from
the camera prior to reversing established direction pat-
terns. In screen-direction continuity, a character may
enter and exit the frame in a constant pattern as a means
of rapidly advancing the character through different geo-
graphic locations. The entrance-exit pattern establishes
progressive continuity although the backgrounds are
constantly changing. Often an **editor** will follow a char-
acter's exit from the frame with a new shot of the charac-
ter already in the center of the frame moving through
another location. The character fully exits the first shot
and is seen moving in the same screen direction in the
subsequent shot.

Contrasting screen-direction patterns of two different
characters can be employed to indicate that the two are
traveling to meet each other.

Although filmmakers often deviate from constant
screen-direction patterns for varied effect, the rules for
directional continuity are essential in establishing the
visual logic of chases, journeys, and complex action.

In another geographical convention, an airplane or ship
traveling east is shown moving toward screen left; a
movement toward screen right indicates westward travel.

Screenplay A fully developed and thorough **treatment**

of a film story. The screenplay contains character **dia-logue**, describes action **sequences**, and becomes the basis for the **shooting script**. Also called a "master-scene script."

Screwball comedy A brand of comic film which originated in the mid-1930s, characterized by a zany, fast-paced, and often irreverent view of domestic or romantic conflicts which ultimately are happily resolved. Witty repartee and unlikely situations were also elements of the screwball comedy. This type of film offered pure escapism for Depression-era audiences.

Frank Capra's *It Happened One Night* (1934) is often cited as the film which introduced the **genre**. Its plot involved Claudette Colbert (a wealthy heiress) who, running away from home, encounters Clark Gable (a disguised newspaperman) on a bus traveling from Miami to New York. The newspaperman's strong confidence and the heiress's uppity ways and hesitancy lead to witty battles and eventually romance.

Capra and Howard Hawks were considered the masters of the screwball comedy. In Hawks' *His Girl Friday* (1940) Rosalind Russell, a star reporter, and Cary Grant, a wisecracking editor, are also caught up in the sex-antagonism game, hurling verbal barbs at one another but eventually succumbing to romance.

Peter Bogdanovich revived the elements and style of the screwball comedy for *What's Up Doc?* (1972), a film starring Barbra Streisand and Ryan O'Neal as a couple engaged in sexual confrontations of the zany, eccentric kind reminiscent of the 1930s.

Script person A label given to that individual who in the

making of a motion picture holds the **shooting script** and observes details such as costuming, props, actor appearance, etc., so that these details will match when repeated action occurs during the process of **triple-take** or **master-shot (scene)** filming. The filming of **close-ups** and medium **shots** of an action photographed initially in long shot may occur hours or even days later. Hence, it is important that details which have to match from shot to shot be carefully noted. This is the responsibility of the script person. See **Continuity**.

Selective key light A type of special-effect lighting achieved by control of the key light (photo 74). Rather than allowing the key light to fall fully onto the face, the light often will be regulated so as to fall only on the eyes or a part of the face. The effect, achieved by special attachments on the lighting instruments, isolates and emphasizes facial features or throws the face into areas of light and shadow. The technique can be an effective means of suggesting terror, fright, or psychological states in a **close-up shot**. Selective key lighting is often employed to heighten important psychological moments in Luchino Visconti's *Ossessione* (1942) and in John Schlesinger's *Marathon Man* (1976).

Selective sound The process in sound mixing of emphasizing certain aural elements for dramatic effect. In the majority of films, background sounds and scenic **sound effects** are atmospheric rather than expressive. If, however, it is to be suggested that a character is intensely conscious of the environment, sound effects of a ticking clock and a dripping faucet may be given greater **volume**

74. Selective key light, falling just across George Cooper's eyes in *Crossfire* (1947), helps convey the psychological mood of the confused GI who is suspected of murder.

and sound **presence** to suggest the interior state of mind. In this sense the sounds have become selective. See **Expressionistic sound.**

Semiological criticism (semiotics) The consideration of film as a language or linguistic system comprised of in-

terpretive signs which include the icon, the index, and the **symbol**. **Icons** are photographic representations of objects. The **index** is a sign which suggests a functional role for the object (icon) as it appears in the film. A symbol is a sign which suggests a meaning or concept apart from the inherent meaning of an object itself, e.g., a cross symbolizes Christianity, the Star of David symbolizes Judaism.

In the analysis of a motion picture through the study of its signs, semiologists attempt to reveal specific meaning as well as the mode of communication of the film. Peter Wollen, Charles Sanders Pierce, and Christian Metz are among the prominent originators of theories of semiological analysis. Semiological critics have tended to emphasize the study of the narrative film because of a professed interest in textual analysis. See **Structuralism**.

Sensurround A motion-picture sound system designed for special-effects purposes and most commonly used to enhance action films, e.g., *Earthquake* (1975), *Midway* 1976), *Rollercoaster* (1976). In the Sensurround process stereophonic-amplification speakers are placed in the front, rear, and sometimes on the sides of the theater auditorium; through high volume and modulation controls, **sound effects** are regulated to give the sensation of pervasive sound within the auditorium. Sensurround is essentially a technical gimmick like the **3-D process** and usually appears only in selected action sequences of a motion picture, such as the bombing sequences in *Midway*.

Sequel A motion picture which continues in narrative

development a story begun in a previous motion picture. Sequels usually are inspired by the success of an earlier film and seek to capitalize on the established appeal of the earlier work. The sequel has remained a staple of production studios where guaranteed mass-audience appeal has always been of utmost consideration. With fewer films being produced during the 1970s, the number of film sequels increased significantly, e.g., *The Godfather* and *The Godfather Part Two*, *Jaws* and *Jaws II*, *Walking Tall* and *Walking Tall Part II*. *True Grit* and *Rooster Cogburn and His Lady*, *The French Connection* and *The French Connection II*. See **Remake**.

Sequence A unit of film composed of a number of interrelated **shots** or **scenes** which together comprise an integral segment of the film narrative. In *Citizen Kane* (1941) the opera-related scenes—rehearsal, performance, and review scenes—together constitute a sequence.

Serial A type of "short subject" motion picture which developed as early as 1905 (*Mirthful Mary*) and was characterized principally by the episodic development of a story which was presented in installments over a period of several weeks. The serial engaged audience interest in a hero or heroine whose exploits reached an unresolved crisis at the end of each episode. This plotting gimmick sustained interest from week to week. The predominant **style** of the serial was melodrama, and plot lines were usually variations of popular film types: science fiction (*Flash Gordon*), the **western** (*The Lone Ranger*), romance (*Gloria's Romance*), action-adventure (*The Perils of Pauline*), mystery (*Charlie Chan*). Serials remained

popular with motion-picture audiences until production
of them ceased in the early 1950s, a time when the serial
became a mainstay of television programming (*Super-
man*). A desire to revive the appeals and special qualities
of the serial, and to incorporate them into a single film,
resulted in *Raiders of the Lost Ark* (1981).

Series films Motion pictures, usually of feature length,
which repeat characters from film to film, employing
stories of similar **style** and type. Series films enjoyed
their greatest popularity during the studio years of the
1930s and 40s. Because of their previous success, they
were regarded by American producers as film products
with an assured audience. Stylistically, the series films
were highly formulaic although they were of varied
type: comedy-romance (the Andy Hardy series); mystery
(the Thin Man series); children's adventures (the Lassie
series).

The series-film concept became a standard television
programming format and to a limited extent still exists
in theatrical filmmaking: the Billy Jack films, the Pink
Panther comedies, and the enormously popular James
Bond series which began in 1962 with *Dr. No*.

Setup A term used to describe the readying procedure
for each **shot** within a film. The placement of the camera
and **lens** on the **scene**, the setting of lights and micro-
phones for the purpose of recording a shot are together
referred to as a setup. The term is sometimes used in
film criticism to refer to a director's individualized **style**
in composing shots and recording the action in a scene.

Sexploitation film (see **Exploitation film**)

Shooting script A script containing **dialogue** and action as well as important production information for the **director** and the **cinematographer**. Included in this production information are **shot** descriptions (scope of shot); shot numbers, location and time notations; and indications of where special effects are required. The director works from this script in the filming of the story. The shooting script can also become an assembly guide for the film **editor**.

Shorts (short subjects) Brief films shown as a part of a theatrical motion-picture program, usually preceding the presentation of the **feature film**. Shorts, along with previews and **cartoons**, were used extensively as filler material when motion-picture programs were repeated every two hours and the standard length of the feature was approximately ninety minutes. After 1960 shorts became rarer in motion-picture houses as programming concepts changed and as exhibitors reacted to the extra cost of renting short-subject films.

Shot The basic unit of film construction. A shot is the continuous recording of a **scene** or object from the time the camera starts until it stops. In the edited film it is the length of film from one splice or optical **transition** to the next.

Shot-sequence editing A process of film construction which adheres rigidly to the conventions of **triple-take filming**. The **editor**, in reconstructing a scene, moves through the **shot sequence**—beginning with a **long shot**

(**cover shot** of the scene) then proceeding to **medium shots** and **close-ups**. This editing process is common in dramatic material which has been filmed for television.

Simultaneity The process in film construction of combining story elements and events which are occurring at the same time. A simple type of simultaneity occurs in the cinema through **parallel development** of separate lines of action. In a more complex manner, simultaneity is the aesthetic process employed by Eisenstein in the Odessa steps sequence of *The Battleship Potemkin* (1925). The short event is fully extended through simultaneity so that it can be perceived in its full impact.

Single-frame filming The process of shooting motion-picture material a **frame** at a time for the purpose of **animation, pixilation,** or a time-lapse effect. A person can appear to be flying 4 feet above ground through single-frame filming, as in Norman McLaren's *Neighbors* (1952). This effect is achieved by taking a single frame each time the actor leaps into the air and repeating the leaps hundreds of times. Cartoon animation is achieved by photographing a hand-drawn action **sequence** frame by frame, with the illusion of movement then occurring in the continuous projection of the individually recorded **images**. See **Time-lapse cinematography.**

Single-system recording (see **Magnetic film**)

Slapstick comedy Comedy derived from broad, aggressive action, with an emphasis often placed on acts of harmless violence. The term comes from a theatrical de-

75. One of the earliest examples of screen slapstick — Lumière's *Watering the Gardener* (1895).

vice developed for comic effect and consisting of two pieces of wood (a "slapstick") which produced a resounding noise when struck against an actor. Early evidence of slapstick comedy in the motion picture is found in the Lumière film, *Watering the Gardener* (1895, photo 75).

Slow motion A motion-picture effect in which **images** are shown at a moving speed that is slower than that of natural movement. The usual method of achieving slow motion is through the technique of **overcranking,** or photographing more than twenty-four frames per second and then projecting the images at sound speed (twenty-four fps).

As a unique cinematic device, slow motion has enjoyed a considerable degree of popularity with filmmakers, originally in an experimental way, and more recently as a standard device in narrative films.

Georges Méliès first made use of slow motion in his film fantasies as another exploration by him of film's "trick" possibilities.

In later periods of film history, filmmakers utilized slow motion to suggest dreams and dreamlike states. Screen fantasies often employed slow motion, as did experimental, psychological films such as *Un Chien Andalou* (1928) and the dream films of Maya Deren. Experimental film artists of the 1920s and 30s, who attempted to rid film of its theatrical and literary elements, utilized the innate cinematic quality of slow motion as a nontraditional way of viewing the world.

The dramatic uses of slow motion in contemporary cinema have been varied and extensive. Lyric, poetic moments in a film story are often conveyed through slow motion. In the horror film *Carrie* (1976), Brian De Palma makes use of extreme slow motion in the prom **sequence** of the picture. The effect intensifies and draws out the heroine's brief moment of glory.

Slow motion is employed as a means of dramatic contrast in *The Reivers* (1969). A horse race involving the lad in the story is declared a default because of cheating on the winner's part and the race must be rerun. The first race was photographed in natural motion and edited to provide an accelerated view of the action. Director Mark Rydell photographed the second race in slow motion, allowing the event to be shown with a different dimension of reality. The action is captured in

intense slow-motion photography rather than achieved through editing dynamics. As the two riders cross the finish line, with the lad the winner the second time, a cut is made which returns the action to natural motion. The dynamic return to natural motion punctuates the moment of victory.

Slow motion lends to all movement a more precise and balletic quality, no matter how frenetic the action. The familiar death sequence in *Bonnie and Clyde* (1967) had a choreographed, balletic quality because of Arthur Penn's use of slow-motion photography to record the event. The drawn-out, agonizing desert race in *Bite the Bullet* (1975) contained numerous sequences shot in slow motion.

Whether slow motion is used to depict beauty, horror, action, dreams, or fantasy, its effect is that of a heightened, extended dramatic experience.

Smash cut Another term for **dynamic cut**—a cut which is abruptly obvious to the viewer.

Socialist realism A term given to the style of filmmaking in Russia advocated by the Stalin government after 1928 as a replacement for the more formalistic methods of post-Revolutionary filmmakers, e.g., Eisenstein, Pudovkin, Vertov. Socialist realism called for simpler, everyday views of life in the new Soviet state. It was believed by the government that this approach would be more useful and instructive for the masses than the formalistic, art-for-art's-sake methods of the 1920s. The call for socialist realism stultified film experimentation in Russia, although **directors** like Eisenstein turned

to inspirational stories about historical figures and were able to bring to the screen impressive, marvelously executed epics, e.g., *Alexander Nevsky* (1938) and *Ivan the Terrible,* Parts One and Two (1944, 1946).

Soft focus A photographic **image** which lacks sharp definition. Within a single **frame** image some parts of the area of view may be in critical focus while others are "soft." The soft images are outside the **depth-of-field** zone either intentionally to emphasize a particular part of the **scene** or simply because greater depth of field was not possible for the chosen **lens,** film stock, and lighting conditions.

Sound advance The advancement of a sound, to be heard in a new **shot** or **scene,** into the end of the preceding scene. Sound advances, common in modern films, are usually combined with cut **transitions** to pull the action of the story forward in a dynamic manner. The device also has conceptual, satirical, and dramatic possibilities. In *Five Easy Pieces* (1970) the sound of a bowling ball rolling down a bowling lane is heard in the final seconds of a scene in a motel room where Jack Nicholson has taken a girlfriend. Just as the ball strikes the tenpin, a cut is made to a new scene where Nicholson is bowling with the woman. The combined sound advance and the cut transition together serve as a sexual **metaphor.** See **Asynchronous sound.**

Sound effects Noises and sounds on the motion-picture **sound track** which have been added to supply realism, atmosphere, and dramatic emphasis to a film **scene.**

Sound effects may be either onscreen effects or they may be offscreen sound effects. Onscreen effects originate within the visible action of the scene. Offscreen effects occur outside the scene and like music are often used as a means of creating mood, atmosphere, or drama. The sound of a coyote howling in the distance has become a clichéd means of suggesting the loneliness of life on the western frontier. Distant foghorns and train whistles have been similarly used in other environments to convey a sense of atmospheric loneliness. In *The Diary of Anne Frank* (1959) considerable dramatic tension was achieved by the distant sounds of gestapo police sirens interspersed throughout the picture.

The stylized use of sound effects to convey mood or drama represents a form of **selective sound**. The sounds may originate in the location and may be synchronous, but their dramatic importance is emphasized through volume or selective isolation from other sounds.

In *Thieves Like Us* (1974), Robert Altman employed radio sounds which served as an expressive motif throughout the picture. While the small-time bank robbers wait outside a bank during one of their unexciting holdups, they listen to a dramatic broadcast of *Gangbusters*. The young robber and his girlfriend listen to a concert of classical music, broadcast from New York, while sipping Coca-Colas and swatting flies on the back porch of their Mississippi hideout. When the two make love, a radio adaptation of *Romeo and Juliet* is heard in the background. The radio, while always a realistic part of these scenes, is employed by Altman as a means of contrasting the common lives of the bank robbers with those which

come over the radio. By so doing, Altman is also able to intensify through the supplied selective sounds an awareness of the quality of the environment in which the characters live.

Sound track The optical or magnetic track at the edge of the film which contains music, **dialogue,** narration, and **sound effects.** In most instances these various sound elements are mixed and synchronized to the desired **image.** When a sound track is not closely synchronized to the screen images, it is referred to as a wild sound track. Most sound tracks are photographed on the edge of the film (optical sound) and these are technically referred to as variable-density sound tracks. A sound reader responds to the printed images to produce sound output.

Source music Music which originates from a source within a film **scene**—a radio, phonograph, live orchestra, etc.

Special-effects film Any film which incorporates a wide variety of special optical effects and trick photography into the story. Special-effects films exploit the unusual possibilities of the motion picture for fantasy and **spectacle,** e.g., *Mary Poppins* (1964), *The Poseidon Adventure* (1972), *Star Wars* (1977), *Close Encounters of the Third Kind* (1977). See **Trick film.**

Spectacle A film characterized by elements which include lavish production design, epic theme, and grand scope. Screen spectacles consist of many types: dramatic

76. An early example of screen spectacle—the Babylonian section of D. W. Griffith's *Intolerance* (1916).

films involving high adventure and heroic characters, *Intolerance* (1916, photo 76), *War and Peace* (1956), *Ben Hur* (1959), *Star Wars* (1977); grand eye-catching musicals, *The Gold Diggers of 1935* (1935), *My Fair Lady* (1964); special-effects films designed to display novel motion-picture processes such as Cinerama (*This Is Cinerama*, 1952), 3-D (*Bwana Devil*, 1952), and **Sensurround** (*Earthquake*, 1975).

Spinoff A term used to describe a motion picture whose concept was inspired by another film—usually a highly successful work which enjoyed wide audience appeal. The popularity of *Young Frankenstein* (1974), for ex-

ample, inspired a number of spinoff comedies including *Sherlock Holmes' Smarter Brother* (1976) and *Old Dracula* (1976).

Split-screen process A type of laboratory effect in which the **frame** has been divided by a sharp line into two or more separate areas of visual information (photo 77). Separately recorded **images** are printed onto various parts of the frame which may be divided horizontally, vertically, or diagonally. A diagonal split-screen **shot** was used as early as 1915 by D. W. Griffith to depict the burning of Atlanta in *The Birth of a Nation.* Extensive use of the

77. Introductory split-screen images are used to reveal Ron Howard as he looked in *American Graffiti* (1973) and as a young man five years older when the story continued in *More American Graffiti* (1979).

split-screen technique appeared in *The Thomas Crown Affair* (1968) and *The Boston Strangler* (1968).

Star system A system, essentially American, for obtaining financial backing for the production of a motion picture, and for the commercial marketing of the picture, by exploiting the popular appeal of the star or stars who appear in the film. The system developed in Hollywood in the first decade of feature-film production and led to enormous salaries for the most popular screen actors. The Metro-Goldwyn-Mayer Corporation in particular was built around its company of actors, labeling its studio as a place with "more stars than there are in the heavens."

The domination of stars in film production and marketing remained strong until the early 1960s when a shifting economy and new approaches to film producing brought about significant changes in industry procedures. To a significant degree, however, American film producers still depend on the popular appeal of familiar entertainment personalities—a fact corroborated by the numerous television actors brought to Hollywood in the late 1970s and early 80s, including most prominently the comedians on the popular television show, *Saturday Night Live*, e.g., Chevy Chase, John Belushi, Bill Murray, and Gilda Radner.

Steadicam A lightweight, portable motion-picture camera mount which was put into wide use during the 1970s and which is remarkable for its steadying abilities when the camera is handheld or placed into motion. The Steadicam permits smooth follow shots which earlier were possible only with the use of heavy dolly devices and

motorized vehicles. The steadicam's capabilities were well displayed in the many action-training scenes in *Rocky* (1976).

Stereophonic sound Sound or music which has been recorded on two or more separate tracks and which, when played back on two or more separate speakers, gives an effect of three-dimensional sound.

Stereoscopic viewer A "three-dimensional" viewing device which gained wide popularity in the mid-nineteenth century. To achieve the three-dimensional effect two photographs of a **scene** appear side by side on a viewing card—one image on the left side and the other on the right. A frontpiece containing two **lenses** permits, as in natural vision, the left eye to focus solely on the left image and the right eye on the right image, thus creating the illusion of depth and dimension. Three-dimensional motion pictures, introduced commercially in 1952, worked on the same principle.

Stills Photographs taken of a film **scene** for promotional purposes. These are usually called production stills since they are taken on the set during the rehearsal or filming of the picture. Because they are to be used in publicizing the motion picture, production stills are usually posed for the best possible quality. A photograph taken from an actual **frame** of the finished motion picture is called a frame still.

Stock footage (shot) A **shot** or **scene** in a motion picture which is taken from existing film material, as op-

posed to new material which is shot specifically for a particular production. Stock footage may be incorporated in the film to avoid the expense of hard-to-derive shots: foreign locations, war scenes, airplanes in flight, etc. Major studios and other archives hold expansive stock libraries which contain every imaginable type of unusual scenic material, as well as **documentary** and newsreel footage of important historical events. The blending of stock shots with newly filmed material requires careful technical attention to avoid detection. Stock footage is often used as the background element in **rear-screen projection** and **traveling matte** shots.

Stop-action cinematography, stop motion The photographing of a **scene** or a situation for trick effect through a stop-and-start procedure rather than through a continuous run of the camera. The stopping of the camera in the middle of a continuing situation for a period of time before resuming filming adds an elliptical quality to a scene. Moving objects such as clouds or automobiles appear to advance in a pixilated manner. This effect is also referred to as **time-lapse cinematography.** Also, in stop-action cinematography, actors or objects can be added to or deleted from the scene while the camera is stopped, then filming of the action is resumed. This stop-start process gives the effect of the sudden appearance or disappearance of the objects or actors when the film is projected. The visual trickery of the stop-action process was often used in the magic and fantasy films produced by Georges Méliès at the turn of the century. The animation of real objects and people to give the impression of

self-locomotion is achieved through single-frame stop-action cinematography.

Stopping down (see **F-stop**)

Store theaters A name given in the United States to the first movie houses created solely for the purpose of showing motion pictures. The name surfaced during the rapid conversion in the early 1900s of shops and other business establishments into makeshift theaters. In 1905 Harry Davis and John P. Harris opened the country's first fully equipped, specially decorated motion-picture theater in Pittsburgh, Pennsylvania, "The Nickelodeon." After this event the word "**nickelodeon**" caught on as the popular term for American movie houses of early vintage. It is estimated that by 1906 there were nearly 1,000 nickelodeons in the United States.

Street film A term which usually refers to a type of motion picture produced in Germany during the 1920s and 30s, so called because much of the action takes place on a city street. In this kind of film, German **directors** often used the street as a setting for revealing social realities for characters. G. W. Pabst's *The Joyless Street* (1925), a study of inequities in post-World War I Vienna, epitomized the German street film. A single Vienna street and its inhabitants offer a somber view of the ruin and degradation that accompanied the times. Bruno Rahn's *Tragedy of a Street* (1929) is another example of the German street film.

Structural cinema A general term for a type of experimental film which places emphasis on sustained or repeated views of filmed material. A film in which a single wide-angle shot of an atomic-bomb explosion is repeated for forty-five minutes without variation is an example of structural cinema (*Atomic Explosion*, 1975). The camera in another film, Paul Winkler's *Brickwall* (1976), pans back and forth across a brick wall for nearly half an hour.

In structural cinema, editing is kept to a minimum. The filmmaker usually chooses a single structural approach to the material to be filmed – a zoom, a pan, a wide angle of view, a **close-up** – and the approach becomes the sustained, unvaried method of exploring the photographed materials. In some instances, the repeated **images** are supplied with laboratory effects such as solarization techniques, tinting, and **superimpositions**. Michael Snow's *Wavelength* (1967) consists of a single **zoom shot** (the structural device) toward a window (photo 78). The zoom takes forty-five minutes to complete. During the zoom, Snow varies image through changes in color temperature, filters, and exposure.

Structuralism A theory of film analysis closely associated with **semiological criticism** because of its systematic approach to film analysis. Structuralism, however, emphasizes **ethnographic** interests rather than linguistic (semiological) approaches in the study of film. The principles of structuralism were in part inspired by the work of anthropologist Claude Lévi-Strauss. Lévi-Strauss studied the oral rituals and mythology of certain South American Indians and by so doing isolated previously

78. *Wavelength* (1967), a structuralist film by Michael Snow, consists of a single zoom shot with the camera aimed toward the wall of a studio loft.

invisible patterns within these forms of communication. These polarized patterns, according to Lévi-Strauss, revealed how certain perceptions of the Indian tribes came to exist.

In a similar manner structuralist principles have sometimes been applied to the full body of a film director's work in order to detect patterns that will reveal social and cultural meanings and allow a better understanding of the artist under examination. In this sense, structuralism is also related to **auteur criticism**. Similarly, structuralism has been applied to a specific film **genre** or an individual film.

Studio lighting (see **Lighting**)

Studio picture A motion picture made principally on a shooting stage rather than on location, and usually characterized by exact technical control of lighting, setting, and sound. A studio picture often conveys a romantic quality because of controlled lighting and decor. Studio pictures also have decided advantages for expressionistic and atmospheric underscoring of theme, e.g., *The Cabinet of Dr. Caligari* (1919), *Broken Blossoms* (1919), *The Informer* (1935), *New York, New York* (1976). See **American studio years**, **Lighting**.

Studio years (see **American studio years**)

Style The manner by which a motion-picture idea is expressed so that it effectively reveals the idea as well as the filmmaker's attitude toward the idea. Style is the filmmaker's individualistic response to the treatment of an idea. The filmmaker's style may be: realistic (Vittorio de Sica, *The Bicycle Thief*, 1948); impressionistic (Federico Fellini, *Roma*, 1972); expressionistic (Stanley Kubrick, *A Clockwork Orange*, 1971); abstract (Alain Resnais, *Last Year at Marienbad*, 1961); surrealistic (Luis Buñuel, *L'Age d'Or*, 1930), etc. Because style is a reflection of the individuality of the filmmaker, no two directors' styles are exactly alike. Hence, style analysis is often a major emphasis in film criticism.

Subjective shot A **shot** within a motion picture or television program which suggests the **point of view** of a character. The camera becomes the eyes of the character, revealing what is being seen as the character moves through or surveys a **scene**. A combined **pan** and **tilt** shot

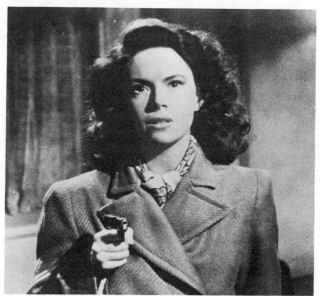

79. Throughout *The Lady in the Lake* (1946), the camera takes the subjective point of view of the principal character (Robert Montgomery). Since the camera view represents what Robert Montgomery is seeing, Jayne Meadows, shown above, must look directly into the camera lens. Montgomery is seen by the audience only in reflected mirror shots.

is a commonly used method of suggesting a character's surveillance of an area; a moving-camera shot conveys in a subjective manner a character's movement through space. A quick **cut-in** to an element in a film scene as a character glances toward it might also be considered a subjective shot since the cut indicates the character's subjective awareness of the detail. Subjective shots are

common in the psychological film and in film mysteries. An extreme use of the subjective shot occurred in *The Lady in the Lake* (1946, photo 79), a film photographed entirely from a single character's point of view.

Subplot A secondary complication within a motion-picture story, usually touching on and enriching the main plot. A subplot in Robert Redford's *Ordinary People* (1980) involves the fate of a young woman who, like the film's principal character (Timothy Hutton), is struggling to recover from a mental breakdown. Eventually the young woman commits suicide, an act which temporarily threatens Hutton's progress toward recovery.

Superimposition An optical technique in which two or more **shots** appear within the same **frame**, one on top of the other (photo 80). It is a popular device in **trick films**, experimental films, and fantasies, where unusual views of reality are desired. Georges Méliès employed superimpositions in trick films as early as 1896. The device was also a common element in the impressionistic and epic work of Abel Gance in France. In his classic **spectacle** *Napoléon* (1927), Gance freely incorporates superimpositions, including a shot of Napoleon spinning a globe which contains a superimposed portrait of Josephine. The device dynamically links Napoleon's desires to conquer the world to his love of Josephine.

Surrealism A modern movement in painting, sculpture, theater, film, photography, and literature, originating in France in the early 1920s, that seeks to express subconscious states through the disparate and illogical arrange-

80. A superimposition permits the ghostlike appearance and disappearance of Dracula in F. W. Murnau's *Nosferatu* (1922).

ment of imagery. Early surrealist filmmakers, Man Ray, Salvador Dali, and Luis Buñuel, captured on film a variety of material phenomena and arranged the imagery in incongruous ways so as to effect subjective, dreamlike meanings. The classic example of an early surrealistic film is *Un Chien Andalou* (1928, photo 81). Surrealism was born in a revolt against realism and traditional art. According to an early manifesto written by its leader, André Breton, surrealism is defined as "pure psychic automatism by which an attempt is made to express, either verbally, in writing, or in any other manner, the true function of thought." See **Avant-garde**.

81. The disparate and illogical arrangement of material objects, a principal characteristic of screen surrealism is evident in this shot from *Un Chien Andalou* (1928).

Suspense film (thriller) A motion picture whose plot creates a high level of anxiety and tension through concern for the fate of the principal character or characters. In the suspense thriller life itself is often threatened— usually as a result of the principal character's unsuspected or knowing involvement in dangerous, potentially deadly situations. As the plot builds toward its resolution, the threat and, thus, suspense increase. Alfred Hitchcock is often referred to as the master of the suspense thriller, e.g., *Rear Window* (1954) and *Psycho* (1960). *Marathon Man* (1976), *Black Sunday* (1977), *Coma* (1978), and *When a Stranger Calls* (1979) are other examples of suspense thrillers.

Sweeten (sound) To embellish an element of a **sound track,** usually by giving the sound greater presence or clarity. The term is most often applied to the work of documentarists, including *cinema-verité* filmmakers, who enhance elements of the sound track for the purpose of adding atmosphere or thematic impact. In Frederick Wiseman's *High School* (1969) a Simon and Garfunkel song being played on a tape recorder by an English teacher for her students is "sweetened" so that the thematic relevance of the song's lyrics is not lost to the viewer. The song is given full presence so that it has the clarity of high fidelity rather than the sound of a piece of music picked up in a classroom.

Swish pan A type of film **transition** achieved by panning the camera rapidly across a **scene.** The speed of the camera movement blurs the **image** and serves to wipe out the preceding scene. A new scene follows. The swish pan, because of its dynamic visual quality, is most frequently employed to link two scenes without a loss of momentum. See **Camera movement, Pan.**

Switchback An earlier term for **parallel development,** the process of including in a film through editing arrangement two or more events which have taken place at approximately the same time. Following the development of one action to a point in time, the **editor** "switches back" to pick up the action of another event. Most commonly in this type of story development, the separate elements eventually coalesce. D. W. Griffith frequently referred to this editing method as the "switchback device" and employed the technique extensively as a means

of narrative construction in his early silent-screen **melo-dramas,** e.g., *The Lonely Villa* (1909).

Symbol An object or **image** which both represents itself and suggests a meaning that is apart from its own objective reality. The object carries a literal reality and a suggestive meaning of a more abstract quality. In *The Birth of a Nation* (1915) the playful fighting of a kitten and two puppies is introduced by Griffith as a symbolic representation of increasing hostilities just prior to the Civil War. Here the symbolic relationship of the animals to the war is created by plot association. In other instances symbols may contain references that are universally or conventionally accepted as such. The white hat is a conventional symbol of the **western** hero figure, the black hat of the villain. Light (white hat) also carries universal connotations of "good" while dark (black hat) has long been a symbolic representation for "evil."

In semiotic criticism the symbol is one of the signs that, along with **index** and **icon,** is examined in the systematic analysis of the motion-picture narrative. See **Metaphor.**

Synchronous sound A film term which refers to the use of **images** and their corresponding sounds as they have apparently occurred simultaneously in real life. In **lip sync** a person speaks and there is a precise coordination of voice sounds and lip movement.

Narration or **voice-over** commentary which describes events on the screen as we see them is also a type of synchronized sound. The narration has been synced to the visual images.

Synchronized sound for the motion picture involves not only speech but noises (**sound effects**) and music as well. A type of synchronous sound occurs in a street **scene** where the typical noises of the city are heard. Music, skillfully composed to match exactly the moods and editing rhythms of a motion picture, can also be described as an evocative use of synchronous sound. "**Mickey Mousing**" of music, for example, requires exact synchronization.

The goal of synchronous sound in recording a dramatic scene is usually to present an accurate appraisal of sound originating in the environment. See **Dialogue**, **Lip sync**, **Realistic sound**, **Sound advance**, **Voice-over**.

Synecdoche A type of metaphor in which a part is used to indicate the whole or the whole is used to imply the part (photo 82). "Hand" is a synecdoche for "laborer;" "wheels" is a synecdoche for "automobile." The whole for a part is evidenced in the use of "the dying year" for "fall."

In the motion picture, synecdochic imagery is common. The use of a close **shot** of synchronized marching feet is a synecdoche for military power; in a more conventional manner an **establishing shot** of the Eiffel Tower is synecdochically representative of Paris.

The synecdoche has specific relevance for film analysis because of its relationship to semiotic criticism, and in particular to indexical analysis of motion-picture content. An awareness of the way various parts represent the whole allows a deeper understanding of methods of effecting connotative meaning within the context of a film. In Eisenstein's *The Battleship Potemkin* (1925),

82. Synecdochic information is represented by a pair of dangling glasses in Sergei Eisenstein's *The Battleship Potemkin* (1925). The glasses, knocked from the face of the ship's Czarist captain, symbolize the first blow against the monarchy, which ultimately is brought down by revolt.

the feet of Cossack soldiers marching methodically down the Odessa steps is a part that stands for the "whole" of Czarist oppression. In the final section of *Potemkin* the well-oiled, smoothly moving parts of the ship's engine are synecdochically representative of the "whole" efficiency of the ship, by then under the command of the rebel sailors.

The metaphorical nature of the synecdoche derives from a connotative relationship of imagery to the film idea.

Tableau A static grouping of live characters within the film **frame** (in theater, within the stage picture). Although more common in theater than in the motion picture, tableaux were often used for dramatic effect by film directors during the era of silent pictures. D. W. Griffith, for one, was fond of the tableau as a means of introducing scenes or providing a visual contrast with action shots, e.g., *A Corner in Wheat* (1909, photo 83). Christopher Miles uses a tableau in *The Virgin and the Gypsy* (1970) to present the stifling formality of a young woman's family when she sees them for the first time after returning home from boarding school.

Take A run of the camera for the purpose of filming a shot or a scene. Each run of the camera from start to finish is referred to as a "take." See **Long take, Shot**.

Teaser A scene which precedes the opening credits of a motion picture and which is designed to develop audience interest in the story that will follow the credits. Often in contemporary film, the credits will be superimposed over the teaser material. "Precredits grabber" is another term sometimes used for the teaser scene.

Technicolor A color-film process developed by Herbert T. Kalmus and Robert Comstock during the years 1916–

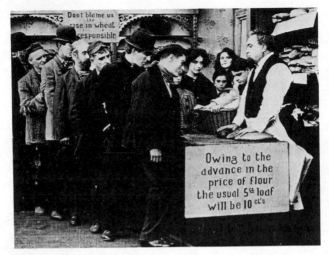

83. The tableau, as seen here in D. W. Griffith's *A Corner in Wheat* (1909), permits a stylized grouping of characters for dramatic and symbolic effect. Griffith suggests the plight of common workers who are caught in a world of spiraling food prices.

1918. Initially the Technicolor system produced color images through a two-color process: red-orange-yellow colors on one negative, and green-blue-purple colors on a second negative. The two separate negatives were then wed to create a scale of color values of less-than-accurate renderings, but it was a process which was utilized by major Hollywood studios after 1924: *Cythera* (1924), *The Phantom of the Opera* (1925), *The Black Pirate* (1926). Technicolor was a popular embellishment for costume-action and romantic films.

Eventually the Technicolor Corporation replaced the two-color lamination process with a three-color process which added blue to the spectrum. *Becky Sharp* (1935) and *The Garden of Allah* (1936) were among the first Hollywood films to be photographed with the three-color process. The quality of color reproduction in these films was significantly improved although the process tended to emphasize the "warmer" colors (yellows, oranges, and browns) of the spectrum, giving the films a golden look.

The Technicolor process held an exclusive monopoly on color filming until the development of new processes in the late 1940s and early 50s by Eastman Kodak, Warner Brothers, and other competing laboratories.

Telephoto lens A **lens** of long focal length with a narrow angle of view. The telephoto lens is one that magnifies the subject or object being photographed at least 50 percent more than does the **normal lens** for any given camera. Telephoto lenses are characterized by a shallow depth of field and by their tendency to compress foreground and background areas. They also appear to decrease the speed of objects and people as they move toward or away from the camera. A telephoto shot is any shot taken with a telephoto lens and recognizable as such.

Three-dimensional film A motion picture produced to allow a stereoscopic effect. In a 3-D, stereoscopic process, two pictures of a scene are taken simultaneously from points slightly apart from one another, and through the

use of eyeglasses the viewer is able to combine the projected images so that the effect of depth and solidity are achieved. The three-dimensional film was introduced to American audiences in 1952 with the release of *Bwana Devil*. After a brief period of curiosity the 3-D film lost its novelty for audiences and except for an occasional film, e.g., *The Stewardesses* (1974), *Comin' At Ya* (1981), use of the technique is rare.

Tilt The movement vertically (up or down) of the camera resting on a fixed base.

Time-lapse cinematography A method of filming which involves interrupted runs of the camera so that the lengthy progress of an actual event can be revealed in a brief period of time. Time-lapse cinematography has both scientific and experimental possibilities. The growth of a flower from seedling to full bloom can be observed on a few seconds of film which has used the time-lapse method. For *Coney Island* (1976) Frank Mouris employed a time-lapse method of filming to present in only three minutes a full day and evening at the amusement park. In time-lapse cinematography the flow of images, when projected, usually possesses an animated or pixilated quality since the process is quite similar to the single-frame methods of film animation.

Tinted film Generally a black-and-white film to which color has been added by hand, dye solution, or laboratory processing. Tinting for visual effect or symbolic value was common prior to the expanded use of **Technicolor** processes in the 1930s, Edison programs included

tinted footage as early as 1896. Georges Méliès in France often applied elaborate hand tinting to his highly imaginative screen fantasies.

Todd-AO A commercial name for a **wide-screen process** introduced by Mike Todd Associates. Todd-AO employed a film width of 65 mm and unlike Cinerama, another wide-screen process, required only a single camera and a single projector. *Oklahoma!* (1955, photo 84) and *Around the World in Eighty Days* (1956) introduced Todd-AO, which was later purchased by Twentieth Century-Fox and used in its film **spectacles** of the 1960s.

Tone A term which refers to one's responses to a particular motion picture as a result of various stimuli which are contained within the film. The filmmaker's attitude toward the treatment of subject matter produces a work's tone. That tone may be ironic, comic, serious, playful, brooding, cheerful, light-hearted, somber, and so forth. The tone of an individual film can be consistent throughout, e.g., Woody Allen's *Interiors* (1978), a somber work from beginning to end. Or the tone of a film may shift constantly, as in François Truffaut's *Shoot the Piano Player* (1960), a work whose tone is alternately comic, serious, playful, and tragic.

Tracking shot A term used interchangeably with **trucking shot**—a moving camera shot where the camera and its mount are moved to follow action. In a tracking (trucking) shot the camera may travel in front of, behind, or beside the moving action.

84. On the left, frames from *Oklahoma!* (1955), filmed in wide-screen Todd-AO; and on the right, frames from a standard-size 35-mm film.

Transition Any one of a number of devices by which a film editor moves from one scene or **sequence** to another. A transition usually involves a passage of time, and can affect the **tone** and flow of a motion picture. The **cut**, **dissolve**, **fade**-out/fade-in, **washout**, optical wipe, **natural wipe**, and **iris** are types of transitions available to the filmmaker. See **Ripple dissolve**.

Traveling matte A process for combining two separately recorded images into a single shot (photo 85). Most commonly the traveling-matte system is a technique for com-

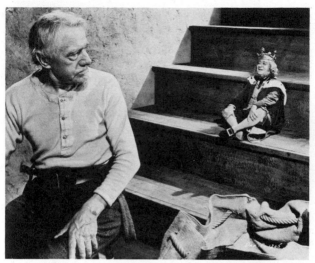

85. A traveling matte makes possible the visualization of leprechauns in the Disney production *Darby O'Gill and the Little People* (1959).

bining a foreground scene with a separately recorded background scene. Traveling-matte shots should not be confused with **process shots,** which consist of live foreground combined with **rear-screen projection.** In the traveling-matte system, foreground scenes are photographed against a solid-color background, usually indoors on a studio stage. A silhouette of the foreground action, called a **matte shot,** is produced on high-contrast film and combined in the optical printer with the background scene. In this initial printing of the silhouette matte, the silhouetted foreground area, because it is opaque, retards

light and remains unexposed. In a second run of the film through the optical printer, the foreground action can be printed onto the unexposed area for a composite of foreground and background. Because the silhouetted matte can and usually does change while being printed, it has been labeled a "traveling matte." The traveling-matte system can sometimes be detected because of blue fringing around the edges of the matte area.

Travelogue A type of **documentary** film which presents, primarily for entertainment purposes, views of interesting places and events—often exotic or historic locations abroad, frequently colorful events surrounding holiday celebrations in different parts of the world. Until the mid-1950s the travelogue often appeared as a **short** in theatrical motion-picture programs.

Treatment A complete narrative description of a film story written as though the author were visualizing the action as it develops. The treatment is eventually developed into a film script, with the precise description of the narrative giving indication of how the story should be "treated" in the script itself. See **Writer**.

Trick film (shot) A film or a film shot which has been derived through the special optical possibilities of the motion picture. The magical feats of stop-action filming, of filming at **fast** or **slow motion**, of animating objects or people through **single-frame filming,** and of **double-exposure** images are among the many optical tricks available to the filmmaker. A film whose design makes extensive use of these special characteristics for the effect of

optical illusion or fantasy is often referred to as a trick film. The films of Georges Méliès, e.g., *Conjurer Making Ten Hats* (1896) and *A Trip to the Moon* (1902), are thought of as trick films. Filmed-for-television programs such as *Topper* and *I Dream of Jeannie,* where characters constantly and magically appear and disappear, follow in the tradition of the trick film as do such experimental works as Norman McLaren's *A Chairy Tale* (1957).

Trigger film A recently developed concept for a short film that has been designed to generate discussion on an issue-oriented topic. The trigger film's method is that of creating a dramatic dilemma (usually staged) that is centered on a timely issue such as teenage drug use, and then ending the film before the dramatic situation is resolved. This open-ended approach is intended to trigger discussion among audience members about the nature of the dilemma and its possible resolution. The trigger-film concept originated in the 1960s at the University of Michigan in a series of films designed for discussion of problems related to highway safety. Numerous other educational filmmakers have since adopted the trigger-film approach.

Triple-take filming A method of filming motion-picture subject matter, usually dramatic material, through a process of repeated action in order to acquire long views, medium views, and close-ups of the scene. Actors repeat movements and lines of dialogue for each separate **take** so that a **matched cut** will be possible. The process also

presents the editor with a variety of shots of a dramatic action, thereby allowing numerous options in the reconstruction of a film scene: in establishing and controlling the **pace** of a scene; in placing dramatic emphasis; in extending time by including in the film two or more different views of the same action.

Triple-take filming was common in feature filmmaking during the studio years when the more intimate 3:4 aspect ratio of motion-picture formats permitted extensive editing within a film scene. With the introduction of wider screens in the 1950s, triple-take filming gave way to longer runs of the camera and a new emphasis on visual scope rather than on selective editing. Triple-take filming remains a popular method in the production of dramatic material for television.

Tripod A three-legged camera mount used for steadying purposes in still photography and cinematography. Tripods which are intended for use in motion-picture filming usually come equipped with a pan head—a moveable apparatus which allows the camera to be pivoted for smooth **pans** and **tilts**. The legs on many tripods are also adjustable so that the shooting position of the camera can be raised or lowered. A specially made tripod which permits extreme low-angle shooting is known as a hi-hat or high-hat tripod. See **High-hat shot**.

Trucking shot A shot in which the camera moves alongside a moving character or object for the purpose of following the action. A trucking shot which moves the camera in a circular pattern is called an **arc shot**.

If the camera moves ahead of characters or moving ob-

jects in a scene described above or follows them from behind, it is usually referred to as a **tracking shot**. The characters are following in the tracks of the camera, or it follows in their tracks. The tracking and trucking shots have been popularly employed for action and chase scenes and are also frequently used for **subjective shots** to show what a character sees while walking or riding in a moving vehicle.

Two-shot The designation for a shot composition with two characters. The term is used in a **shooting script** to indicate that in a scene containing two characters both are to appear in one composition rather than through intercutting between single shots of the two. An **over-the-shoulder** or **reverse-angle shot** is a type of two-shot.

Typecasting Selecting an actor for a certain role because of physical or professional qualities which make the actor ideally suited to play the character. In the motion-picture medium, where physique is all important, typecasting has been the rule rather than the exception. Once an actor has developed an appealing screen persona, the tendency has been to repeat that image from film to film. Major stars as well as character actors have sustained their motion-picture careers through typecasting.

In some instances directors will cast against type in order to give a role a new dimension, e.g., Paul Newman in *The Mackintosh Man* (1973).

Undercrank (see **Fast motion**)

Underexposure (see **Exposure**)

Underground film A term which was widely used during the 1940s and 50s to describe films which:

1 Were personal, noncommercial films.
2 Sought to break away from the established traditions of the feature, narrative film.
3 Dealt with personal, taboo themes not permitted in commercial films.
4 Sought to elevate "pure" cinematic techniques—**superimposition, slow motion**, speeded action, pixilation—over the story film.

 The underground-film movement had its greatest raison d'être when Hollywood pictures were more traditional in form and technique. In the 1950s and 60s, as feature films became more personal and innovative, many of the goals, intentions, themes, and techniques of underground filmmakers were absorbed into the commercial cinema. See **New American Cinema**.

Variable focal-length lens (see **Zoom shot**)

VistaVision A **wide-screen process** first attempted as early as 1919 and redeveloped at Paramount Pictures in 1953. The VistaVision system was designed to permit the projection of sharp, wide-screen images without the addition of new equipment. In the filming process, picture **frames** were photographed horizontally in the camera, rather than vertically, allowing for a frame size almost three times the width of a 35-mm frame. The printing of the larger frames onto standard 35-mm filmstrip permitted ordinary methods of screen projection for higher and wider images. *White Christmas* (1954) and *Strategic Air Command* (1955) successfully utilized the VistaVision method.

Voice-over The use of film narration, commentary, subjective thought, or dialogue in which the speaker or speakers remain unseen. The most frequent use of voice-over occurs in documentary and instructional films which are said to be "narrated." The device is also used in dramatic films for narrative exposition and, frequently, to suggest a person's thoughts while that person is shown on the screen. In *Bread and Chocolate* (1978) Italian director Franco Brusati engages the principal character, Nino, in a conversation with his wife and father-in-law

who are never seen in the film. This is achieved by the
use of dialogue that combines Nino's **lip-sync** words with
the voice-over dialogue of the unseen characters. See
Narration.

Volume (sound) The level of amplification of motion-
picture sound. Volume may refer generally to the pro-
jected level of amplification through a theater's sound
system or it may refer to the **sound track**'s aural ele-
ments which, in the making of the film, were recorded at
varying levels for dramatic effect. Volume and sound
presence serve as the primary means by which an aural
element can be given aesthetic or dramatic emphasis.
In *Reds* (1981) the steadily increasing volume of "The
Internationale" serves to highlight a culminating moment
in Russian history and to bring the first half of Warren
Beatty's film to a stirring musical climax. Later, near the
conclusion of the film, the same anthem appears again
on the sound track, but at an extremely low volume. In
this instance, the music suggests distant memory and a
fading dream for John Reed (Beatty), the film's princi-
pal character. Sound volume, at low or high levels, is a
common method of conveying memory and subjective
states.

Washout An optical **transition** used for editing purposes that are similar to the motion-picture **fade.**

Unlike the fade-out where the images fade to black, in a washout the images suddenly start to bleach out or to color until the screen becomes a frame of white or colored light. A new scene will then follow. Ingmar Bergman made extensive use of the washout in his psychological film *Cries and Whispers* (1972). Bergman varied the technique for both the purpose of transitions and for continuing his expressive use of color in that picture. The washouts would bring a single, rich color to the end of a scene in *Cries and Whispers* to symbolize the emotions and psychological passions at work in the story.

Washouts were also effectively employed in the fantasy sequences of *Catch 22* (1970). See **Exposure.**

Western A descriptive label for a type of motion picture that is characteristically American in its mythic origins. Motion pictures classified as westerns share a number of common qualities and filmic conventions. Generally, westerns are set on the American frontier during the latter part of the nineteenth century. Plotting conventions usually center on the classic conflict of maintaining law and order on the rugged frontier. The villains of western films conventionally use guns or other forceful means to take what they want; they are characters without any

sense of moral compunction. The western hero on the other hand exhibits great courage in dealing with the evil forces and reveals a simplistic sense of duty and honor. A common characteristic of both hero and villain is the willingness of each to use guns in protecting themselves. Showdowns, shoot-outs, and gunfights on horseback, on trains, or in stagecoaches are common to plot resolution in the western film.

The format of the western genre as it has evolved in American filmmaking is simple and direct. The *mise-en-scène* draws on the romantic appeal of the open, untamed edges of the frontier, on lonely isolated forts and ranch houses, and on the stark facade of still-forming frontier towns. The forces of evil in these locations, often a gang of men, are quickly introduced through dramatic actions which display their dastardly deeds: a bank robbery, a train or stagecoach holdup, cattle rustling, or human massacre. Equal attention is given early on to suggesting the rugged qualities of the hero who must contend with the villains. The hero may be a local law-enforcement officer, a territorial marshal, or a skilled gunfighter who is brought in from another frontier location. Eventually a showdown occurs, e.g., *High Noon* (1952), *Shane* (1953). In some instances, the hero may be a group of men—a posse—which organizes against the gang of villains. Still another variation of the western plot makes it necessary for the hero to pursue the villains into the unpopulated hinterlands beyond the frontier edges; in this variation of format the dramatic conflict centers on an extended "search and destroy" mission, e.g., *The Outlaw Josey Wales* (1976), *Rooster Cogburn and His Lady* (1976).

The appeal of the western film is derived from its fast-paced action, its romantic use of locations, and its clean, simple development of plot where dramatic conflicts, moral codes, and story conventions are easily understood.

Certain distinctions have been made between the serious western film and the western film of more benign intentions. To be a serious western, critics have claimed that the hero and villain must be equally committed to the killing of men in maintaining their positions on the frontier. Westerns of the other type, usually those made with a series hero such as Gene Autry or Roy Rogers, involve courageous deeds, but not to the point of death.

Whodunit A colloquial term for a mystery or detective film whose plot is centered on efforts to solve a crime.

Wide-angle lens A lens which provides a broad angle of view, employed most commonly in long shots and in situations where a great focus range is a consideration. Wide-angle lenses can also be used to make small space appear larger, distort perspective, and provide a sense of increased speed for moving objects or persons as they come in close range of the lens. Extreme-wide-angle lenses, often referred to as **fish-eye lenses**, produce even greater distortion.

Wide-screen processes Motion-picture screen formats with aspect ratios wider than the once standard 3 by 4 (1:1.33) height-to-width ratio. **Cinerama, CinemaScope,** SuperScope, and Panavision were commercial names of wide-screen processes introduced by American studios

in the early 1950s. Cinerama was a multiprojector, peripheral-vision wide-screen process with an aspect ratio of approximately 1:2.85. CinemaScope, SuperScope, and Panavision employed an **anamorphic lens** for an aspect ratio of approximately 3 by 7 (1:2.55). The now-standard wide-screen aspect ratio is approximately 1:1.65.

Wipe A transitional device which occurs when one shot moves across the screen from left to right or right to left and appears to wipe away the preceding shot. A flip wipe achieves the same effect but reveals the new scene in a manner similar to flipping a card which has a new image on the opposite side. These wipes usually are achieved through laboratory effects and are considered to be slick transitional techniques, used to effect a change of scene without a loss of dramatic pace.

A wipe that is achieved by using objects or characters to wipe out a scene is known as a natural wipe. In *The Battleship Potemkin* (1925) a woman who is fleeing the Odessa steps massacre rushes toward the camera with an open umbrella. The umbrella is brought right up to the lens until it wipes out the scene. A new action then follows this natural wipe. See **Head-on, tail-away**.

Writer (screen) The role of the motion-picture writer in the filmmaking process includes the major responsibility of providing a film scenario or film script which ultimately will become a **shooting script**. A **treatment** is a narrative description of a film story usually developed in a form similar to a short story. Characters and plot are

described, scene by scene, so that the dramatic flow of the story, as it will appear on the screen, is clear.

A *film script* is a more fully developed and thorough treatment of the story. The film script contains dialogue and action sequences, and becomes the basis for the shooting script.

The *shooting script* contains, in addition to dialogue and action description, important production information for the director and the director of cinematography. Included in this production information are shot descriptions (scope of shot), shot numbers, location and time notations, and indications of where special effects are required. The director works from this script in the filming of the story. It can also become a guide for the film editor.

The screenwriter may be involved in one, two, or all three phases of film scripting. Often more than one writer is involved.

The extent to which the film writer's work remains intact throughout the shooting period varies greatly. Many directors view the film script as merely a blueprint for building the film story, and proceed to embellish, delete, and rewrite parts of the script as they see fit. The script for Robert Altman's *Nashville* (1975), for example, underwent great change during filming, with both the director and the actors contributing to plot development and dialogue. In modern filmmaking this is frequently the case. Director Alfred Hitchcock, on the other hand, is said to have deviated rarely from the film script, having finalized the script earlier in story conferences with the writer or writers.

A film script usually falls into one of two categories: (1) the original screenplay or (2) the adapted screenplay.

Great screenwriters have contributed significantly to great films: Herman Mankiewicz to *Citizen Kane* (1941), Dudley Nichols to *Stagecoach* (1939), Robert Towne to *Chinatown* (1974), George S. Kaufman and Morrie Ryskind to *A Night at the Opera* (1935). Other screen-writers are not so well known, even some of those whose films have become highly successful. Because film scripts are translated into visual images, the exact role of the film writer cannot always be immediately evaluated. Yet, it is always possible to assess the quality of the script in terms of (1) idea, (2) story originality, (3) dialogue, and (4) power of theme, and to view the writer as a major contributor to each of them. These dramatic qualities are innately related to the contributory function of any writer who is assigned credit for a film story.

Zagreb School of Animation (see Animated film)

Zoëtrope (wheel of life) A nineteenth-century animating device developed by William Horner and used to illustrate the persistence-of-vision theory (photo 86). The effect of continuous movement was achieved by placing on the inside of a cylindrical drum a sequence of images of a figure in the progressive stages of a simple action. Each strip of images (contained on a length of paper) was called a "program." Slitted holes cut through the outside of the drum produced a shutterlike mechanism, permitting momentary intervals between the passage of each image as the viewer peered into the revolving Zoëtrope to see the figure in an animated state. A version of the Zoëtrope was first patented in 1867.

Earlier animating devices included the Stroboscope, the Phénakistoscope, and the Thaumatrope. The Stroboscope, demonstrated in Germany in 1832 by Simon Ritter von Stampfer, achieved the same effect as the Zoëtrope by spinning a slitted paper disc in front of a revolving imaged disc. Joseph Plateau's Phénakistoscope (later renamed Phantascope) placed the slits and images on a single disc, with the viewer peering through the slits toward a mirror reflection of the spinning images. The Thaumatrope, or "wonder turner," appeared in the 1820s as the simplest demonstration of a persistence-of-

86. An advertisement for the Zoëtrope and various action strips available for animated display within the "wheel of life."

vision device. Separate objects, drawn on opposite sides
of a circular card (a lion and an empty cage), seemed to
blend into a single image when the card was spun by at-
tached strings. The lion appeared to be seated in the cage.
The invention of the Thaumatrope has been attributed
to Dr. John Paris.

Zoom shot A shot which changes the **angle of view** from
a closer to a longer shot and vice versa. The zoom shot
looks somewhat like a **dolly shot** because it appears to
move closer to or farther away from a scene in a fluid
continuous movement. In a zoom shot, however, the
change of view is achieved without physically moving
the camera as in the dolly shot.

The widening or narrowing of the angle of view in a
zoom is possible because the lens used has a variable focal
length. The lens used in zoom shots is referred to as a
zoom lens or as a variable focal-length lens. The lens can
be adjusted to change from a long shot (wide angle of
view) to a close-up (narrow angle of view), or vice versa.

An optical difference exists between the zoom shot and
the dolly shot because a dolly shot does actually seem to
move through space, providing a dimensional perspective
on objects or figures it passes in the scene. In a zoom shot
all objects of the scene are magnified or diminished
equally, and the space traversed is less noticeable and less
dynamic than in a dolly shot.

The principal advantages of the zoom shot in filmmak-
ing are the speed with which it permits a change in angle
of view and its use in punctuating character reactions and
revealing important information in startling ways.

AN OUTLINE
OF FILM HISTORY

THROUGH THE CENTURIES

Eleventh
century
Scientists realize the possibility of project-
ing light through a small hole so that an ex-
terior scene appears on an interior surface.

Sixteenth
century
Leonardo da Vinci outlines the concept of
the *camera obscura*.

Mid-
sixteenth
century
Giambattista Della Porta presents short sce-
nic illustrations through a *camera obscura*.

Seventeenth
century
Athanasius Kircher develops his "magic
lantern."

FOUNDATIONS

1824
Peter Mark Rôget presents the paper enti-
tled "The Law of Persistence of Vision with
Regard to Moving Objects" before the Roy-
al Society of London.

1826
Dr. John Ayrton Paris invents the Thauma-
trope ("wonder turner").

1830s
Joseph Niepce and Louis Daguerre develop
the process which permits the retention of
photographic images on metal plates.

William Henry Fox Talbot produces positive prints on paper.

1832 Joseph Plateau produces the Phénakistoscope ("magic disc").

Simon Ritter von Stampfer invents the Stroboscope.

1834 William George Horner invents the Daedalum, later known as the Zoëtrope ("wheel of life").

1839 Daguerre displays examples of the daguerreotype in Paris.

1849 Langenheim brothers in Philadelphia produce photographs on glass plates.

1877 Thomas Alva Edison develops his phonograph sound recorder.

Eadweard Muybridge successfully photographs a galloping horse with a battery of cameras.

1882 Etienne-Jules Marey invents a gunlike camera ("photographic gun").

1884 George Eastman places Kodak rolls on the market.

1888 Eastman patents a film emulsion set on a transparent celluloid base.

1889 Edison laboratories develop the Kinetograph camera.

1891 Edison develops the Kinetoscope, a peep-
 show machine for a single viewer.

1893 The world's first film studio, the "Black
 Maria," is completed in West Orange, New
 Jersey, for Edison.

1894 The first Kinetoscope parlor officially opens
 in New York City.

1895 Auguste and Louis Lumière devise a porta-
 ble camera-projector (the Cinématographe).

THE MOVIES BEGIN

1895 Lumière brothers' first film, *Workers Leav-
 ing the Lumière Factory,* sets the precedent
 for the documentarylike approach that they
 continue to follow in their other films.

 Woodville Latham invents the loop proce-
 dure (Latham Loop) for projecting film.

December Lumière brothers project motion pictures
28 publicly in Paris.

1896 Robert W. Paul patents the Bioscope pro-
 jector in England.

 Georges Méliès, "the father of the narrative
 film," begins making trick films; he contin-
 ues to explore the realm of fantasy through-
 out his career.

April 23 The first public demonstration of Edison's

Vitascope projector at Koster and Bial's Music Hall in New York City.

1900–1905 "Brighton School" at work in England: a group of photographers whose experiments in film reveal the ability of shot interaction to convey emotional responses and unstated information.

1900–1910 Hundreds of short motion pictures are made from popular stage plays.

1902 Méliès, *A Trip to the Moon* (Fr.): this fantastic journey brings its creator international fame.

Edwin S. Porter, *A Romance of the Rails* (U.S.): indicates a growing awareness of the rudimentary elements of film expression.

1903 Porter, *The Life of an American Fireman* (U.S.): suggests the dramatic and symbolic possibilities of film editing.

Porter, *The Great Train Robbery* (U.S.): reveals the effectiveness of parallel editing and establishes the appeal of the western.

1905 The Nickelodeon Theater opens in Pittsburgh: the first fully equipped motion-picture theater in the United States.

The first trade publication, *Views and Film Index,* is published in the United States.

The standard length of movies is one reel.

Cecil Hepworth, *Rescued by Rover* (Br.): introduces consistent patterns of screen movement as a source of story continuity.

1906 There are nearly a thousand nickelodeons in the United States.

1907 The Film d'Art Company is founded in France to produce culturally significant works.

Chicago creates the first city film censorship board.

1908 Emile Cohl makes his first animated films in France, and J. Stuart Blackton pioneers animation in the United States.

1909 35mm becomes the standard film gauge internationally.

The American movie industry establishes the National Board of Censorship of Motion Pictures to counter attempts of state and municipal interference.

D. W. Griffith, *A Corner in Wheat* (U.S.): this film by "the father of film technique" constitutes an early effort at dialectical filmmaking.

Winsor McCay, *Gertie the Dinosaur:* the first important animated film made in the United States.

1910 There are 10,000 nickelodeons throughout the United States.

 The Star System begins in the United States as the first actress is featured under her own name: Florence Lawrence ("The Biograph Girl").

1911 The Centaur Film Company builds the first studio in Hollywood.

 Pennsylvania creates the first state reviewing committee for examining the moral quality of films.

 The first fan magazine, *Motion Picture Story Magazine,* is established in the United States.

 Griffith, *The Battle* (U.S.): this documentarylike story displays the director's growing mastery of the film medium.

1912 Carl Laemmle establishes Universal Pictures.

 Adolph Zukor establishes the Famous Players production company.

 Enrico Guazzoni, *Quo Vadis?* (It.): this elaborate spectacle achieves tremendous success and establishes Italy's importance in epic filmmaking.

 Louis Mercanton, *Queen Elizabeth* (Fr.): Sarah Bernhardt appears in this fifty-minute version of the stage play.

1913 Stellan Rye, *The Student of Prague* (Ger.):
 this expressionistic fantasy is a prototype
 for the mystical horror film.

THE MOVIES GROW UP

1914 The feature film becomes the norm in the
 industry.

 The Strand Theater, the first of the great
 motion-picture houses, opens in New York
 City.

 W. W. Hodkinson founds Paramount Pic-
 tures Corporation.

 Charles Chaplin makes his appearance in a
 Keystone film; he makes thirty-five com-
 edies in one year and creates the "little
 tramp" character.

 The most famous serial, *The Perils of Paul-
 ine* (featuring Pearl White), appears.

 Giovanni Pastrone (under the pseudonym
 Piero Fosco), *Cabiria* (It.): the pageantry
 and ornate costuming in this spectacle win
 it international acclaim.

 Frank Powell, *A Fool There Was* (U.S.):
 Theda Bara makes her first appearance as a
 femme fatale, and the word "vamp" enters
 the language.

 Mack Sennett, *Tillie's Punctured Romance*
 (U.S.): the first feature-length comic film.

1915 The United States Supreme Court rules, in the *Mutual Film Corporation v. Ohio* case, that the motion-picture medium is not entitled to the freedom of speech guarantees of the First Amendment.

The National Board of Censorship becomes the National Board of Review of Motion Pictures.

William Fox forms Fox Film Corporation.

Thomas Ince initiates the "Studio System."

Cecil B. De Mille, *The Cheat* (U.S.): sophisticated story of sin, sex, and sacrifice uses cameo-style lighting for an added psychological undercurrent.

Griffith, *The Birth of a Nation* (U.S.): this monumental but highly controversial work, almost three hours in length, utilizes the resources of the motion pictures as no film has previously done.

1916 Samuel Goldfish and Edgar Selwyn establish the Goldwyn Picture Corporation.

Griffith, *Intolerance* (U.S.): this epic film, more than three hours in length, interweaves four separate stories in a complex narrative that pleads for peace and brotherhood in the world.

Victor Sjöström (Seastrom), *The Kiss of Death* (Swed.): uses a modern approach to dramatic material in recreating an event through a series of flashbacks.

1917 Ufa (Universum-Film-Aktiengesellschaft) production company is formed in Germany with government support.

Chaplin, *Easy Street* (U.S.) and *The Immigrant* (U.S.): two of a dozen films for Mutual in which the little tramp grows from a caricature into a fully developed human character, and social criticism emerges with tragicomic effect.

1918 Griffith, *Hearts of the World* (Br.): successful propagandistic effort which treats the Germans in a negative and one-dimensional manner as it accounts the impact of World War I on several characters.

Ernst Lubitsch, *Carmen* (Ger.): exotic costume spectacle with an overtone of sexual intrigue by the "European master of screen pageantry" wins international acclaim.

McCay, *The Sinking of the Lusitania* (U.S.): the first animated feature.

1919 Soviet film industry is nationalized.

United Artists distribution company is

formed by Mary Pickford, Charles Chaplin, Douglas Fairbanks, and D. W. Griffith.

Block-booking is a growing practice.

De Mille, *Don't Change Your Husbands* (U.S.) and *Male and Female* (U.S.): candid explorations of sex and marriage which bring a new image of the American woman —"at once provocative, beautiful, sensuous, and independent"—to the screen.

Abel Gance, *J'Accuse* (Fr.): grand-scale, antiwar film, three hours in length, by the "Griffith of Europe" combines trick effects, metaphorical image juxtapositions, and documentary footage.

Griffith, *Broken Blossoms* (U.S.): effectively uses studio environment to create atmospheric effects.

Mauritz Stiller, *Sir Arne's Treasure* (Swed.): this epic film creates an association between the environment and the characters' lives in an authentic historical recreation of sixteenth-century Sweden.

Erich von Stroheim, *Blind Husbands* (U.S.): subtle and candid treatment of a triangular love affair among the rich marks the director's debut.

Robert Wiene, *The Cabinet of Dr. Caligari* (Ger.): classic macabre fantasy that exploits expressionistic techniques in this strange

tale of a somnabulist under the spell of a mad doctor.

1920 CBC Film Sales (later Columbia Pictures) is founded by Joe Bromdt and Harry and Jack Cohen.

Lev Kuleshov founds his workshop in Moscow and begins explorations of editing techniques.

Carl Boese and Paul Wegener, *The Golem* (Ger.): influential expressionistic story of a clay figure infused with life who turns against his creator.

De Mille, *Why Change Your Wife?* (U.S.): sophisticated battle-of-the-sexes film.

Stiller, *Erotikon* (Swed.): sophisticated sex comedy notable for its visual innuendo in treating erotic details.

1921 Chaplin, *The Kid* (U.S.): this film, the director's first feature, proves to be the biggest commercial success of his career.

Rex Ingram, *The Four Horsemen of the Apocalypse* (U.S.): this allegory about the futility of war brings Rudolph Valentino instant fame as he appears as a new type of romantic idol.

Stroheim, *Foolish Wives* (U.S.): an American woman becomes entangled in upper-

class corruption and decadence in Europe in this realistic and carefully detailed study.

1922 Two-thirds of the American states have or are attempting to enact some form of legislation for the regulation of motion pictures.

The film industry organizes the Motion Picture Producers and Distributors of America (MPPDA) and hires Will H. Hays as president to improve the image of Hollywood.

Robert Flaherty, *Nanook of the North* (U.S.): this influential nonfiction film captures the life of an Eskimo family.

Fritz Lang, *Dr. Mabuse the Gambler* (Ger.): penetrating portrait of postwar German society that follows the exploits of an arch-criminal to his end as a madman.

F. W. Murnau, *Nosferatu* (Ger.): shot on location, this unauthorized version of Bram Stoker's *Dracula* introduces the vampire to film audiences.

1922–1925 Dziga Vertov, *Kino-Pravda (Film-Truth)* newsreels (USSR): through montage, newly recorded *cinema verité* footage and vintage films are organized, in twenty-three issues, to capture the truth of life.

1923 Warner Brothers Pictures is incorporated.

Chaplin, *A Woman of Paris* (U.S.): reveals a

sophisticated approach to sexual matters as a young woman must choose between her luxurious life as a kept woman and her true love.

René Clair, *The Crazy Ray* (*Paris Qui Dort,* Fr.): this short extensively utilizes the trick possibilities of the film medium.

James Cruze, *The Covered Wagon* (U.S.): this epic film about pioneers on the American frontier inspires many imitators.

De Mille, *The Ten Commandments* (U.S.): this historical spectacle's visual ostentation and special effects establish the director as Hollywood's foremost "showman" and disguise his usual sin-and-sex story.

Lang, *Die Nibelungen* (Ger.): this two-part, stylized extravaganza (*Siegfried* and *Kriemhild's Revenge*) emphasizes the role of destiny in Germanic legend.

1924 Metro-Goldwyn-Mayer (M-G-M) is consolidated.

CBC Films Sale becomes Columbia Pictures.

Clair, *Entr'acte* (Fr.): free-form mockery of reality using trick effects and absurd action.

John Ford, *The Iron Horse* (U.S.): exciting action sequences and an evocative use of

the environment distinguish this epic western.

Fernand Léger, *Ballet Mécanique* (Fr.): avant-garde short that juxtaposes mechanical objects and fragments of reality.

Paul Leni, *Waxworks* (Ger.): expressionistic fantasy that links the stories of three evil historical characters with the nightmare vision of a poet.

Murnau, *The Last Laugh* (Ger.): innovative and highly influential film whose imaginative camera techniques reveal the subjective states of the central character.

Stroheim, *Greed* (U.S.): brings a new realism to the American screen in a frank and sordid treatment of materialistic obsession.

1925 Chaplin, *The Gold Rush* (U.S.): the director's tragicomic vision of the world comes to fruition as the little tramp uncharacteristically finds love, happiness, and wealth.

E. A. Dupont, *Variety* (Ger.): its dynamic use of camera serves to dramatize the tormented internal state of the central figure in a story of jealousy and murder.

Sergei Eisenstein, *The Battleship Potemkin* (U.S.S.R.): the director's theory of "montage of collision" finds expression in this tribute to Russia's failed revolution of 1905, a work which has influenced filmmakers everywhere.

Robert Julian, *The Phantom of the Opera* (U.S.): Lon Chaney rises to stardom in the most successful horror film of the decade.

G. W. Pabst, *The Joyless Street* (Ger.): the least romantic of the "street films," reveals the physical devastation and social disparities within the economically chaotic post-war environment.

King Vidor, *The Big Parade* (U.S.): this internationally successful film concerns the maturation of a young man during World War I.

THE AGE OF SOUND

1926 John Grierson coins the word "documentary" in a review of Flaherty's *Moana—A Romance of the Golden Age* (U.S.).

August 6 Alan Crosland, *Don Juan* (U.S.): premieres with Vitaphone (sound-on-disc) sound—a synchronized musical background.

Buster Keaton, *The General* (U.S.): "the great stone face" creates a consummate blending of visual gags and social irony.

Albert Parker, *The Black Pirate* (U.S.): the first feature to use a two-color Technicolor process throughout.

Vsevolod Pudovkin, *Mother* (U.S.S.R.): links the individual to mass causes and em-

phasizes character development within a
political setting.

1927 The Academy Awards (Oscars) are first pre-
sented by the Academy of Motion Picture
Arts and Sciences.

Movietone (sound-on-film) sound premieres
with short "preludes" to feature-length
films.

October 26 Crosland, *The Jazz Singer* (U.S.): premieres
with music and several talking sequences
and starts the industry's rush to sound con-
version.

Gance, *Napoléon* (Fr.): this epic, more than
four hours in length, draws praise for its
technical virtuosity, including the use of a
triptych—three screens spreading before
the spectators—for the projection of four
sequences.

Lang, *Metropolis* (Ger.): this architectur-
ally dynamic expressionistic film examines
a future technological society in which the
incompatible aims of science, industry, and
labor lead humanity to the brink of de-
struction.

Murnau, *Sunrise* (U.S.): the director's mo-
bile camera gives a lyrical expressiveness to
this triangular love story.

Pudovkin, *The End of St. Petersburg*

(U.S.S.R.): reveals an individual's growth and commitment to revolution within an historical period.

Walter Ruttmann, *Berlin, The Symphony of a Great City* (Ger.): captures the "essence" of Berlin through a montage of shapes and movements.

Josef von Sternberg, *Underworld* (U.S.): marks the beginning of the gangster cycle.

William Wellman, *Wings* (U.S.): spectacular World War I air battles highlight the first film to win the Academy Award for Best Picture.

1928 RKO (Radio-Keith-Orpheum) is established.

Salvador Dali and Luis Buñuel, *Un Chien Andalou* (Fr.): the most famous work of the French surrealist movement.

Walt Disney, *Steamboat Willie* (U.S.): the first animated film with synchronized sound.

Carl Dreyer, *The Passion of Joan of Arc* (Fr.): shot primarily in close-up, this film's fragmented juxtaposition of images stirs intense controversy.

Bryan Foy, *The Lights of New York* (U.S.): the first all-talking feature.

Pudovkin, *Storm over Asia* (U.S.S.R.): traces the irresistible storm of revolution in the rise of a simple Mongolian nomad to the leader of his people against the ruling imperialist powers.

Sjöström, *The Wind* (U.S.): the wind nearly drives a pioneer woman mad as she battles for survival in her new environment.

1929 Film projection speed is standardized at twenty-four frames per second.

More than 300 dialogue films are made in the United States as the industry completes the transition to sound.

British filmmakers, under the leadership of John Grierson, enter upon a decade of socially relevant documentaries that achieve international renown and inspire directors throughout the world.

Harry Beaumont, *The Broadway Melody* (U.S.): this "100% All Talking, All Singing, All Dancing!" film wins the Academy Award for Best Picture and leads to a rash of Hollywood musicals.

Alexander Dovzhenko, *Arsenal* (U.S.S.R.): lyrical tribute to the indestructible revolutionary spirit of the Ukranian people.

Alfred Hitchcock, *Blackmail* (Br.): the first British sound film displays a keen awareness

of the sound/image relationship in creating screen suspense.

Joseph Santley and Robert Florey, *The Cocoanuts* (U.S.): the first Marx Brothers' film adds a new absurd dimension to screen comedy.

Vertov, *Man with a Movie Camera* (U.S.S.R.): a lively film about Russian urban life that dynamically uses the camera and montage for didactic purposes.

Vidor, *Hallelujah!* (U.S.): the first sound feature with an all-black cast.

1930 Buñuel, *L'Age d'Or* (Fr.): surrealistic work that is banned in Paris after causing riots.

Jean Cocteau, *Blood of a Poet* (Fr.): the director's first film combines surrealistic and impressionistic experience to reveal the mental processes of a poet.

Dovzhenko, *Earth* (U.S.S.R.): lyrical treatment of collective farmers' struggle for unity in the Ukraine.

George Hill, *The Big House* (U.S.): this exposé of the penal system provides a model for later films.

Mervyn LeRoy, *Little Caesar* (U.S.): propels Edward G. Robinson to stardom as a ruthless gangster in this amoral depiction of brutality.

Lewis Milestone, *All Quiet on the Western Front* (U.S.): presents a sympathetic view of German soldiers in its account of the horrors of war.

Pabst, *Westfront 1918* (Ger.): this highly realistic antiwar film traces the lives of several German soldiers on the front during World War I.

Sternberg, *The Blue Angel* (Ger.): Marlene Dietrich achieves stardom as a cabaret singer who leads a professor to degradation and death.

1931 Double-feature programming is introduced.

Tod Browning, *Dracula* (U.S.): Bela Lugosi appears in his most famous role in this classic that inspires many imitators.

Clair, *A Nous la Liberté* (Fr.): satire on modern industrial society that destroys individual freedom and turns men into machines.

Lang, *M* (Ger.): skillfully interplays sound and picture in this study of a psychopathic child killer.

Wellman, *Public Enemy* (U.S.): this documentarylike examination of a lower-class boy's growth into a vicious killer makes James Cagney a star.

James Whale, *Frankenstein* (U.S.): loose

adaptation of Mary Shelley's novel becomes a classic on the strength of Boris Karloff's acting and Jack Pierce's makeup for the monster.

1932 Postdubbing techniques are put into practice.

Venice Film Festival, the first international festival of its kind, begins.

Browning, *Freaks* (U.S.): highly controversial, bizarre tale of real circus freaks who take revenge on "normal" performers who deceive them.

Disney, *Flowers and Trees* (U.S.): the first use of the three-color Technicolor process appears in this cartoon.

Howard Hawks, *Scarface* (U.S.): this violent story of a Capone-like gangster sparks protests over its brutality.

LeRoy, *I Am a Fugitive from a Chain Gang* (U.S.): this exposé of injustice in the American penal system leads to reforms in Georgia, where the film is set.

Lubitsch, *Trouble in Paradise* (U.S.): the famous "Lubitsch touch" results in a stylish and urbane comedy of roguery and love.

1933 British Film Institute is founded.

German film industry is under Nazi control.

Lloyd Bacon, *Forty-Second Street* (U.S.): Busby Berkeley's synchronized, highly stylized musical numbers inject new life into the genre as the story turns to backstage efforts to produce a show.

Merian C. Cooper and Ernest B. Schoedsack, *King Kong* (U.S.): Willis O. Brien's extraordinary special effects make this "beauty and the beast" story a classic.

Thornton Freeland, *Flying Down to Rio* (U.S.): Fred Astaire and Ginger Rogers begin a partnership that brings the dance film to new, stylish heights.

Alexander Korda, *The Private Life of Henry VIII* (Br.): this internationally successful historical romance establishes a model for other character studies in period settings.

Gustav Machaty, *Extase* (Czech.): early erotic classic of an adulterous relationship creates a furor with a nude swimming sequence.

Jean Vigo, *Zéro de Conduite* (Fr.): combines realistic and symbolic imagery with a literal application of sound, which significantly influences French film.

1934 Frank Capra, *It Happened One Night* (U.S.): this screwball comedy sweeps the Academy Awards for Best Picture, Director, Writer,

Actor, and Actress and begins a cycle of similar films.

Flaherty, *Man of Aran* (Br.): controversial account of the daily lives of islanders off the coast of Ireland battling the environment for existence.

W. S. Van Dyke, *The Thin Man* (U.S.): this extremely popular sophisticated comedy/mystery adds a new dimension to the relationships of film couples in showing a well-adjusted, witty, loving husband and wife.

Vigo, *L'Atalante* (Fr.): realism merges with poetic imagery in this story of awakening sensuality and love aboard a barge.

1935 Museum of Modern Art Film Library opens.

Twentieth Century-Fox is formed by the merger of the Fox Film Corporation and Twentieth Century Pictures.

Ford, *The Informer* (U.S.): this antihero film is one of the first to make a precise application of sound track to *mise-en-scène*.

Robert Mamoulian, *Becky Sharp* (U.S.): the first feature-length film in three-color Technicolor.

1935-1951 *The March of Time* newsreels appear in monthly editions and greatly influence

journalistic practices and the movie-going public.

1936 Cinémathèque Française, the largest film archive in the world, is founded.

Capra, *Mr. Deeds Goes to Town* (U.S.): populist film fantasy in which the common man triumphs over corruption and cynicism.

Chaplin, *Modern Times* (U.S.): satire on the impact of technology on the human condition.

Pare Lorentz, *The Plow That Broke the Plains* (U.S.): government-financed, poetic documentary of the great Dust Bowl disaster.

Kenji Mizoguchi, *The Sisters of Gion* (Japan): classic study of the conflict between traditional and modern values focuses on women's roles in a changing society.

Leni Riefenstahl, *Triumph of the Will* (Ger.): monumental Nazi-subsidized propaganda film of the 1934 Nuremberg party rally that dramatizes Hitler's power and popularity in a calculated display that is disguised as documentary reportage.

1937 William Dieterle, *The Life of Emile Zola*

(U.S.): Academy Award–winning film that mixes biography with social commentary.

Lorentz, *The River* (U.S.): this government-sponsored poetic documentary traces the sources of erosion in the Mississippi River basin.

Jean Renoir, *Grand Illusion* (Fr.): study of the "illusions" that rigid rules of conduct, nationalism, and a divisive class structure impose upon men, leading them to war against human sympathies and each other.

1938 International Federation of Film Archives is established.

United States Film Service is founded, with Pare Lorentz as its chief.

Capra, *You Can't Take It with You* (U.S.): Academy Award-winning film that extols the virtues of honesty, goodwill, and personal expression over sophistication and power.

Eisenstein, *Alexander Nevsky* (U.S.S.R.): stylized, heroic study of a Russian prince who leads his people to victory over Teutonic invaders.

Riefenstahl, *Olympia* (Ger.): two-part study of the 1936 Olympics that emphasizes the

fitness of German youth striving to prove themselves the "master race."

1939 National Film Board of Canada is founded.

Victor Fleming, *Gone with the Wind* (U.S.): winner of ten Academy Awards, this classic historical spectacle, more than 3½ hours in length, stars Clark Gable and Vivien Leigh in an adaptation of Margaret Mitchell's epic of the south during the Civil War period.

Fleming, *The Wizard of Oz* (U.S.): musical adaptation of Frank Baum's fantasy establishes Judy Garland as a major star.

Ford, *Stagecoach* (U.S.): this classic action western focuses upon the personal dramas of a group of stagecoach passengers whose journey through a hostile environment serves to bring out qualities that ennoble them.

Renoir, *The Rules of the Game* (Fr.): deep-focus filming and a mobile camera distinguish this study of the hypocrisy of aristocratic society whose social rituals are acted out according to strict rules of conduct.

1940 Chaplin, *The Great Dictator* (U.S.): the director's first full talking film is a bold, satiric attack on Hitler.

George Cukor, *The Philadelphia Story* (U.S.): this romantic comedy concerns a society woman's growth as she comes to an understanding of the needs and frailties of human beings.

Ford, *The Grapes of Wrath* (U.S.): this optimistic adaptation of John Steinbeck's epic novel, reflecting the nation's positive mood, centers upon the plight of a group of downtrodden sharecroppers whose disheartening journey across the United States to find a better life fails to erode their spirit.

1941 Ford, *How Green Was My Valley* (U.S.): this Academy Award–winning nostalgic story of the breakup of a Welsh mining family mirrors the economic decay of the entire valley.

John Huston, *The Maltese Falcon* (U.S.): this study of greed, loyalty, and betrayal —starring Humphrey Bogart as the antihero detective in an adaptation of Dashiell Hammett's novel; also marks the director's film debut.

Orson Welles, *Citizen Kane* (U.S.): the director's debut is a classic, highly imaginative screen biography whose richly textured structure and innovative use of cinematic techniques leave a lasting influence on the film medium.

1942 Ford, *The Battle of Midway* (U.S.): first
 journalistic report to cover a strictly Amer-
 ican effort during World War II.

 Luchino Visconti, *Ossessione* (It.): the real-
 istic, on-location scenes and sensual quali-
 ties of this unauthorized version of James
 M. Cain's novel, *The Postman Always Rings
 Twice,* produce a movement in Italy away
 from romantic comedies.

 Welles, *The Magnificent Ambersons* (U.S.):
 this adaptation of Booth Tarkington's novel
 of a family's disintegration at the end of the
 nineteenth century emphasizes the dramatic
 conflict between the nostalgic past and the
 rise of a new social order.

 William Wyler, *Mrs. Miniver* (U.S.): Acad-
 emy Award–winning tribute to British
 fortitude which centers on one family's
 courageous efforts to "carry on" during
 the war.

1942-1945 Capra, "Why We Fight" series (U.S.): seven-
 part informational documentary explaining
 the historical events that led to the United
 States' involvement in World War II.

1943 Maya Deren, *Meshes of the Afternoon*
 (U.S.): influential subjective self-study that
 mixes dream and reality and reasserts the
 possibilities of personal cinematic expres-
 sion.

Dreyer, *Day of Wrath* (Den.): the director's first feature in more than a decade concerns the spiritual growth of a woman who is accused of witchcraft in seventeenth-century Denmark.

Wellman, *The Ox-Bow Incident* (U.S.): this unromantic western stands as a forceful indictment of mob rule as three innocent men are lynched over the objections of the rational members of a posse.

1944 Eisenstein, *Ivan the Terrible, Part One* (U.S.S.R.): this spectacular film traces the plots and counterplots in sixteenth-century Russia during Ivan's rise to power.

Vincente Minnelli, *Meet Me in St. Louis* (U.S.): large-scale, sentimental musical of a family living in St. Louis at the turn of the century.

Otto Preminger, *Laura* (U.S.): this mystery classic concerns a detective who falls in love with a portrait of the woman whose "murder" he is investigating.

Preston Sturges, *The Miracle of Morgan's Creek* (U.S.): irreverent comedy that satirizes society's conventions, as a pregnant young woman, who can't remember the name of the father-to-be, frantically searches for him.

1945 Czechoslovakia, Poland, and Yugoslavia nationalize their film industries.

Marcel Carné, *The Children of Paradise* (Fr.): complex, classic romance, set in the nineteenth century, traces the lives of several characters whose loves and passions bind them together.

Henry Hathaway, *The House on 92nd Street* (U.S.): documentarylike work, shot in New York City, concerning the FBI's hunt for spies during World War II, inspires many imitators and leads to an increase in on-location filming.

Roberto Rossellini, *Open City* (It.): this poignant account of underground resistance in Rome during the Nazi occupation propels neorealism to international attention.

Billy Wilder, *The Lost Weekend* (U.S.): Academy Award-winning study of the nightmarish world of an alcoholic.

1946 An average of 90 million tickets are sold each week in the United States as Hollywood has its most successful year.

Cannes Film Festival is founded.

Cocteau, *Beauty and the Beast* (Fr.): special visual effects help to create a magical fan-

tasy world in this sophisticated interpretation of the popular fairy tale.

Vittorio De Sica, *Shoeshine* (It.): neorealistic film that sets a standard with its concern for the plight of common people trapped by social conditions.

Eisenstein, *Ivan the Terrible, Part Two* (U.S.S.R.): this operatic study of Russia's first czar incorporates two experimental color sequences for symbolic value.

Wyler, *The Best Years of Our Lives* (U.S.): Academy Award-winning film that centers on the problems of three World War II veterans trying to adjust to civilian life.

UNCERTAINTY AND UPHEAVAL

1947 House Un-American Activities Committee investigates the Communist influence in Hollywood; the Hollywood Ten are blacklisted.

The Actor's Studio, which emphasizes the discovery of inner realities and naturalistic characterization, is founded.

Chaplin, *Monsieur Verdoux* (U.S.): controversial black comedy that concerns the exploits of a modern bluebeard who proclaims his amateur status at killing in comparison to the governments of the world.

Edward Dmytryk, *Crossfire* (U.S.): this treatment of anti-Semitism reflects Hollywood's postwar willingness to tackle serious social issues.

Elia Kazan, *Gentleman's Agreement* (U.S.): a writer poses as a Jew in this Academy Award–winning film that examines the issue of anti-Semitism.

1948 Television begins its expansion and poses a serious threat to the film industry.

The United States Supreme Court rules in the *Paramount* case that the industry's studio-theater chain corporations violate antitrust laws, and the studios must divest themselves of their theaters.

Bulgaria, Hungary, and Romania nationalize their film industries.

De Sica, *The Bicycle Thief* (It.): influential neorealistic work in which social hardship erodes an honest man's integrity until he becomes a thief in an effort to survive.

Flaherty, *Louisiana Story* (U.S.): this film depicts, through documentary and staged elements, a boy's changing attitude toward an oil-drilling team that invades the serenity of the Louisiana bayou.

Rossellini, *The Miracle* (It.): the second part of the uncompleted feature, *L'Amore*,

which concerns a woman who believes that she has conceived miraculously, precipitates a challenge to legal censorship in the United States that is resolved in the Supreme Court in 1952.

Visconti, *La Terra Trema* (It.): this documentarylike study of the fishermen in Sicily concentrates on one family's attempt to secure financial independence.

1949 Robert Hamer, *Kind Hearts and Coronets* (Br.): satiric black comedy that concerns a young man's rise to titled rank by the murder of eight intervening heirs, all played by Alec Guinness.

Carol Reed, *The Third Man* (Br.): classic thriller, set in postwar Vienna, that centers on an American writer who is forced to choose between friendship and morality.

Robert Rossen, *All the King's Men* (U.S.): Academy Award-winning film about political corruption traces the rise of an unknown to power.

1950 Robert Bresson, *Diary of a Country Priest* (Fr.): intense, austere story of a young priest's inner turmoil as he confronts his ineffectualness and approaching death.

Buñuel, *Los Olvidados* (Mex.): this brutal account of juvenile delinquency reestab-

lishes the director's importance after eighteen years of obscurity.

Cocteau, *Orpheus* (Fr.): a study of the poet's nature that embodies the conflict between tradition and the avant-garde.

Akira Kurosawa, *Rashomon* (Japan): this complex story concerning the nature of truth propels Japanese filmmaking to international attention.

Wilder, *Sunset Boulevard* (U.S.): this somber, expressionistic film centers on a faded film star whose career ironically reflects Hollywood's own decline.

Fred Zinnemann, *The Men* (U.S.): realistic study of paraplegic war victims that emphasizes character psychology and marks the film debut of Marlon Brando, who displays a new style of acting, "the Method," on screen.

1951 House Un-American Activities Committee resumes its investigation of Communist influence in Hollywood.

Cahiers du Cinéma is first published.

Berlin Film Festival is established.

Christian Nyby, *The Thing* (U.S.): science-fiction thriller, set in the Arctic, in which

scientists encounter a creature from another world.

Robert Wise, *The Day the Earth Stood Still* (U.S.): this serious science-fiction film concerns an alien's visit to earth to warn its inhabitants that they face destruction if they extend their conflicts into space.

1952–1953 The film industry introduces new projection systems and wide-screen formats in an attempt to regain viewers.

1952 The United States Supreme Court rules that the motion-picture medium is entitled to First Amendment safeguards; this ruling reverses the 1915 decision.

An average of 50 million tickets are sold each week in the United States.

The shift begins toward the use of color in Hollywood-made films.

Cinerama debuts in *This Is Cinerama* (U.S.): a travelogue-styled demonstration of the possibilities of the wide screen.

De Sica, *Umberto D* (It.): austere story of the day-to-day existence of an old man who struggles to survive on his small pension.

Gene Kelly and Stanley Donen, *Singin' in the Rain* (U.S.): classic musical comedy concerns a Hollywood studio's filmmaking

efforts during the transition from silent to sound pictures.

Arch Oboler, *Bwana Devil* (U.S.): the first full-length 3-D (Natural Vision) film.

Zinnemann, *High Noon* (U.S.): allegorical work about the consequences of taking a stand against evil.

1953 Henry Koster, *The Robe* (U.S.): Cinema-Scope, a wide-screen anamorphic-lens process, is introduced in this extremely successful Biblical spectacle.

Mizoguchi, *Ugetsu* (Japan): atmospheric, stylized account of two peasants whose selfish ambitions destroy their families in sixteenth-century Japan.

Preminger, *The Moon Is Blue* (U.S.): this comedy, released without a seal of approval, stirs a controversy because of its racy dialogue and sexual implications and begins a trend toward greater freedom of content selection.

George Stevens, *Shane* (U.S.): classic western concerns a gunfighter who aids homesteaders in their conflict with cattlemen.

Jacques Tati, *Mr. Hulot's Holiday* (Fr.): this comedy marks the director's appearance as Mr. Hulot, an old-world gentleman

whose vacation at a seaside resort is a series of mishaps.

Zinnemann, *From Here to Eternity* (U.S.): Academy Award–winning film adaptation of James Jones' novel about Army life on Hawaii just prior to the bombing of Pearl Harbor.

1954 Michael Curtiz, *White Christmas* (U.S.): VistaVision, which allows the projection of wide-screen images without an anamorphic lens, is introduced in this musical.

Federico Fellini, *La Strada* (It.): this parable of the relationship of individual needs to the human condition reveals the director's break with neorealism.

John Halas and Joy Batchelor, *Animal Farm* (Br.): this ambitious, animated-film adaptation of George Orwell's novel has a widespread influence on British animation.

Kurosawa, *The Seven Samurai* (Japan): epic samurai film that concerns the efforts of seven warriors to protect a village from bandits in the sixteenth century.

Kazan, *On the Waterfront* (U.S.): Academy Award–winning film that centers on an individual's growth and subsequent battle against corruption.

Visconti, *Senso* (It.): lavishly rendered sto-

ry of upper-class infidelity; set in the nineteenth century.

Andrej Wajda, *A Generation* (Pol.): this story of young soldiers facing the reality of battle during World War II brings Polish film to international attention.

1955 Richard Brooks, *The Blackboard Jungle* (U.S.): realistic study of delinquency in a New York high school.

Delbert Mann, *Marty* (U.S.): this Academy Award-winning, realistic story of romance between two average people is the first independently produced, low-budget film to gain wide recognition.

Preminger, *The Man with the Golden Arm* (U.S.): highly controversial film about drug addiction that further extends the boundaries of subject matter considered acceptable for motion pictures.

Nicholas Ray, *Rebel without a Cause* (U.S.): James Dean stars as a teenager rebelling against his family's values while seeking honest relationships.

Satyajit Ray, *Pather Panchali* (India): the first part of the Apu trilogy, a realistic account of Apu's early boyhood with his family, establishes its director on the international scene.

NEW DIRECTIONS

1956-1959 Six Free Cinema programs are shown at the National Film Theatre in Britain.

1956 Ingmar Bergman, *The Seventh Seal* (Swed.): Death stalks a knight who is seeking a meaning to life in this expressionistic allegory set in the Middle Ages.

Bresson, *A Man Escaped* (Fr.): a soldier's inner turmoil, resulting from physical confinement and social alienation, leads to his spiritual awakening.

Ford, *The Searchers* (U.S.): influential western that concerns a man's obsessive search for his niece, who was captured by Indians during a murder raid.

Kon Ichikawa, *The Burmese Harp* (Japan): epic study of a Japanese soldier's spiritual growth, brought about by the horrors of war.

Roger Vadim, *And God Created Woman* (Fr.): this sexually liberating film propels Brigitte Bardot to international stardom.

1957 Bergman, *Wild Strawberries* (Swed.): an aged professor's journey enables him to discover the value of life.

Fellini, *Nights of Cabiria* (It.): explores life's cruelties in a story of a downtrodden prostitute.

Stanley Kubrick, *Paths of Glory* (U.S.): highly acclaimed but controversial anti-military film that examines a court-martial incident in France during World War I.

1958–1962 The New Wave flourishes in France.

1958 Jack Clayton, *Room at the Top* (Br.): this account of a young man's rise to a higher class status begins the movement in Britain toward greater expression in treatment of contemporary themes.

Louis Malle, *The Lovers* (Fr.): this satiric look at love spurs the growing film liberation and revival in France.

Roman Polanski, *Two Men and a Wardrobe* (Pol.): parable of prejudice; two men with the burden of a wardrobe meet rejection and violence as they attempt to merge into society.

Ray, *The Music Lovers* (India): intense, lyrical story of an aristocrat's obsession with music, an obsession that leads to his family's destruction.

Ray, *The World of Apu* (India): the final part of the Apu trilogy concerns Apu's maturation into a man who is strong enough to endure the pain of life.

Wajda, *Ashes and Diamonds* (Pol.): realism

and romantic lyricism combine in this work which reveals the anguish of the Poles at the close of World War II as they exchange one occupying force, the Germans, for another, the Russians.

1959 Claude Chabrol, *The Cousins* (Fr.): examines the relationship between two cousins living together and studying in Paris, whose conflicting lifestyles lead to disaster.

Jean-Luc Godard, *Breathless* (Fr.): seminal film in the New Wave that makes Jean-Paul Belmondo a star and influences many works in its break with the traditions of commercial filmmaking.

Alain Resnais, *Hiroshima Mon Amour* (Fr./Japan): complex time-space narrative that blends past and present, public and private horror into a work that reveals the lasting effects of war.

Tony Richardson, *Look Back in Anger* (Br.): "kitchen-sink realist" work centers on the frustrations of an "angry young man"; an adaptation of John Osborne's play.

François Truffaut, *The 400 Blows* (Fr.): influential freestyle handling of the story of the hardships of a boy's life.

1960 Michelangelo Antonioni, *L'Avventura* (It./Fr.): unconventional film that deals with

the complexities of human behavior among the morally bankrupt.

Fellini, *La Dolce Vita* (It.): this influential work provides an episodic view of life in Rome at the end of the 1950s.

Hitchcock, *Psycho* (U.S.): classic thriller that initiates a new age of graphically explicit works of violence.

Richard Leacock, Donn Alan Pennebaker, Robert Drew, and Al Maysles, *Primary* (U.S.): this film about the 1960 presidential primary in Wisconsin gives impetus to the direct-cinema movement.

Karel Reisz, *Saturday Night and Sunday Morning* (Br.): realistic study of a factory worker's frustration with his place in the British lower class.

1961 Antonioni, *La Notte* (It./Fr.): a series of incidents reveal the emptiness of a relationship between a married couple.

Buñuel, *Viridiana* (Sp./Mex.): ironic treatment of religious obsession and sexual repression.

John Cassavetes, *Shadows* (U.S.): breaks with the traditions of commercial filmmaking and provides stimulus to the independent cinema.

Kurosawa, *Yojimbo* (Japan): popular samurai warrior brings "peace" to a village beset by two warring families.

Resnais, *Last Year at Marienbad* (Fr./It.): highly formalized, graphic film that is concerned with the implications of time and thought.

Truffaut, *Jules and Jim* (Fr.): lyrical story, in pre-World War I Paris, concerns two friends whose love and changing relations with a free-spirited woman parallel the period's historical developments.

1962 Buñuel, *The Exterminating Angel* (Mex.): allegorical examination of the collapse of social restraints as supper-party guests find themselves mysteriously trapped in their host's home.

Polanski, *Knife in the Water* (Pol.): the director's first feature is a study of emotional violence presented in an austerely naturalistic style.

Richardson, *The Loneliness of the Long Distance Runner* (Br.): develops the tension between social resentment and personal freedom as an "angry young man," in a grim industrial setting, strikes out in frustration at society.

Terence Young, *Dr. No* (Br.): the first film

in the enormously successful James Bond series revitalizes the spy genre.

1963 Swedish Film Institute is founded.

New York Film Festival is established.

Lindsay Anderson, *This Sporting Life* (Br.): this social-realist study of a rugby player gives evidence of a trend toward greater psychological emphasis in British film.

Fellini, *8½* (It.): semiautobiographical, self-reflective work concerning the director's difficulties in making a film.

Joseph Losey, *The Servant* (Br.): a young, upper-class man is dominated and corrupted by his servant.

Richardson, *Tom Jones* (U.S.): highly successful free-style period piece that reflects the New Wave influence.

John Schlesinger, *Billy Liar* (Br.): personal analysis of a young undertaker who fantasizes away his dreary existence.

1964 Kenneth Anger, *Scorpio Rising* (U.S.): study of the motorcycle subculture that places a violent masculine persona above obscure feelings of inferiority.

Antonioni, *The Red Desert* (It./Fr.): color is effectively used to delineate the psychological response of a woman striving for

fulfillment in a stultifying industrial environment.

Kubrick, *Dr. Strangelove, or How I Learned to Stop Worrying and Love the Bomb* (Br.): satirically exposes the events leading to total nuclear disaster.

Sergio Leone, *A Fistful of Dollars* (It./W. Ger./Sp.): this internationally successful "spaghetti western," notable for its hard-hitting action and violence, propels Clint Eastwood to stardom.

Pier Paolo Pasolini, *The Gospel According to St. Matthew* (It./Fr.): widely acclaimed account of Christ's life in a social-realist context.

Hiroshi Teshigahara, *Woman of the Dunes* (Japan): allegorical tale of the conflict between the acceptance of transitory physical existence and the desire for immortality.

1965

Milos Forman, *Loves of a Blonde* (Czech.): satire that examines the personal effect of outmoded social conventions.

Miklós Jancsó, *The Round-Up* (Hung.): austere account of Austrian efforts to discover the Hungarian rebels within a group of prisoners they have captured.

Ján Kadár and Elmar Klos, *The Shop on Main Street* (Czech.): poignant account of

anti-Semitic cruelty during the Nazi occupation of Czechoslovakia.

Sidney Lumet, *The Pawnbroker* (U.S.): examines the life of a concentration camp survivor who isolates himself from human contact behind the impersonal dealings of a pawnbroker.

1966 Bergman, *Persona* (Swed.): explores human psychology and the value of artistic expression as a nurse attempts to help a famous actress overcome her psychosomatically induced muteness.

Véra Chytilová, *Daisies* (Czech.): surrealistic film that focuses on two women who attempt to strike out at a war-mongering, male-dominated society.

Jiří Menzel, *Closely Watched Trains* (Czech.): sex and defiance are linked in this black comedy set within Nazi-occupied Czechoslovakia.

Gillo Pontecorvo, *The Battle of Algiers* (Algeria/It.): documentarylike film, so realistic that it appears to be a compilation of actual newsreel footage, that recreates the events leading to Algerian independence.

Volker Schlöndorff, *Young Torless* (W. Ger.): psychological study of a boy who is subjected to harsh treatment in a German boarding school at the turn of the century.

Andy Warhol, *The Chelsea Girls* (U.S.): successful Underground film in which footage shot at the Chelsea Hotel in New York is projected onto two screens simultaneously.

REVITALIZATION

1967 The American Film Institute is founded.

Godard, *Weekend* (Fr./It.): offers Brechtian theatricality in a weekend trip that becomes the scene of carnage and cannibalism.

Norman Jewison, *In the Heat of the Night* (U.S.): Academy Award-winning film that deals with prejudice as a black detective and a white police chief reluctantly work together to solve a murder.

Mike Nichols, *The Graduate* (U.S.): this extremely popular, seriocomic study of youthful malaise in affluent America incorporates an LP-length set of songs into the sound track.

Arthur Penn, *Bonnie and Clyde* (U.S.): this nostalgic, romanticized treatment of societal misfits and poetic rendering of violence has a vast influence on films to follow.

Pennebaker, *Monterey Pop* (U.S.): first of a series of rock documentaries which captures on film popular musical performances in vast outdoor settings.

Bo Widerberg, *Elvira Madigan* (Swed.): internationally successful romantic story of star-crossed lovers.

Frederick Wiseman, *Titicut Follies* (U.S.): nonfiction account of inhumane conditions in a Massachusetts institution for the criminally insane.

1968 Motion Picture Association of America (MPPA) replaces the self-regulation code with a classification system for rating films.

Anderson, *If . . .* (Br.): study of youthful rebellion against British tradition.

Bergman, *Shame* (Swed.): explores the responsibility of artists and their uncertain roles in war-torn society.

Jancsó, *The Red and the White* (Hung.): somber story of war's absurdity; set during the Russian Revolution.

Kubrick, *2001: A Space Odyssey* (Br.): influential special-effects film that ponders mankind's uncertain fate.

Pasolini, *Teorema* (It.): controversial film in which symbolism and realism are freely mixed.

1969 George Roy Hill, *Butch Cassidy and the Sundance Kid* (U.S.): extremely popular, romanticized account of outlaw life.

Rainer Werner Fassbinder, *Why Does Herr*

R. Run Amok? (W. Ger.): this film about the disastrous effects of conformity brings the director to international attention.

Dennis Hopper, *Easy Rider* (U.S.): astoundingly successful low-budget film that concerns the odyssey, across the United States, of two men who want to come to terms with their country.

Sam Peckinpah, *The Wild Bunch* (U.S.): nostalgic but extremely violent interpretation of outlaw life stirs controversy.

Schlesinger, *Midnight Cowboy* (U.S.): Academy Award–winning film that deals candidly with loneliness and alienation.

1970 Robert Altman, *M*A*S*H* (U.S.): irreverent, antiwar comedy that establishes the director's reputation.

Bernardo Bertolucci, *The Conformist* (It./ Fr./W. Ger.): complex account of a young man's efforts to find release from guilt through political conformity.

Arthur Hiller, *Love Story* (U.S.): extremely successful, old-style Hollywood creation of a young couple's doomed love.

Bob Rafelson, *Five Easy Pieces* (U.S.): dissatisfaction with American life is expressed in a musician's rejection of his career and personal commitment.

George Seaton, *Airport* (U.S.): big-box-office, melodramatic account of efforts to safely land a jet liner following a midair bomb explosion.

Michael Wadleigh, *Woodstock* (U.S.): documentary record of the grand musical/communal event at Woodstock.

1971 Australian Film Development Corporation —later the Australian Film Commission— is created.

Altman, *McCabe and Mrs. Miller* (U.S.): impressionistic, unromantic genre study of life on the western frontier.

Kubrick, *A Clockwork Orange* (Br.): highly stylized, controversial story of life in a bland but violent city of the future.

Dusan Makavejev, *WR: Mysteries of the Organism* (Yug./W. Ger.): repressed sexuality is the focal point of this attack on contemporary decadence.

Nicholas Roeg, *Performance* (Br.): an ambiguous, sometimes surreal account of shifting realities.

Don Siegel, *Dirty Harry* (U.S.): this mythic, violent action thriller concerns a loner police officer who lives by his own code of behavior to correct injustice.

Jan Troell, *The Emigrants* (Swed.): lyrical saga about a Swedish family's emigration to nineteenth-century America.

Melvin Van Peebles, *Sweet Sweetback's Baadasssss Song* (U.S.): extremely successful, controversial independent black production that concerns white society's oppression of blacks.

1972 Bertolucci, *Last Tango in Paris* (It./Fr.): intense, highly controversial film that stars Marlon Brando as an expatriate American whose sexual abuse of a young French woman reveals his hostility to life.

Francis Ford Coppola, *The Godfather* (U.S.): this Academy Award–winning epic of a Mafia patriarch's family becomes one of the most profitable films ever made.

Bob Fosse, *Cabaret* (U.S.): uses song-and-dance routines to comment upon societal values which allowed the Nazi takeover in Germany.

Werner Herzog, *Aguirre, The Wrath of God* (W. Ger.): an account of a sixteenth-century Spanish soldier's increasing madness as he penetrates deeper and deeper into the jungle.

Martin Ritt, *Sounder* (U.S.): treats the day-to-day problems of a poverty-stricken black family during the Depression.

1973 Bergman, *Cries and Whispers* (Swed.): this psychosexual study of four women employs symbolic expression.

Bergman, *Scenes from a Marriage* (Swed.): originally a six-part television film; details the progress of a troubled marriage.

William Friedkin, *The Exorcist* (U.S.): extremely successful film in which the Devil possesses the body of a 12-year-old girl.

Hill, *The Sting* (U.S.): this lighthearted story of two con artists marks the revival of escapist screen comedy.

George Lucas, *American Graffiti* (U.S.): a nostalgic recreation of early sixties small-town life for a group of high school graduates.

1974 Mel Brooks, *Blazing Saddles* (U.S.): this parody of the western, which combines sight gags, slapstick, and farfetched situations into a zany plot, is the first of a series of comic updates of Hollywood genre pictures by the director.

Coppola, *The Godfather, Part Two* (U.S.): continues the Corleone saga, past and present, and traces the motivational roots of twentieth-century gangsterism.

Peter Davis, *Hearts and Minds* (U.S.): this powerful documentary is the first serious

American film effort to come to grips with the social and political realities of the Vietnamese war.

Fassbinder, *Ali: Fear Eats the Soul* (W. Ger.): explores the problems of loneliness and alienation in modern Germany, where individual happiness is endangered by societal pressure.

Lina Wertmüller, *Swept Away* (It.): a working-class Communist man and a wealthy bourgeois woman are stranded on an island, and he temporarily becomes the master, as social and class distinctions are overturned.

1975 Altman, *Nashville* (U.S.): epic character study set in America's capital of country-western music.

Hal Ashby, *Shampoo* (U.S.): this exploration of American morality centers on the life of a sexually active hairdresser.

Forman, *One Flew over the Cuckoo's Nest* (U.S.): a mental patient's conflict with institutional authority sweeps the Academy Awards for Best Picture, Director, Writer, Actor, and Actress—the first time since 1934.

Herzog, *The Mystery of Kaspar Hauser* (W. Ger.): the story of a "primitive" man, kept in isolation from civilization, who

mysteriously emerges from the mountains to be mistreated by the society that he encounters.

Kubrick, *Barry Lyndon* (Br.): visually ravishing film that traces the rise and fall of an adventuresome Irishman in eighteenth-century society.

Steven Spielberg, *Jaws* (U.S.): this extraordinary box office success concerns a malevolent shark who terrorizes a community.

Peter Weir, *Picnic at Hanging Rock* (Austral.): this story of an ill-fated summer outing of schoolgirls brings Australian film to international attention.

1976 John Avildsen, *Rocky* (U.S.): upbeat American success story of a small-time boxer who gets a chance to prove that he's "somebody."

Bertolucci, *1900* (It./Fr./W. Ger.): epic that concentrates on the lives of two Italian families from the early twentieth century to the modern era.

Martin Scorsese, *Taxi Driver* (U.S.): grim, controversial study of a psychopathic cab driver who erupts into violence.

Wertmüller, *Seven Beauties* (It.): intricate, ironic study of sexuality and honor.

1977 Woody Allen, *Annie Hall* (U.S.): offbeat

romance in which the director extends his comedy toward introspective analysis and pathos.

Lucas, *Star Wars* (U.S.): this heroic space fantasy, the biggest box office success in Hollywood's history, revitalizes the science-fiction genre.

Spielberg, *Close Encounters of the Third Kind* (U.S.): visually compelling account of human contact with UFOs.

Weir, *The Last Wave* (Austral.): psychic thriller about an Australian lawyer who is haunted by apocalyptic visions.

Wim Wenders, *An American Friend* (W. Ger./Fr.): this thriller comments upon European and American relations as a West German craftsman is corrupted by his American "friend."

1978 Ashby, *Coming Home* (U.S.): examines the aftermath of the Vietnamese war in a story about an embittered paraplegic, a Marine captain, and the captain's wife.

Michael Cimino, *The Deer Hunter* (U.S.): Academy Award-winning film that focuses on the lives of three men whose experiences in Vietnam significantly change them.

Ermanno Olmi, *The Tree of Wooden Clogs* (It.): impressionistic look at the daily life

of five families in an Italian farm community.

Claudia Weill, *Girlfriends* (U.S.): a portrait of a woman's personal growth and professional success and her maturing relationship with her former roommate.

1979 Coppola, *Apocalypse Now* (U.S.): adapts Joseph Conrad's *Heart of Darkness* into an epic account of the Vietnamese war in which a soldier's journey leads him to recognize man's capacity for evil.

Fassbinder, *The Marriage of Maria Braun* (W. Ger.): ironic story of a German woman's quest for financial security, which parallels her country's economic revival after World War II.

Ritt, *Norma Rae* (U.S.): humanistic account of a young Alabama woman who becomes the catalyst for a New York labor organizer's work.

Schlöndorff, *The Tin Drum* (W. Ger.): this adaptation of Gunter Grass' novel concerns a child's attempt to avoid adult responsibilities by "refusing" to grow up.

Peter Yates, *Breaking Away* (U.S.): study of four male friends in transition after high school.

Ira Wohl, *Best Boy* (U.S.): intimate portrait

of a retarded, middle-aged man's efforts to achieve a new lifestyle.

1980 Michael Apted, *Coal Miner's Daughter* (U.S.): traces country singer Loretta Lynn's rise to stardom.

Irvin Kershner, *The Empire Strikes Back* (U.S.): this sequel to *Star Wars* adds a dimension of romance to its extraordinary special effects and action sequences.

Robert Redford, *Ordinary People* (U.S.): Academy Award-winning film adaptation of Judith Guest's novel about a family's adjustment to the death of their elder son.

Scorsese, *Raging Bull* (U.S.): portrait of a brutal boxer whose self-destructive behavior ruins his career and his marriage.

1981 Cimino, *Heaven's Gate* (U.S.): the critical and popular failure of this $36 million epic prompts consideration of investment limits on Hollywood productions.

Spielberg, *Raiders of the Lost Ark* (U.S.): an adventure film, inspired by the motion-picture serial, grosses more than $200 million.

Hugh Hudson, *Chariots of Fire* (Br.): stylish British film, about two men who run to prove themselves, is surprise Oscar winner as Best Picture of 1981.

TERM AND FILM TITLE INDEX

TOPICAL INDEX